T0047416

the
faith
of
graffiti

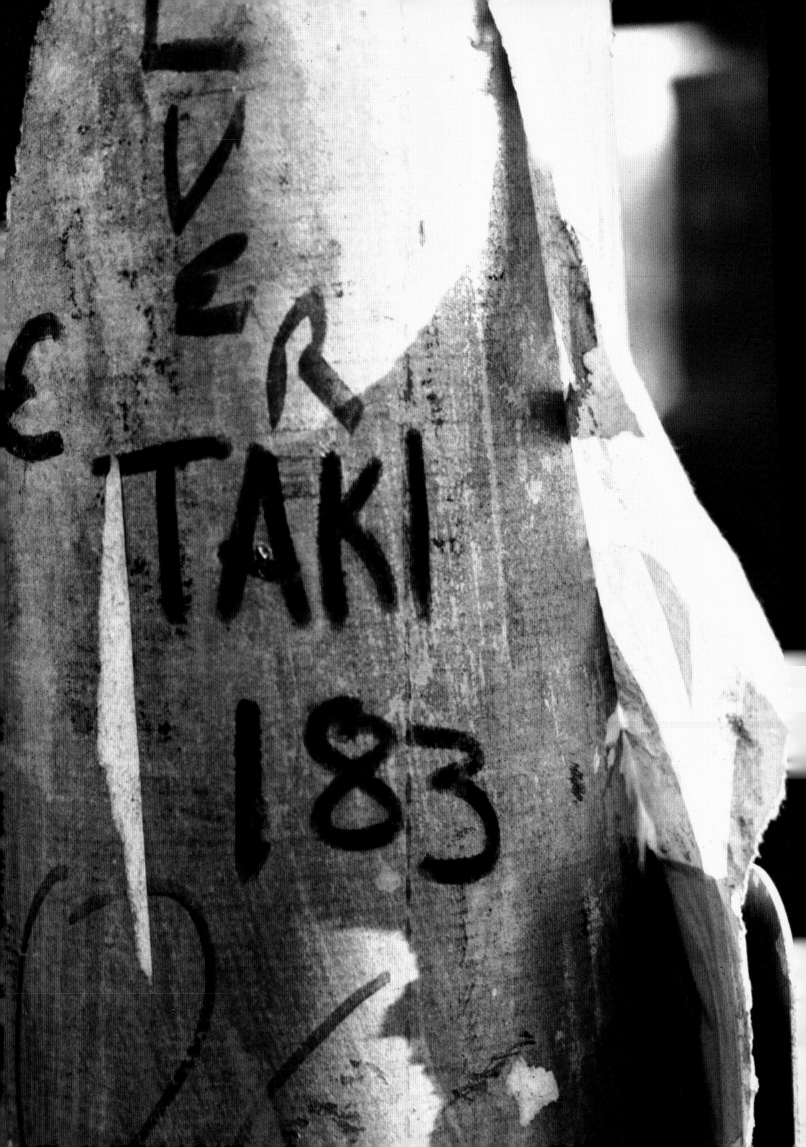

the
faith
of
graffiti

photographs by
jon naar
words by
norman mailer

icon !t
itbooks
AN IMPRINT OF HARPERCOLLINSPUBLISHERS

the faith of graffiti

by Norman Mailer

1.

Journalism is chores. Journalism is bondage unless you can see yourself as a private eye inquiring into the mysteries of a new phenomenon. Then you may even become an Aesthetic Investigator ready to take up your role in the Twentieth Century mystery play. Aesthetic Investigator! Make the name A hyphen Roman numeral I, for this is about graffiti.

A-I is talking to CAY 161. That is the famous Cay from 161st Street, there at the beginning with TAKI 183 and JUNIOR 161, as famous in the world of wall and subway graffiti as Giotto may have been when his name first circulated through the circuits of those workshops which led from Masaccio through Piero della Francesca to Botticelli, Michelangelo, Leonardo, and Raphael. Whew! In such company Cay loses all name, although he will not necessarily see it that way. He has the power of his own belief. If the modern mind has moved from the illumination of the first master of fresco, that simple subtle Giotto who could find beatitude in a beheading as well as the beginnings of perspective in the flight of angels across the bowl of a golden sky, if we have mounted the high road of the Renaissance into Raphael's celebration of the True, the Good, and the Beautiful in each human succulent three-dimensionality of the gluteus maximus and bicep on out to our own vales and washes into Rothko and Ellsworth Kelly, why so, too, have we also moved from the celebration to the name, traveled from that mysterious, even frightening, notion that men and women in the sweetmeat of their bodies had wrested a degree of independence from Church and God down now to the twentieth-century certainty that life is an image.

A couple of stories:

The first is a Jewish joke. Perhaps it is *the* Jewish joke. Two grandmothers meet. One is pushing a baby carriage. "Oh," says the other, "what a beautiful

grandchild you have." "That's nothing," says the first, reaching for her pocket-book. "Wait'll I show you her picture!"

The second seems apocryphal. Willem de Kooning gives a pastel to Robert Rauschenberg, who takes it home and promptly erases it. Next he signs his name to the erasure. Then he sells it. Can it be that Rauschenberg is saying, "The artist has as much right to print money as the financier?" Yes, Rauschenberg is giving us small art right here and much instruction. Authority imprinted upon emptiness is money. And the ego is capital convertible to currency by the use of the name. Ah, the undiscovered links of production and distribution in the psychic economy of the ego! For six and a half centuries we have been moving from the discovery of humanity into the circulation of the name, advancing out of some profound and primitive relation to dread so complete that painting once lay inert on the field of two dimensions (as if the medieval eye was not ready to wander down any fall). Then art dared to rise into that Renaissance liberation from anxiety which loosed the painterly capacity to enter the space-perspective of volume and depth. Now, with graffiti, we are back in the prison of two dimensions once more. Or is it the one dimension of the name – the art-form screaming through space on a unilinear subway line?

Something of all this is in the mind of our Aesthetic Investigator as he sits in a bedroom on West 161st Street in Washington Heights and talks to CAY 161 and JUNIOR 161 and LI'L FLAME and LURK. They talk about the name. He has agreed to do a centerpiece for a picture book on graffiti by Mervyn Kurlansky and Jon Naar, has agreed to do it on the instant (in a Los Angeles hotel room) that he has seen it – presentation by way of Lawrence Schiller – the splendid photographs and his undiscovered thoughts on the subject leap together. He has a match. Maigret at the moment he will solve a mystery for Simenon or Proust with the taste of the madeleine on his lip can hardly be happier. There is something to find in these pictures, thinks A-I, some process he can all but name, not quite. All the intellectual hedonism of an elusive theme is laid out before him. So, yes, he accepts. And discovers weeks later that his book has already been given a title. It is *Watching My Name Go By*. He explains to the pained but sympathetic ears of his collaborators that an author needs his own title. It is like the tool one fashions to build those other tools which build a house. Even if the title comes last.

Besides, there is a practical reason. Certain literary men cannot afford titles like *Watching My Name Go By*. Norman Mailer may be first in such a category. One should not be able to conceive of one's bad reviews before writing a word. (Of course, his collaborators might reply that A-I is the name of a steak sauce. Much comment will certainly be available on the style as stale gravy.)

But then he also does not like *Watching My Name Go By* for its own forthright meaning. It implies a direct and sentimental connection to the world. There is no reason to be certain these young graffiti writers have such simple relation.

Besides, they do not use their own name. They adopt a name. It is like a logo. Moxie or Socono, Tang, Whirlpool, Duz. The kids bear a not quite

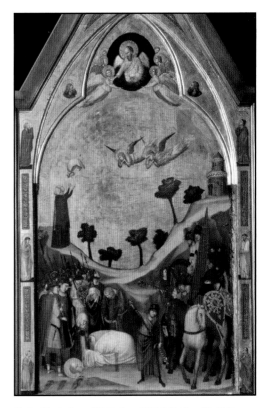

Giotto, *Martyrdom of St. Paul*, ca. 1330. Collection, The Vatican Museums, Rome.

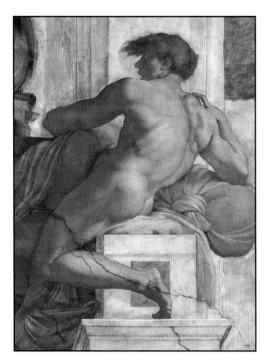

Michelangelo, *The Ignudi*, 1509, Collection,
The Vatican Museums, Rome.

definable relation to their product. It is not MY NAME but THE NAME. Watching The Name Go By. He still does not like it. Yet every graffiti writer refers to the word. Even in newspaper accounts, it is the term heard most often. "I have put my name," says Super Kool to David Shirey of the *Times*, "all over the place. There ain't nowhere I go I can't see it. I sometimes go on Sunday to Seventh Avenue 86th Street station and just spend the whole day" – yes, he literally says it – "watching my name go by." But then they all use it. JAPAN I, being interviewed by Jon Naar and A-I in a subway, grins as a station cop passes and scrutinizes him. He is clean. There is no spray can on him today. Otherwise he would run, not grin. Japan says, with full evaluation of his work, "You have to put in the hours to add up the names. You have to get your name around." Since he is small and could hardly oppose too many who might choose to borrow his own immortal JAPAN I, he merely snorts in answer to the question of what he would do if someone else took up his name and used it. "I would still get the class," he remarks.

Whether it is one's own interviews or others', the word which prevails is always the name. MIKE 171 informs *New York Magazine*, "There are kids all over town with bags of paint waiting to *hit* their names." A bona fide clue. An object is hit with your name, yes, and in the ghetto, a hit equals a kill. "You must kill a thing," said D. H. Lawrence once, "to know it satisfactorily." (But then who else could have said it?) You hit your name and maybe something in the whole scheme of the system gives a death rattle. For now your name is over their name, over the subway manufacturer, the Transit Authority, the city administration. Your presence is on their presence, your alias hangs over their scene. There is a pleasurable sense of depth to the elusiveness of the meaning.

So he sits with Cay and Junior and the others in the bedroom of Junior's parents and asks them about the name. It is a sweet meeting. He has been traveling for all of a wet and icy snowbound Sunday afternoon through the monumental drabs of South Bronx and Washington Heights, so much like the old gray apartment house ranks of the Brooklyn where he grew up, a trip back across three generations because the Puerto Ricans in this apartment may not be so different from the poor ambitious families of relatives his mother would speak of visiting on the Lower East Side when she came as a child up from the Jersey shore to visit. So little has changed. Still the-smell-of-cooking-in-the-walls, like a single word, and the black-pocked green stucco of the halls, those dark pits in the plaster speaking of the very acne of apartment house poverty. In the apartment itself, entering by the kitchen, down through the small living room and past the dark bedrooms in a file off the hall, all the shades drawn, a glimpse has been had of the television working in the living room like a votive light in some unilluminated and poor slum church chapel (one damp fire in the rain-forest) while the father in shorts sleeps on the sofa, and the women congregate – the kitchen is near. The windows are stained glass, sheets of red and yellow plastic pasted to the glass – the view must be on an air shaft. No light in this gray and late afternoon day. It is all the darkness of that gloom which sits in the very center of slum existence, that amalgam of worry and dread, heavy as buckets of oil, the true wages of the working class, with all that

attendant fever in the attractions of crime, the grinding entrapments of having lost to the law – lawyer's fees, bondsmen, probation officers, all of it – and the twice grinding worries of debt and economic disaster if a bookie is calling for payment on bets lost in games which took place weeks ago.

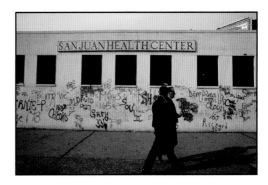

Yet now there is also a sense of protection in the air. The mood is not without its reverence: CAY 161 has the face of a martyr. He looks as if he has been flung face-first against a wall, as if indeed a mighty hand has picked him up and hurled him through the side of a stone house. He is big, seventeen, and almost six feet tall, once good-looking and may yet be good-looking again, but now it is as if he has been drawn by a comic strip artist, for his features express the stars, comets, exclamation points, and straight-out dislocation of eyes and nose and mouth which accompany any hero in a comic strip when he runs into a collision. SOCK! ZAM! POW! CAY 161, driving a stolen van, fleeing the cops in an old-fashioned New York street chase, has gone off the road on a turn, "and right on 161st Street where he was born and raised, he hit a hydrant, turned over a few times, and wound up inside a furniture store . . . When the police looked inside the car," – description by José Torres in the *N.Y. Post* – "Cay lay motionless in the driver's seat, and another youth, a passenger in the car, sprawled unconscious outside, hurled from the car by the impact." The friend had a broken leg, and Cay was left with part of his brain taken out in a seven-hour operation. The doctor gave warning. He might survive as a vegetable. For two months he did not make a move. Now it is six months later, a trip from June to Christmas, and Cay is able to talk, he can move. His lips are controlled on one side of his face but slack on the other – he speaks as if he has had a stroke. He moves in the same fashion. Certain gestures are agile, others come up half-paralyzed and top-heavy, as if he will fall on his face at the first false step. So his friends are his witness. They surround him, offer the whole reverence of their whole alertness to every move he makes, yet casually. There is all the elegance of good manners in the way they would try to conceal that he is different from the others.

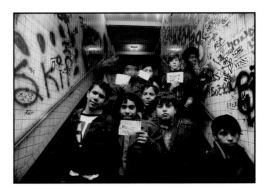

But Cay is happy now. He is in Junior's house, JUNIOR 161, his best friend. They have gone out writing together for years, both tall, a twin legend – when one stands on the other's shoulders, the name goes up higher on the wall than for anyone else. True bond of friendship: they will each write the other's name, a sacramental interchange. Junior has a lean body, that indolent ghetto languor which speaks of presence. "I move slow, man," says the body, "and that is why you watch me, because when I move fast, you got to watch out." He is well dressed, ghetto style – a white turtleneck sweater, white pants, a white felt hat, nothing more. Later he will step out like this into the winter streets. You got to meet the eye of the beholder with some class. Freezing is for plants.

A-I interviews them. Yes, they started three years ago and would hit four or five names a day. Junior liked to work at least an hour a day. So go the questionnaire questions: Cay liked to use red marker, Junior blue. Hundreds of masterpieces to their credit. Yes, Junior's greatest masterpiece is in the tunnel where the track descends from 125th Street to 116th Street. There, high on the wall, is JUNIOR 161 in letters six feet high. "You want to get your name

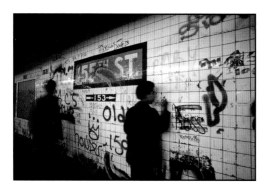

in a place where people don't know how you could do it, how you could get up to there. You got to make them think." It is the peril of the position which calls. Junior frowns on the later artists who have come after Cay and himself. The talk these days is of SLY and STAY HIGH, PHASE 2, BAMA, SNAKE, and STITCH. The article by Richard Goldstein in *New York* (March 26, 1973) has offered a nomenclature for the styles, Broadway, Brooklyn, and Bronx, disquisitions on bubble and platform letters. Perhaps his source is AMRL, also known as BAMA, who has said to another reporter in his own full articulate speaking style, "Bronx style is bubble letters, and Brooklyn style is script with lots of flourishes and arrows. It's a style all by itself. Broadway style, these long slim letters, was brought here from Philadelphia by a guy named Topcat. Queens style is very difficult, very hard to read."

Junior is contemptuous of this. The new forms have wiped out respect for the old utilitarian lettering. If Cay likes the work of STAY HIGH, Junior is impressed by none. "That's just fanciness," he says of the new. "How're you going to get your name around doing all that fancy stuff?"

Cay speaks into this with his deep, strangled, and wholly existential voice – he cannot be certain any sound he utters will come out as he thinks. "Everybody tries to catch up to us," he says.

"You have to put in the hours?"

A profound nod.

Of course, he is not doing it any longer. Nor is Junior. Even before the accident, both had lost interest. On the one hand, the police were getting tough, the beatings when you were caught were now certainly worse, the legal penalties higher, the supplies of paint getting to be monitored, and on the other hand something had even happened to the process itself. Names had grown all over walls – a jungle of ego creepers and tendrils had flowered through a series of psychic rain storms which passed like unwritten history over New York. Then the rain had blown by. All discussion on this winter afternoon was directed toward the curiosity of past passions to write the name, as if, like the Twist, it was over.

A-I queries them. Tentatively he offers a few questions about the prominence of the name, of why people use that word. He hesitates how to pose the question – he fears confidence will be lost if he is too abstract, or to the contrary too direct, he does not wish to ask straight-out, "What is the meaning to you of the name?" but, indeed, he does not have to – Cay speaks up on what it means to watch the name go by. "The name," says Cay, in a full voice, Delphic in its unexpected resonance – as if the idol of a temple has just chosen to break into sound – "The name," says Cay, "is the *faith* of graffiti."

It is quite a remark. He wonders if Cay knows what he has said. "The name," repeats Cay, "is the *faith*." He is in no doubt of the depth of what he has said. His eyes fix on A-I, his look is severe. Abruptly, he declares that the proper title is "The Faith of Graffiti." And so it is.

A Sunday afternoon has come to its end. A-I walks downstairs with Junior, Cay, Lurk, and Li'l Flame, and is shown modest examples of their writing on the apartment house walls. Cay has also used another name. At times he has

called himself THE PRAYER 161. They say goodbye in the hall. Cay shows A-I the latest 161st Street sequence of thumb-up finger-curled handshakes. The pistol-pointed forefinger and upraised thumb of one man touch the thumb and forefinger of the other in a quick little cat's cradle. Cay's fingers are surprisingly deft. Then he and Junior spar a bit, half-comic for he lurches, but with the incisive tenderness of the ghetto, as if his moves also say, "Size don't come in packages and a cripple keeps the menace." It is agreeable to watch. As he attempts to spar, Cay is actually moving better than he has all day.

The name is the faith of graffiti. Was it true that the only writing which did not gut one's worth lay in those questions whose answers were not known from the start? A-I still had no more than a clue to graffiti. Were the answers to be found in the long war of the will against the power of taboo? How much of just such emotion still lived in the pleasurable anxiety of the painter's act? But then who could know when one of the gods would turn in the winds of sleep as images were drawn? Was that a thought in the head of the first savage ready to delineate the ineluctable silhouette of an animal on the wall of a cave? If so, the earliest painting had been not two dimensions but one – one, like graffiti – the hand pushing forward into the terror of future punishment from demons filled with fury at human audacity. Later would come an easier faith that the Lord might be on the side of the artist.

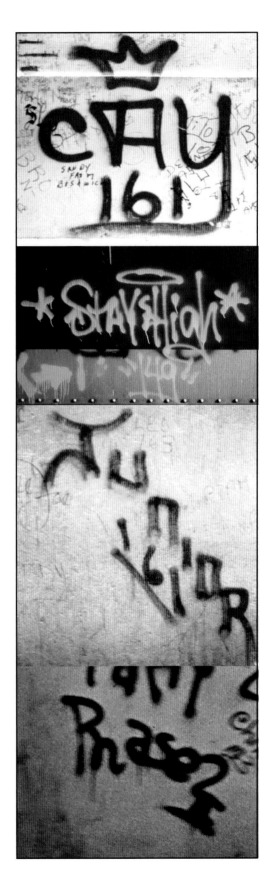

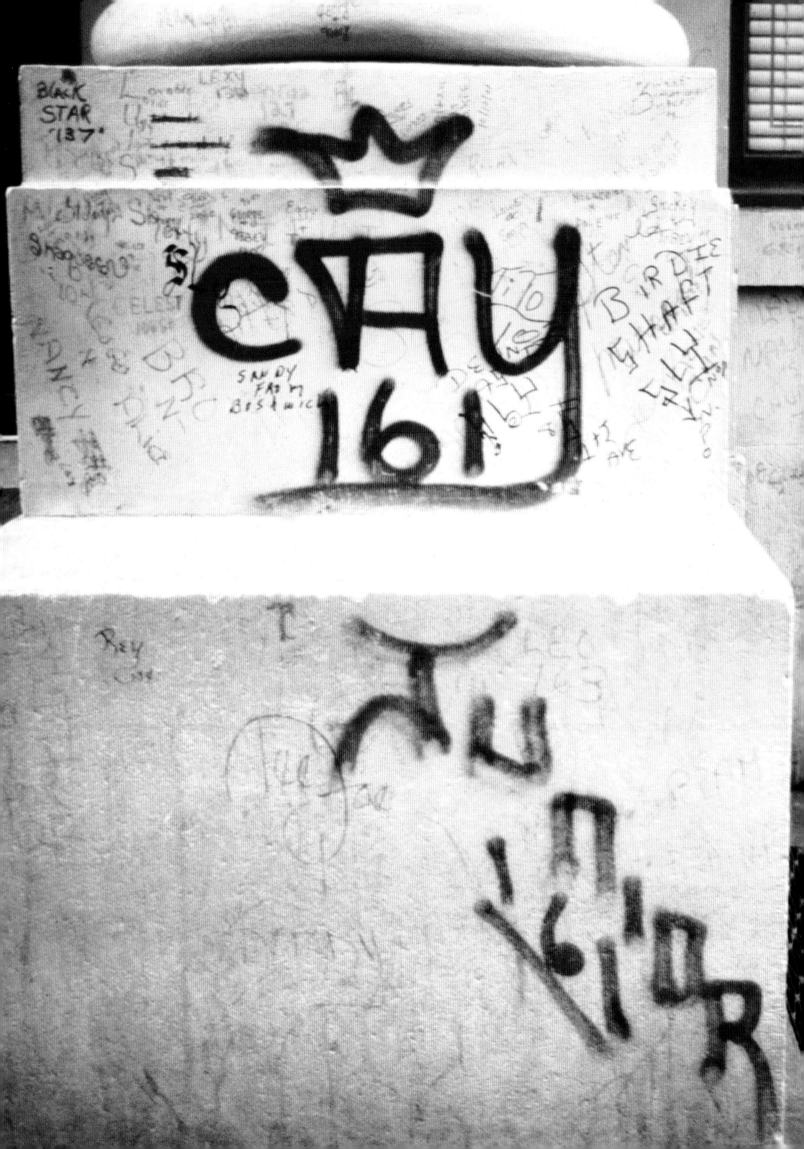

2.

No, size don't come in packages, and the graffiti writers had been all heights and all shapes, even all the ages from twelve to twenty-four. They had written masterpieces in letters six feet high on the side of walls and subway cars and had scribbled furtive little toys, which is to say small names without style, sometimes just initials. There was panic in the act, a species of writing with an eye over one's shoulder for the oncoming of the authority. The Transit Authority cops would beat you if they caught you, or drag you to court, or both, and the judge donning robes of Solomon would condemn the early prisoners with the command to clean the cars and subway stations of the names. HITLER 2 (reputed to be so innocent of his predecessor that he only knew Hitler 1 had a very big rep!) was caught, and passed on the word of his humiliation. Cleaning the cars, he had been obliged to erase the work of others. All proportions kept, it may in simple pain of heart have been not altogether unequal to condemning Cézanne to wipe out the works of Van Gogh.

So there was real fear of being caught. Pain and humiliation were the implacable dues, and not all graffiti artists showed equal grace under such pressure. Some wrote like cowards, timidly, furtively, jerkily. "Man," was the condemnation of the peers, "you got a messed-up handwriting." Others laid one cool flowering of paint upon another, and this after having passed through all the existential stations of the criminal act, even to first *inventing* the paint, which was of course the word for stealing the stuff from the stores, but then an invention is the creation of something which did not exist before – like a working spray can in your hands (and indeed if Plato's Ideal exists, and the universe is first a set of forms, then what is any invention but a theft from the given universal Ideal?).

There was always art in a criminal act – no crime could ever be as automatic as a production process – but graffiti writers were somewhat opposite to criminals since they were living through the stages of the crime in order to commit an artistic act – what a doubling of the intensity of the artist's choice when you steal not only the cans but try for the colors you want, not only the marker and the color but the width of the tip or the spout, and steal them in double amounts so you don't run out in the middle of a masterpiece. What a knowledge of cop's habits is called for when any Black or Puerto Rican adolescent with a big paper bag is bound to be examined by a Transit cop if he goes into the wrong station. So a writer has to decide after his paint has been invented by which subway entrance it is to be transported, and once his trip

is completed back to the station which is the capital of his turf, he has still to find the nook where he can warehouse his goods for a few hours. To attempt to take the paint out of the station is to get caught. To try to bring it back to the station is worse. Six or seven kids entering a subway in Harlem, Washington Heights, or the South Bronx are going to be searched by transit cops for cans. So they stash it, mill around the station for a time painting nothing, they are after all often in the subways – to the degree they are not chased it is a natural clubhouse, virtually a country club for the sociability of it all – and when the cops are out of sight and a train is coming in, they whip out their stash of paint from its hiding place, conceal it on their bodies, and in all the wrappings of oversize ragamuffin fatigues, get on the cars to ride to the end of the line, where in some deserted midnight yard they will find their natural canvas which is of course that metal wall of a subway car ready to reverberate into all the egos of all the metal of New York, what an echo that New York metal will give into the slapped-silly senses of every child-psyche who grew up in New York, yes, metal as a surface on which to paint is even better than stone.

But it is hardly so quick or automatic as that. If they are to leave the station at the end of the line, there is foreign turf to traverse which guarantees no safe passage, and always the problem of finding your way into the yards.

In the A-train yard at 207th Street, the unofficial entrance was around a fence which projected out over a cliff and dropped into the water of the Harlem River. You went out one side of that fence on a narrow ledge, out over the water, and back the other side of the fence into the yards "where the wagons," writes Richard Goldstein, "are sitting like silent whales."

We may pick our behemoth – whales and dinosaurs, elephants folded in sleep. At night, the walls of cars sit there like the mechanical beast of omnibus possessed of soul – you are not just writing your name but trafficking with the iron spirit of the vehicle now resting. What a presence. What a consecutive set of iron sleeping beasts down all the corrals of the yard, and the graffiti writers stealthy as the near-to-silent sound of their movements working up and down the lines of cars, some darting in to squiggle a little toy of a name on twenty cars – their nerve has no larger surge – others embarking on their first or their hundred-and-first masterpiece, daring the full enterprise of an hour of living with this tension after all the other hours of waiting (once they had come into the yard) for the telepathic disturbance of their entrance to settle, waiting for the guards patrolling the lines of track to grow somnolent and descend into the early morning pall of the watchman. Sometimes the graffiti writers would set out from their own turf at dark, yet not begin to paint until two in the morning, hiding for hours in the surest corners of the yard or in and under the trains. What a quintessential marriage of cool and style to write your name in giant separate living letters, large as animals, lithe as snakes, mysterious as Arabic and Chinese curls of alphabet, and to do it in the heat of a winter night when the hands are frozen and only the heart is hot with fear. No wonder the best of the graffiti writers, those mountains of heavy masterpiece production, STAY HIGH, PHASE 2, STAR III get the respect, call it the glory, that they are known, famous and luminous as a rock star. It is their year. Nothing automatic

about writing a masterpiece on a subway car. "I was scared," said Japan, "all the time I did it." And sitting in the station at 158th and St. Nicholas Avenue, watching the trains go by, talking between the waves of subway roaring sound, he is tiny in size, his dark eyes as alert as any small and hungry animal who eats in a garden at night and does not know where the householder with his varmint gun may be waiting.

Now, as Japan speaks, his eyes never failing to miss the collection of names, hieroglyphs, symbols, stars, crowns, ribbons, masterpieces, and toys on every passing car, there is a sadness in his mood. For the peak of the movement is long over. Now the cars are being cleaned faster than they are written upon, an act which was impossible a year ago, but the city has mounted a massive campaign. There was a period in the middle when it looked as if graffiti would take over the world, when a movement which began as the expression of tropical peoples living in a monotonous iron-gray and dull brown brick environment, surrounded by asphalt, concrete, and clangor, had erupted biologically as though to save the sensuous flesh of their inheritance from a macadamization of the psyche, save the blank city wall of their unfed brain by painting the wall over with the giant trees and petty plants of a tropical rain-forest, and like such a jungle, every plant large and small spoke to one another, lived in the profusion *and* harmony of a forest. No one wrote over another name, no one was obscene – for that would have smashed the harmony. A communion took place over the city in this plant growth of names until every institutional wall, fixed or moving, every modern new school which looked like a brand new factory, every old slum warehouse, every standing billboard, every huckstering poster, and the halls of every high-rise low-rent housing project which looked like a prison (and all did) were covered by a foliage of graffiti which grew seven or eight feet tall, even twelve feet high in those choice places worth the effort for one to stand on another, ah, if it had gone on, this entire city of bland architectural high-rise horrors would have been covered with paint – graffiti writers might have become mountaineers with pitons for the ascent of high-rise high-cost swinger-style apartments in the East Sixties and Seventies, the look of New York and afterward the world might have been transformed, and the interlapping of names and colors, those wavelets of ego forever reverberating upon one another, could have risen like a flood to cover the monstrosities of abstract empty techno-architectural twentieth century walls where no design ever predominated over the most profitable (and ergo most monotonous) construction ratio implicit in a ten or twenty million dollar bill.

The kids painted with less than this in view, no doubt. Sufficient in the graffiti-proliferating years of the early Seventies to paint the front door of every subway car they could find. The ecstasy of the roller coaster would dive down their chest if they were ever waiting in a station when a twelve-car train came stampeding in and their name, HONDO, WILDCAT, SABU, or LOLLIPOP, was on the *front*! Yes, the graffiti had not only the feel and all the superpowered whoosh and impact of all the bubble letters in all the mad comic strips, but the *zoom*, the *aghr*, and the *ahhr*, of screeching rails, the fast motion of subways

Have you ever been caught by the Police?
Boogie's been caught lots of times – 'cause he can't run!
I ain't never been caught!
He can't run, man!
How old are you?
12.
Ha! You ain't no 12.
How old?
More 13.
(Star III and Boogie on subway with Naar and Kurlansky)

Do all of you write your names on the walls?
Sure! Except him.
Don't you write?
No I don't write!
Why not?
I got somebody who writes for me.
(Snake 4, PA28, Test 1, Pool, Super pad, Bam Bam, 2 fast, Little hit, Sisco kid on East 161st Street, New York)

What happens if you get caught writing?
You're made to scrub it or you get fined $1,000 or you get one year in jail.
I don't do it anymore – I'm 18 – I could get life.
(Dutch+Tipps, ballpark on First Avenue with Naar)

They've messed up my property three times. If I catch them I'll break their arms with a lead pipe.
(White property owner)

roaring into stations, the comic strips come to life. So it was probably not a movement designed to cover the world so much as the excrescence of an excrescence. Slum populations chilled on one side by the bleakness of modern design, and brain-cooked on the other by comic strips and TV ads with zooming letters, even brain-cooked by politicians whose ego is a virtue – I am here to help my nation – brained by the big beautiful numbers on the yard markers on football fields, by the whip of the capital letters in the names of the products, and gut-picked by the sound of rock and soul screaming up into the voodoo of the firmament with the shriek of the performer's insides coiling like neon letters in the blue satanic light, yes, all the excrescence of the highways and the fluorescent wonderlands of every Las Vegas sign frying through the Iowa and New Jersey night, all the stomach-tightening nitty-gritty of trying to learn how to spell was in the writing, every assault on the psyche as the trains came slamming in. Maybe it was no more than a movement which looked to take some of the excrescence left within and paint it out upon the world, no more than a species of collective therapy of grace exhibited under pressure in the act of voiding waste, maybe it was a movement which never dreamed of painting over the blank and empty modern world, but the authority of the city reacted as if the city itself might be in greater peril from graffiti than from junk, and a war had gone on, more and more implacable on the side of the authority with every legal and psychological weedkiller on full employ until the graffiti of New York was defoliated, cicatrized, Vietnamized. Now, as A-I sat in the station with Jon Naar and Japan and they watched the trains go by, aesthetic blight was on the cars. Few masterpieces remained. The windows were gray and smeared. The cars looked dull red or tarnished aluminum – their recent coat of paint remover having also stripped all polish from the manufacturer's surface. New subway cars looked like old cars. Only the ghost-outline of former masterpieces still remained. The kids were broken. The movement was over. Even the paint could no longer be invented. Now the cans set out for display were empty, the misdemeanors could be called criminal mischief, a felony, the fines were severe, the mood was vindictive. Two hideous accidents had occurred. One boy had been killed beneath a subway car, and another had been close to fatally burned by an inflammable spray paint catching a spark, yes, a horror was on the movement and transit patrols moved through the yards and plugged the holes of entrance. The white monoliths of the high-rise were safe. And the subways were dingier than they had ever been. The impulse of the jungle to cover the walled tombs of technology had been broken. Was it that one could never understand graffiti until there was a clue to the opposite passion to look upon monotony and call it health? As A-I walked the streets with Jon Naar, they passed a sign: DON'T POLLUTE – KEEP THE CITY CLEAN. "They don't see," the photographer murmured, "that sign is a form of pollution itself."

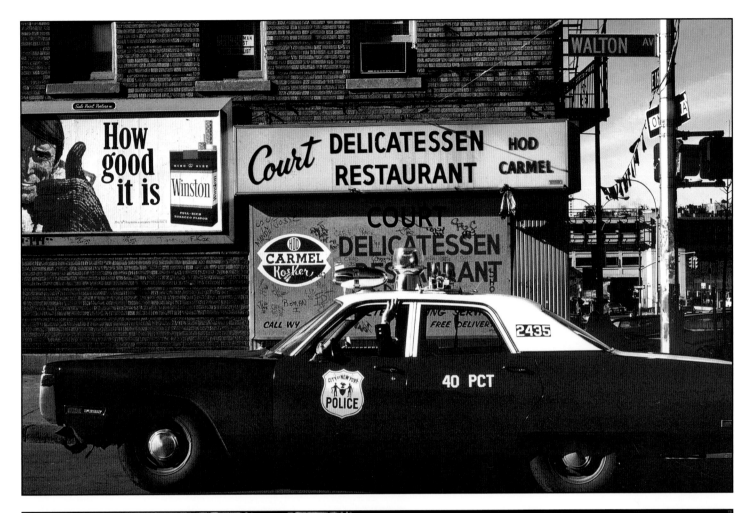

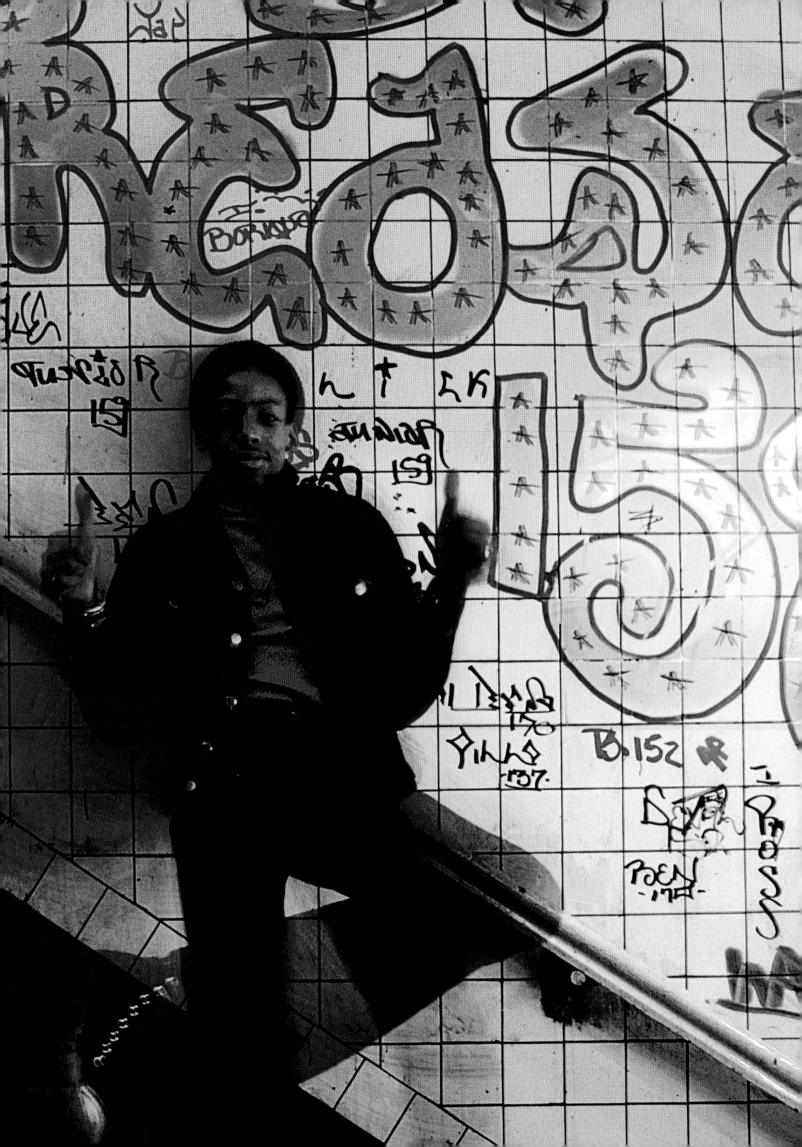

3.

Since the metaphor of plant life had climbed all over his discussion of graffiti (as if the metaphor had its own right to a part of the jungle), he went with profit to the Museum of Modern Art, for it confirmed the botanical notion with which he began: that if subway graffiti had not come into existence, some artist might have found it necessary to invent it for it was in the chain of such evolution. Modern painting being always available for description as the entropy of representational forms, one might as well suppose that the third dimension of space perspective was relinquished by the artist in order to obtain a possible vision of the fourth, which in the worst of moods could also be a way of saying art had been rolling down the fall-line from Cézanne to Frank Stella, from Gauguin to Mathieu. On such a map, subway graffiti was an alluvial delta, the mud-caked mouth of a hundred painterly streams. If the obvious objection was that you might interview a thousand Black and Puerto Rican kids who rushed to write their name without having thought about or ever seen a modern painting on any wall, the answer, not quite as obvious, was that plants spoke to plants. Cousin to graffiti, form might talk across the air to form – a rose of exceptional petals growing by the side of a jungle river might feel able to inspire similar petals in another rose high on the jungle cliffs, too high for its pollen to rise. We do not begin to comprehend the telepathic power of things.

Famous plant-man Backster, attaching the electrodes of his polygraph to a philodendron one night, wonders in the wake of this passing impulse how to test the plant for some emotional reaction. He thinks of burning one of its leaves. Abruptly, the polygraph registers a large emotional reaction. A current is coursing through the philodendron at the horror of this thought. (When Backster does burn the leaf, however, the polygraph registers little: now, the plant is numb. Its sensitivity seems to be its life, its suffering an abstention from life.) By the new if unheard music of the experiment, plants must be a natural species of wireless. (What, indeed, did Picasso teach us if not that every form offers up its own scream when it is torn.) Radio is then no more than a prosthetic leg of communication, whereas plants speak to plants, and are aware of the death of animals on the other side of the hill. Some artists might even swear they have known this from the beginning, for they would see themselves as stimulants who inject perception into the vein of one or another underground river in the blind vision of the century. (And like a junkie, does the century move into apathy from the super-brilliance of its injections?)

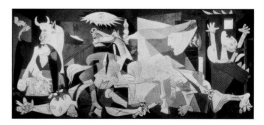

Frank Stella, *Tuftonboro IV*, 1966. Collection, The Museum of Modern Art, New York. Gift of David Whitney.

Jackson Pollock, *Blue Poles (No. 11)*, 1953. The Australian National Gallery, Canberra, Australia.

Pablo Picasso, *Guernica*, 1937. On extended loan to Reina Sofia Museum, Madrid, from the artist.

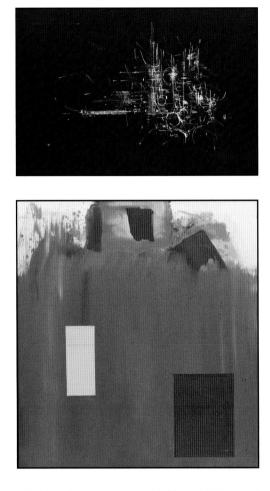

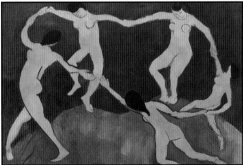

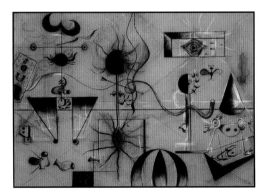

So when it comes to a matter of what might influence the writers of graffiti, one is not obliged therefore to speak only of neon signs, decals on custom cars, and comic strips, TV products and the heavy ego of TV – that nattering flickering contemporary ship-of-state – one has the other right to think the kids are unwittingly enriched by all art which offers the eye a family resemblance to graffiti. Which might enable us then to talk of Jackson Pollock and the abstract graffiti of his confluences and meanderings, of Stuart Davis' dramatization of print as a presence which grows in swollen proportion to its size, even include Hans Hofmann's *Memoria in Aeternum,* where those red and yellow rectangles float like statements of a name over indistinct washes beneath, or Matisse's blue and green *Dance.* (Matisse's limbs wind onto one another like the ivy-creeper calligraphies of New York graffiti.) So might one refer as well to all work which speaks of ghetto emotion in any place, of Siqueiros' *Echo of a Scream,* or Van Gogh's *Starry Night.* If the family histories of the most messed-up families have all the garbage-can chaos of de Kooning's *Woman,* no wonder the subway writers prided themselves on style and éclat – "you got a messed-up handwriting" being the final term of critical kill.

But on reflection, was old A-I trying to slip in some sauce on the distribution of art down from the museums through media to the masses, smuggle over some old piety how the subway children may never have seen *Memoria in Aeternum* at the head of the stairs at M.O.M.A. but still had it filter through to them by way of Hofmann's imitators, and his uncredited influence on advertising artists working for layout? Fell crap! Rather say art begot art, and the migrations were no one's business. For if plants were telepathic, then humans lived in a psychic sea where all the forms of art also passed through the marketplace of the dreamer in his sleep, and every part of society spoke to every other part, if only with a curse. Lyndon Johnson orated once of a great society and the ghettoes of New York responded, ego to ego, with their greatness, and began some years later, to lay it on the wall.

So he had the happy thought in his visit to the Modern Art to decide that some paintings might be, by whatever measure, *on the air* – leave it to the engineers of some oncoming future occult, some techno-coven, to try to determine the precise migrations of Miró's *The Family* over into the head of an *espontanéo* with a spray can looking over his shoulder for the black mother in a uniform who will beat his own black blue. Let us, by such comfort, take hope that investigation into the mystery of why the name is the faith of graffiti may be able to go on. May we even be refreshed after intermission.

Georges Mathieu, *Untitled,* 1958. Collection, The Museum of Modern Art, New York. The John S. Newberry Collection.

Hans Hofmann, *Memoria in Aeternum,* 1962. Collection, The Museum of Modern Art, New York.

Henri Matisse, *Dance,* (First Version) 1909. Collection, The Museum of Modern Art, New York. Gift of Nelson A. Rockefeller in honor of Alfred H. Barr, Jr.

Joan Miro, *The Family,* 1924. Collection, The Museum of Modern Art, New York. Gift of Mr. and Mrs. Jan Mitchell.

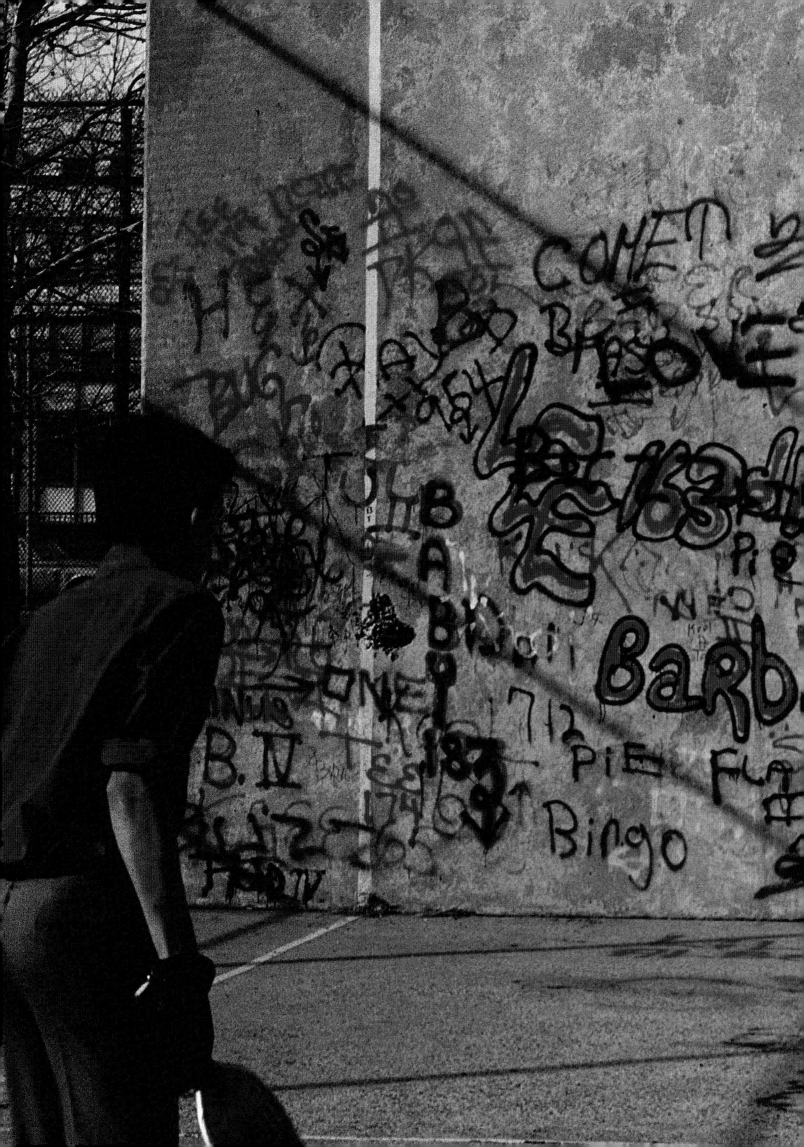

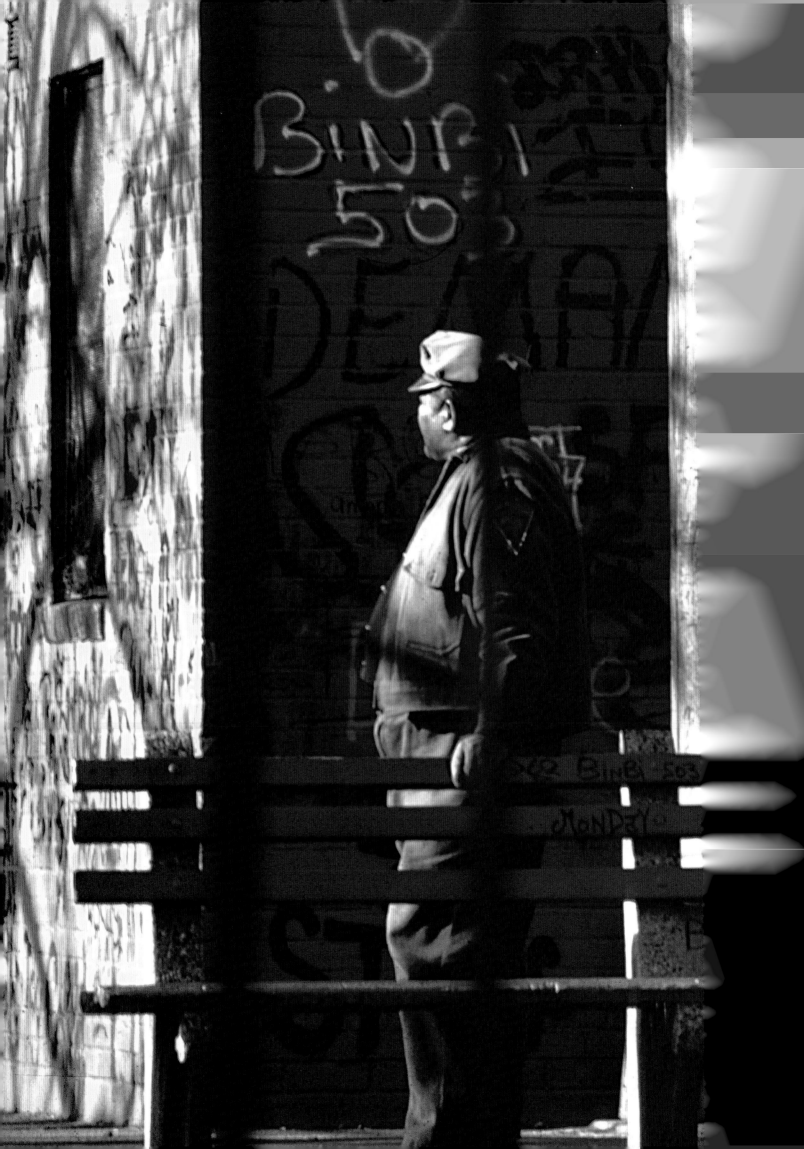

4.

Like a good reporter he goes to see the Mayor. It is ten days to Christmas and into the final two weeks of the Lindsay administration on that Saturday morning he has his appointment to visit, almost a week in fact from the previous Sunday when he talked to Junior and Cay. Again the weather is iron-gray and cold. At Gracie Mansion, the wind is driving in from the East River, and the front porch looks across its modest private lawn over F.D.R. Drive to the Triboro Bridge in the North. (To the West, just across East End Avenue, apartment houses rise like the sheer face of Yosemite.) It is not a large lawn in front of the Mayor's residence nor even a large house and old white Gracie Mansion might be no exceptional residence on any wealthy road in Portland, Oregon or Portland, Maine – there is even a basketball hoop on a backyard not far from the front door, a political touch to date perhaps from recent years when the Knicks became the most consistently successful team in New York – yet with all its limited grandeur, Gracie Mansion is still one fine Federalist of a house (built in 1799), and if the spirit of an age could have been captured by a ratio, then where better to measure this magic mean if not in the proportions of the Mansion's living room and dining room which speak in their harmony of some perfect period of Arcadian balance between the early frontier being settled to the near West and the new sense of democratic government forging itself in the state capitals of the East. How better to characterize the decorum, substance, grace, and calm center of such architecture if not to think that the spirit and style of the *prose* of the American Constitution is also in it (even to the hint of boredom in prose and buildings both), yes, why not precisely these high ceilings, paucity of curves, and all the implicit checks and balances of the right angle? Lindsay, it may be said, is at home in such surroundings. They seem built to his frame. Only a tall lean man could look well-proportioned in so philosophically dominating a set of rooms where nothing like a Gothic arch is ever present to suggest any mad irreconcilable opposites of God and man, no Corinthian columns to resonate with Praetorian tyrannies (and orgies at the top), nor any small and slanted ceilings to speak of craft and husbandry, just government here in Federal style without the intervention of Satan or Jehovah (and next to nothing of Christ), just a fundament of Wasp genius in a building style to state that man could live without faith if things were calm enough. Perhaps the economy of balance is the true god of the Wasp.

His appointment is at eleven, but it is an unusual morning for the Lindsay family since they have been up until five the night before at a farewell party

Standing before the gleaming white ceramic exterior of the boathouse, the Mayor noted that he had asked for tighter legislation against graffiti vandals, but he said that police action alone would not cure the problem.
 – *New York Times*, August 25, 1972

The Mayor said it was "the Lindsay theory" that the rash of graffiti madness was "related to mental health problems."
 – *New York Times*, September 29, 1972

A broad, tough bill to combat the graffiti that are defacing public buildings, subways and buses was voted out of the City Council's General Welfare Committee yesterday ...
 The bill also makes it unlawful for any person to carry a spray can of paint in any public building or facility, unless the can is completely enclosed in a sealed container, or the person has permission from an official of the building.
 – *New York Times*, September 15, 1972

The graffiti movement is a lot like rock'n roll in its pre-enlightened phase. To me, it announces the first genuine teenage street culture since the fifties.
 – Richard Goldstein, *New York Magazine*, March 26, 1973

given by the Mayor to honor the eight years of his administration, (and pay off a few campaign debts), and the Mayor has entertained hundreds of friends and contributors by acting in a skit, indeed his leading lady of the night before, Flo Henderson, showing the same rueful happy smile the others exhibit, now wanders into the dining room where they are all taking breakfast. Lindsay has worked as hard as any man in New York for eight years, and can afford the luxury of being hungover before a reporter this Saturday morning. What a nice relaxation in the center of one's pole-axed lobes. So Lindsay chuckles at the memory of each inside absurdity of the night before, each unexpected rejoinder, every zany fly-away of party dialogue, all Lindsays smile and laugh at the expression on Tom Morgan's face, press secretary to the Mayor, a tall man with a dark brush mustache who recapitulates in the sardonic gloom of his hungover eyes the incandescence of all those good drinks at that good party, and watching them all, studying Lindsay's face with its patrician features so endowed with every purchase on the meaning of handsome that he could be not only a movie star but there at the front, right ahead of Burt Lancaster and Steve McQueen, on a par with Robert Redford, and hardly a millimeter of profile behind Paul Newman, it occurs indeed that no movie star could be more convincing than Lindsay if it came to playing some very important American politician in the quiet American years from 1800 to 1825, even his eroded teeth – Lindsay's one failing feature – speaking with authenticity of the bad teeth of those English ruling classes who became the American ruling classes in that Federalist era one hundred and seventy years ago, and so sitting in such a dining room, and a little later adjoined to a living room with Lindsay and Morgan to bring up the subject of his interview, he is thinking that Gracie Mansion never had a Mayor nearly so perfectly suited to itself; if there were some divine renting agency in the halls of karma, then come soon or late the post of Mayor of New York would have had to be found for John Vliet Lindsay or the house would feel unfulfilled.

For Lindsay, however, the question may have been whether an ambitious man had ever come to power at a time less promising for himself. He had labored in his two terms, innovated and negotiated, explored, tinkered, tampered, and shifted the base of every municipal machine of government upon which he could work his cadres. He had built a constituency in the ghetto. Mailer-Breslin running for the Mayoralty in '69 also ran into one argument over and over in Bedford-Stuyvesant, Harlem, and the South Bronx. It was, "What do we want with you? Lindsay's our man." Lindsay had walked the streets in summer riots, and held some kind of line for decontrol, which is to say, local control, in the ghetto schools against all the implacable trade-union hatred of the United Federation of Teachers. That had taken political courage. Yet make him no saint! If Lindsay had in part carried through a program of increasing self-government and opportunity in the ghettos, he had also worked with the most powerful real estate interests in the city. No question that in his eight years, the ugliest architecture in the history of New York had also gone up. The new flat tops of the skyline now left New York as undistinguished in much of its appearance as Cleveland or Dallas. It is possible Lindsay had bought social

relief at the price of aesthetic stultification, call it desecration – the view of New York's offices and high rise apartments proving sacrilegious to the mood of any living eye – Wasp balance had done it again.

Still with all this effort New Yorkers hated him. For every intolerable reason, first of which was his defense of the ghettoes. "If I wanted a nigger for Mayor, I'd have voted for a nigger," said every archetype of a cab driver to any tourist who would listen. And yet this Federalist movie star, this hard working mayor for ghetto rights, had been the first and most implacable enemy of subway graffiti. So there was a feather of a pause falling through the mood when he told Lindsay and Morgan why he had come.

But A-I had his speech. If he thought the Mayor had done an honorable job, and was prepared to say so, he still could not comprehend how a man who worked so hard to enter the spirit of ghetto conditions had been nonetheless so implacable in his reaction to graffiti. "Insecure cowards," Lindsay had called the kids. "A dirty shame." Others in his administration offered civic blasts: "graffiti pigs," "thoughtless and irresponsible behavior." So on. It was surprising. While the management of a city required you to keep it clean – where would a mayor hide if he could not get the garbage out? – there was a difference between political necessity and the fury of this reaction. How could he call the kids cowards? Why the venom? It seemed personal.

Lindsay grinned. He had heard enough preambles from reporters to know when an interview was manageable. "Well, yes," he said, "I did get hot under the collar, and I suppose if we had to go through it again, I would hope to lose my temper a little less, but you have no idea what a blow that graffiti was to us." He shook his head at the memory. "You see we had gone to such work, such ends, to get those new subway cars in. It meant so much to people here in the city to get a ride for instance in one of the new air-conditioned cars. On a hot summer day their mood would pick up when they had the luck to catch one. And you know, that was work. It's hard to get anything done here. You stretch budgets, and try to reason people into activities they don't necessarily want to take up on their own, you have to face every variety of criticism, and it all requires so much time. We were proud of those subway cars. It took a lot of talking to a lot of committees to get that accomplished."

Morgan nodded. "And then," Lindsay said, "the kids started to deface them."

A-I put his demurrer. "Deface," after all, was the core of the argument. Some people might think subway graffiti was art. He suggested in passing Claes Oldenburg's classic remark "…You're standing there in the station, everything is gray and gloomy and all of a sudden one of those graffiti trains slides in and brightens the place like a bouquet from Latin America."

Lindsay smiled as if recalling the screams, moans, epithets, and agonized squawks of every bright college intellectual on his staff when Oldenburg's quote first came riding in. Grand division in the Establishment! Aesthetic schism! "Yes, we remember that quote," Lindsay's grin seemed to say. He had the most curious quality of personality. One did not know if he were secretly more or less decent than his personality. While the personality itself was decent

New York City is spending $10 million a year to clean off the handwriting on the walls. Mayor John Lindsay announced yesterday, that in spite of the city's best efforts, 63 per cent of all the subway cars, 46 per cent of all buses and 50 per cent of all housing projects are "Heavily defaced by graffiti."
– Jane Rosen, *The Guardian*, March 29, 1973

Isenberg smiles when he recalls the two times Mayor Lindsay burst into this office and – with four-letter fervor – ordered him to clean up the mess. One time the mayor had snipped a ceremonial ribbon at the opening of a Brooklyn swimming pool that was already scarred with graffiti and the other time he had spotted a graffiti-laden bus in midtown. "I certainly got reamed out," Isenberg recalled.
– *New York Sunday News*, May 6, 1973

"It is part of the widespread vandalism, the mood to destroy, the brutalism that is everywhere."
– Dr. Frederick Wertham

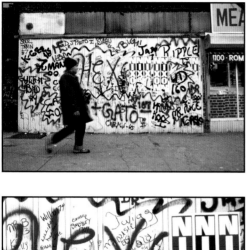

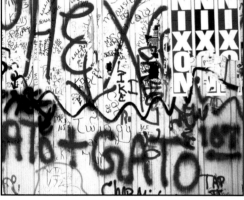

enough, it was also patently not the man, nor, unhappily for him, characteristic at all of New York. He seemed now like a Westerner, full of probity, rawhide, and something buried in the personality, a man you might not get to know at all even after a night of drinking together. He wasn't in the least like Richard Nixon except to share one quality. Lindsay was out of focus. He had always been out of focus. Part of his political trouble.

Well, Lindsay suggested, they had never really wondered whether it was anything but defacement. "People would come into new cars and suddenly they'd see them all marked up, covered inside and out, and it depressed people terribly. You know, we have to be a kind of nerve center to the city. Reports came in from everywhere. This graffiti was profoundly depressing – it truly hurt people's moods. The life would go out of everybody when they saw the cars defaced, they saw it as defacement, no question of that. And we kept hearing one request over and over, 'Can't you do something about it?' Then, too, we had our own pride in these matters. You know, you get to feel after you've put through a new municipal building that it's yours in some way. As Mayor I'd get as angry when a city building got marked up as if I owned it personally. Oh, it's easier to talk about it now, but I must say it was hard at times not to blow up."

"Actually," Morgan observed, "the Mayor would go around calming some of us down. 'Remember,' he would tell us, 'they're only kids.'"

Yes, in the framework of that time in the Summer of '71 and the Winter and Spring of '72 when Lindsay was looking to get the Democratic nomination for President, what an upset to his fortunes, what a vermin of catastrophe that these writings had sprouted like weeds all over the misery of Fun City, a new monkey of unmanageables to sit on Lindsay's overloaded political back. He must have sensed the Presidency draining away from him as the months went by, the graffiti grew, and the millions of tourists who passed through the city brought the word out to the rest of the nation: "Filth is sprouting on the walls."

Of course, where was the tourist who could distinguish between men's-room and subway graffiti? Who was going to dare to look long enough to see that it was a name and not an obscene thought in the writing. Today, just before he had come to Gracie Mansion, he had stopped in the lavatory of a York Avenue bar for a minute, and there on the john wall was drawn a pure old-fashioned piece of smut graffiti. A balloon of dialogue issued out of a girl's mouth. No art in the lettering, no style, "Did you know," said her balloon, "that your clit is in your ass?" Some lost shard of fecal communion now nailed to the wall. Was there a public comfort station in America which did not have a dozen such insights, "Suck me," "Fuck you"? That was what people expected to see on the subways. They assumed the full explosive shithouse within the mad maniacal freak impulse of America was now erupting in their faces. So they did not look to read, but rode in the cars with their heads down, and brought the news out to the rest of America that Lindsay could not keep the city clean. No wonder he called it a dirty shame. And labeled the bravery of the graffiti writers cowardice. That was his attempt to soothe the cowardice and the terror in the heart of every subway citizen who looked at the graffiti and put his head down so his eye would not meet any eye which might be connected to a hand

which held a knife, yes, that was one side of the fear, and the other was fear of the insane graffiti writer in the self for what filth would burst out of every civilized office worker in New York if ever *they* started to write on moving public walls, my god, the feces to spread and the blood to spray, yes, the good voting citizen of New York would know that the violent ward at Bellevue was opening its door to him on the day he would take a spray can to a subway, and so New York citizenry saw all the children as mad, and therefore saw madness, instability, and horror in the New York cloaca of every public transit. No wonder Lindsay had gone to war against graffiti. The city would finally tolerate drugs, graft, insanities of traffic, mugging, every petty crime of the street, and every major pollution, but it could not accept a towering rain-forest of graffiti on all the forty-story walls. Yes, build a wall and balance a disease. For the blank wall of the new architecture was the deadening agent to balance the growing violence beneath. (Could it be said that the monotony of modern architecture increased all over the world in direct relation to the volcanic disturbances of each society it would contain?) Plastic above, dynamite below.

In the face of such questions the interview was effectively over. They chatted for a while, and got up to say goodbye. On the way out, A-I noticed there was a Rauschenberg on the wall.

Lindsay, in his courtesy, walked with him to the gate. Wearing a blue windbreaker he looked in the gray outdoor light like a veteran big-league ballplayer, tall, weathered, knowledgeable. They took leave not uncordially, and he complimented the Mayor on eight good years, even meant it.

"I wish I had the talent to write," Lindsay said in parting. Was that a politician's gift? A-I pulled back the reply that he wished he could have been Mayor.

Outside the fence, a policeman was standing with a drawn gun. It was a simple measure of the times: be forever ready at the Gracie gate.

And indeed a ten-year-old boy on roller skates cried aloud, "That's him, that's him, that's the Mayor," and promptly took out a cap pistol and fired a number of bang-bangs at the back of John Lindsay going back into his house.

For a while, A-I walked, and had a little fantasy of how impossible it would have proved if the miracle worked and he had been elected in the campaign of 1969. What would he have done about graffiti? Would he have tried to explain its virtues to the people of New York? – and laughed in all the pain of absolute political failure. The answer was simple – nobody like himself would ever be elected Mayor until the people agreed bad architecture was as poisonous as bad food. No, graffiti as a political phenomenon had small hope for life, and his faith in the question would have to explore in another place. Did the final difficulty lie in the meaning of graffiti as art? There the inquiry might become as incomprehensible as the motives of the most advanced of the arts and the artists. On then to the rim of the enigma, to the Sea of Vortices where the meanings whirl with no meaning.

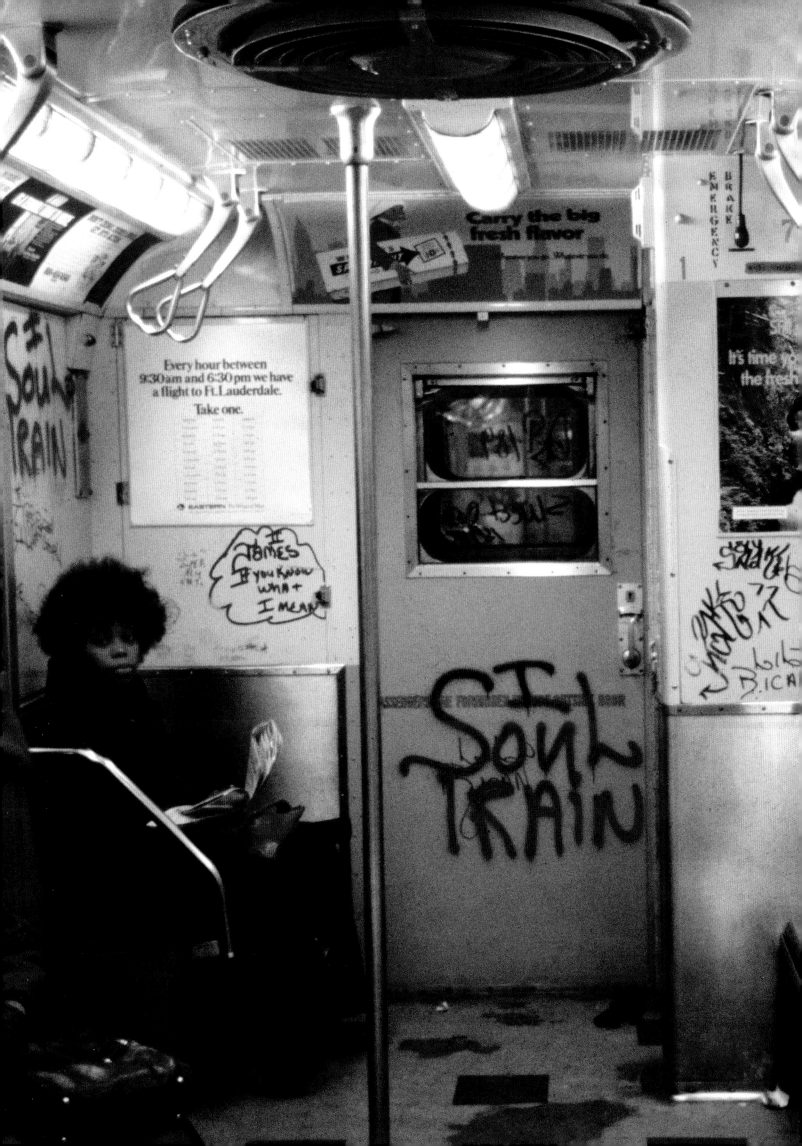

5.

Years ago, so much as twenty years ago, A-I had conceived of a story he was finally not to write, for he lost his comprehension of it. A rich young artist in New York in the early Fifties, bursting to go beyond Abstract Expressionism, began to rent billboards on which he sketched huge, ill-defined (never say they were sloppy) works in paint chosen to run easily and flake quickly. The rains distorted the lines, made gullies of the forms; automobile exhausts laid down a patina; and comets of flying birds crusted the disappearing surface with their impasto. By the time fifty such billboards had been finished – a prodigious year for the painter – the vogue was on. His show was an event. They transported the billboards by trailer-truck and broke the front wall of the gallery to get the art objects inside. It was the biggest one-man exhibition in New York that year. At its conclusion, two art critics were arguing whether such species of work still belonged to art.

"You're mad," cried one, "it is not art, it is never art."

"No," said the other, "I think it's valid."

So would the story end. Its title, Validity. But before he had written a word he made the mistake of telling it to a young Abstract Expressionist whose work he liked. "Of course, it's valid," said the painter, eyes shining with the project. "I'd do it myself if I could afford the billboards."

The story was never written. He had assumed he was proposing a satire, but it was evident he had no insight into how painters were ready to think. Some process had entered art and he could not discern it out.

Let us go back to the pastel by de Kooning which Rauschenberg erased. The details, when further inquiry is made, are less impromptu. Rauschenberg first informed de Kooning of what he would do, and de Kooning agreed. The work, when sold, bore the inscription "a drawing from Willem de Kooning erased by Robert Rauschenberg." Both artists are now proposing something more than that the artist has the same right as the financier to print money, they may even be saying that the meat and marrow of art, the painterly core, the life of the pigment, and the world of technique with which hands lay on that pigment are convertible to something other. The ambiguity of meaning in the Twentieth Century, the whole hollow in the heart of faith, has become such an obsessional hole that art may have to be converted into intellectual transactions. It is as if we are looking for stuff, any stuff, with which to stuff the hole, and will convert every value into stuff for this purpose. For there is no doubt that in erasing the pastel and selling it, art has been diminished and our knowledge of society

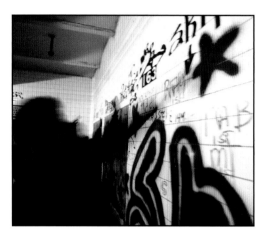

enriched. An aesthetic artifact has been converted into a sociological artifact – it is not the painting which intrigues us now but the ironies and lividities of art fashion which made the transaction possible in the first place. Something rabid is loose in the century. Maybe we are not converting art into the comprehension of social process in order to stuff the hole, but rather are using art to choke that hole, as if society is so hopeless, which is to say so twisted in knots of faithless ideological spaghetti, that the glee is in strangling the victims.

But take the example further. We can imagine a show at the Guggenheim. It will be like many we have seen. A plausible modern one-man show. Nothing will be exhibited but computer read-out sheets from a labyrinthine statistical operation. Hundreds of such sheets tacked to the wall. Somewhat irregularly. Attempts at neatness will be contradicted by a confusion in the style of placing as the wall of the Guggenheim spirals up the ramp. Checkerboards of placement to alternate with ascending bands, then cul-de-sacs of paper stapled up every way.

We try to digest the aesthetic experience. Of what do the computer read-out sheets consist? What is the subject of their inquiry, we ask? And what is the motive of the artist? Is he telling us something about the order and disorder of the mind in relation to a technological world? Has he presented us with an ongoing composition of exceptional cunning? Is it possible he even has set the problem for the computer himself, so that the endless file of numbers on these computer sheets may reflect some numerical analogue to the tension of major themes in his brain; perhaps the composition is then the numerical installation of his themes out on the world; and do we then have here an arithmetical display whose relation to art is as complex as *Finnegans Wake*'s to literature?

Full quantum of bullshit, responds the painter. The computer sheets were selected at random. Because the artist did not wish to bear any unconscious responsibility for the selection, he chose an acquaintance with whom he shared no great psychic identity to pick up the computer sheets for him. Neither he nor the acquaintance ever inquired into the subject of the statistical problem, and he never took a look at what was brought back. Rather, he hired the janitor at the Guggenheim by telephone and told him to tack up the pages any way he wished. The variance in composition was merely a reflection of the passing personnel: the janitor worked with two assistants, one was neat, the other drunk. And the painter never came to see the show. The show was the fact that people came to see the show, studied the walls, lived for an uncertain hour in the Guggenheim and went out again, their minds exercised by a question which not only had no answer, but conceivably did not possess a question. The artist had done his best to have no intent, not unless his intent was to demonstrate that three-quarters of the experience in viewing a painting is the context of the museum itself. We are next to one of John Cage's compositions in silence. Art has been saying with more and more intensity: the nature of the painting has become less interesting than the nature of the relation of painting to society – we can even erase Rauschenberg's erasure, get the artist out of it altogether, and it is still art. The world is turning inside-out.

What step is left to take? Only one. A show which offers no art object at all. The last reference of painting or sculpture is the wall on which something can

be hung, or the floor on which a piece can sit. That must now disappear. The art-piece enters the artist: sometimes the work can only be experienced within the psyche.

From the *New York Times*, Sept. 2, 1973, by Peter Plagens:

> A marksman-friend shot Chris Burden in the upper left arm with a .22 long-jacket before an audience of 12 intimates. He (Burden) figured on a graze wound with a Band-Aid slapped on afterward, but it "felt like a truck hit my arm at 80 miles per hour"; he went to the hospital, nauseous, and filed the requisite police report ("accident").

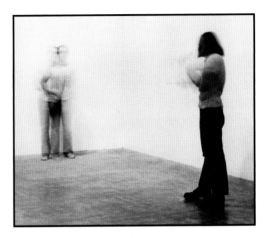

Plagens goes on to describe other "pieces." Burden is developing his instinct to choose situations for their possibility of danger, pain, humiliation, or boredom. There is:

> "Movie on the Way Down," in which Burden, hanging by his heels, nude, six feet off a gym floor with a movie camera in his hands, is summarily chopped loose.

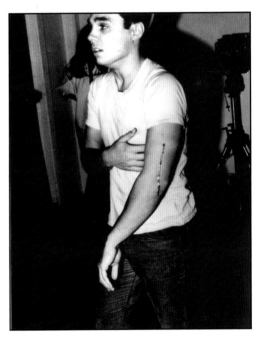

Chris Burden – "Shoot," before and after.

The movie is presumably taken on the way down (is it filmed in slow motion?) and he ends with a cut lip. There are other pieces where he rockets flaming matches "at his nude supine wife" or sets ablaze two 16-foot wooden crosses on Laguna Canyon Rd. at 2 A.M. – "the intended audience for that piece," says Burden, "was the one guy driving down the road who saw it first." Ah, Los Angeles! For "Endurance/real time," he 1) stays in a locker for five days, 2) does 1600 tours of a gallery on his bicycle and 3) remains in bed for three weeks and a day. He also pretends to be a dead man lying under a tarpaulin on the street and is arrested by the police for creating a traffic hazard. He gets a hung jury at his trial and the case is dismissed but "one of the nine votes for conviction, a stewardess, told Burden if she ever saw him under a tarp again, she'd run over him herself." He has even a study in the shift of identity. For "I Became a Secret Hippie," Burden cuts his hair short and dresses in F.B.I. clothes. "If you want to be a heavy artist nowadays," Plagens, reporting on Burden, concludes, "you have to do something unpleasant to your body, because everything *else* has been done ... [Burden] may be a product of art-world art history – backed into some untenable masochistic corner because all the other novelty territory has been claimed."

At the least, Burden is fulfilling the dictum of Jean Malaquais that once there are enough artists in the world, the work of art will become the artist himself. Burden is refining his personality. Through existential tests. The art is nearer to the film of improvisation than to the canvas. Burden is not exploring his technique, but his vibrations. The situations he chooses are, as Plagens describes, "edgy," which is to say they have nothing remotely resembling a boundary until they are done. In "Movie on the Way Down," Burden can hardly know if he will cut his lip or break his neck, feel a live instant on the descent or some dull anxiety, a dead instant. When he shoots lighted matches at his nude wife, the areas defined are as empty before the action as an empty Go board before the first stone is laid. Given every variable from Women's Liberation to the oldest sadomasochistic

... in New York's Razor Gallery... There, looking strangely static anchored against stark white walls, the wildly expressive works of such graffiti masters as Phase 2, Flint, Mico, Slim 1, T-Rex 131, Tabu, Bama and Me 163 send out their carnival message in a caterwauling fantasia of neon superdoodles and shocking-pink stars, stripes and arrows...

The pictures at the exhibition are going for between $200 and $3,000.

– S.K. Oberbeck, *Newsweek*, October 1, 1973

From the quotations of Chairman Martinez

"Graffiti writing is a way of gaining status in a society where to own property is to have an identity."

"Anybody can be a writer, but if you're recognized, it means you're a master."

"One thing a masterpiece can't do is drip. SuperKool 223 does beautiful pieces, but his paint drips."

"Super Strut is very good but he is not recognized as a master because he's written over a mess of masterpieces people took big chances to make."

"A couple of writers have even done masterpieces to honor a master from another ghetto."

whip-sniff out of Wilhelm Stekel, he can know in advance only that a psycho-dramatic enterprise will be commenced, but where it may end, and what everybody might feel, and will the matches even land and burn her skin – will the marriage be fortified or scorched? – no, there is no confidence which questions can offer a hint of an answer. It is like playing a game on a board without edges. Perhaps he is not refining his personality so much as attempting to clear a space in his psyche free of dread. But isn't that the fundamental operation of the primitive at the dawn of civilization, the first exercise in the establishment of the ego? For what is the human ego but a clearing in the forest of the psyche free of dread? Money, held in one's hand, is free of time. Cash has no past; its future is assignable. It is powerful and empty. So, too, is the ego. It bears the same relation to the psyche as cash bears to the security or comfort of the body. The ego is virtually separate from the psyche even as money is still separate from every organic communicating logic of nature. We are back to the cave man and his cave painting. His hand is drawing the outline of the animal in defiance of those gods who watch him, even as Burden is smashing his nose on the floor or displaying his wife in defiance of the last gods of conventional art, that audience remnant of a once-leviathan bourgeois culture which still trickles out to see Happenings, its familiarly labeled masochism equaled by its remaining mysticism – the desire of the middle class to preserve its last religion: the world of the artist, palette, museum, and gallery wall, its middle-class passion to appreciate the work of art.

But art may be the little ball rolling off the table. Perhaps it signifies to us, like the line left on a graph by a moving instrument, some unheard reverberation from the subterranean obsession of us all: Is civilization coming to an end? Is society burning our private leaf? Is the day of the cave man returning? And the cave drawing? Has our search for ego once so routine – a useful (somewhat heartless) society – now grown outside the measure of all our experience so that we no longer construct a sensible control center at the core of the mind, but draw back instead from simple desires whose fears we cannot comprehend, and plunge into absurdities which offer us that curious calm in the art of the absurd, even as the cave man defying his gods discovered he was not always dead on the next day and so could use the space he earned to conceive of projects for the future never quite glimpsed before – like society itself.

But we are at the possible end of civilization, and our instinct, battered, all polluted, dreams of some cleansing we have not found; tribal impulses start up across the world. The descending line of the isolated artist and the solitary work goes from Michelangelo all the way down to "Shoot," and if we are cast back into the emotional imperative of the cave painting and trying to make some scratch in the world before us in order that we may discover if disaster exists, it is Chris Burden we can comprehend more easily than the writers of graffiti. They are still somewhat other.

For a new civilization may be stirring in its roots. If in the beginning of Western painting man was small and God was large, if in the Renaissance man was mysteriously large in his relation to God, now in our time man has disappeared. He is God. He is mass-man without identity, and he is God. He is all the schizophrenia of the powerless and all-powerful in one psyche.

As we lose our senses in the static of the oncoming universal machine, so does our need to exercise the ego take on elephantiastical proportions. Graffiti is the expression of a ghetto which is near to the plague, for civilization is now inimical to the ghetto. Too huge are the obstacles to any natural development of a civilized man. In the ghetto it is almost impossible to find some quiet location for your identity. No, in the environment of the slum, the courage to display yourself is your only capital, and crime is the productive process which converts such capital to the modern powers of the world, ego and money.

With a difference. For the kids work together. The cave painting is now collective. One rushes in to prevent the drip of another. With his breath he flowers the drop about to fall and presses it back into its defining line. They work with speed, they work with cool, they paint their masterpieces (now that they are found for an instant by society) before the cameras of a German TV crew. They make an hour film for Europe. They are elegant in their movements. And do their best for the show. It is natural. They are used to working in the illumination of high pressure. They paint backdrops after all for the Joffrey Ballet while the dance is on, their paintings sell for $200 then $2000, they are hired, they are bought, they rise. Some will yet be bastions of a fat and dying world. But the beginning of another millennium of vision may also be with them. For we do not know with what instruments we will draw in years to come nor by which materials. Will it be by the laser of a laser up on the canvas of a bubble cloud chamber that gangs of artists will shift the patterns of the atom, and do we have a clue to the beauties of growth and malignancy we will yet create and in which arenas? And by what vanities of hoodlums and astronauts? We only sense that if we go on, still rising from the first squiggle of graffiti in the first motile cell, we may not ever know even as we forge our wonders in all the blind heat of ego-lust what we will finally discover as we go out into the vortex of the last sleep. Do we learn then whether we are angels seeking to articulate the aesthetic of a great god, or demonic cave-painters looking to kill the abominable snowman of our dread night? In any event, wherever, whatever, art is not peace but war, and form is the record of that war.

Yet there is a mystery still. From which combat came these curious letters of graffiti, with their Chinese and Arabic calligraphies; out of what connection to the past are these lights and touches of flame so much like the Hebrew alphabet where the form of the letter itself was worshipped as a manifest of the Lord; no, it is not enough to think of the childlike desire to see one's name ride by in letters large enough to scream your ego across the city, no, it is almost as if we must go back into some more primeval sense of existence, into that curious intimation of how our existence and our identity may perceive each other only as in a mirror. If our name is enormous to us, it is also not real – as if we have come from other places than the name, and lived in other lives.

Perhaps that is the unheard echo of graffiti, the vibration of that profound discomfort it arouses, as if the unheard music of its proclamation and/or its mess, the rapt intent seething of its foliage, is the herald of some oncoming apocalypse less and less far away. Graffiti lingers on our subway door as a memento of what it may well have been, our first art of karma, as if indeed all the lives ever lived are sounding now like the bugles of gathering armies across the unseen ridge.

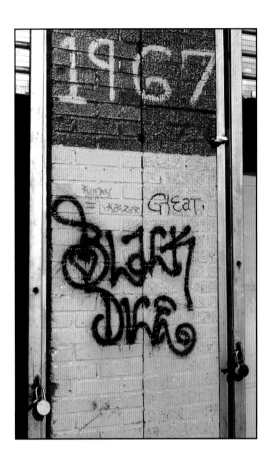

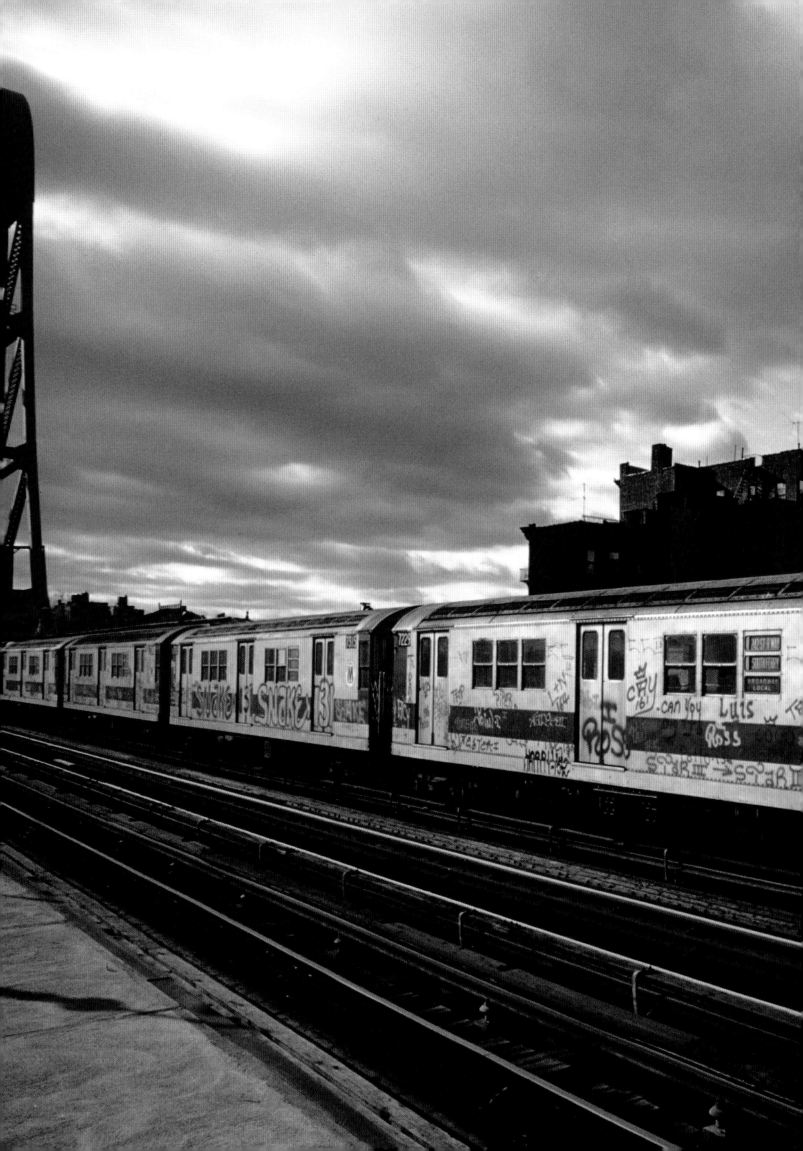

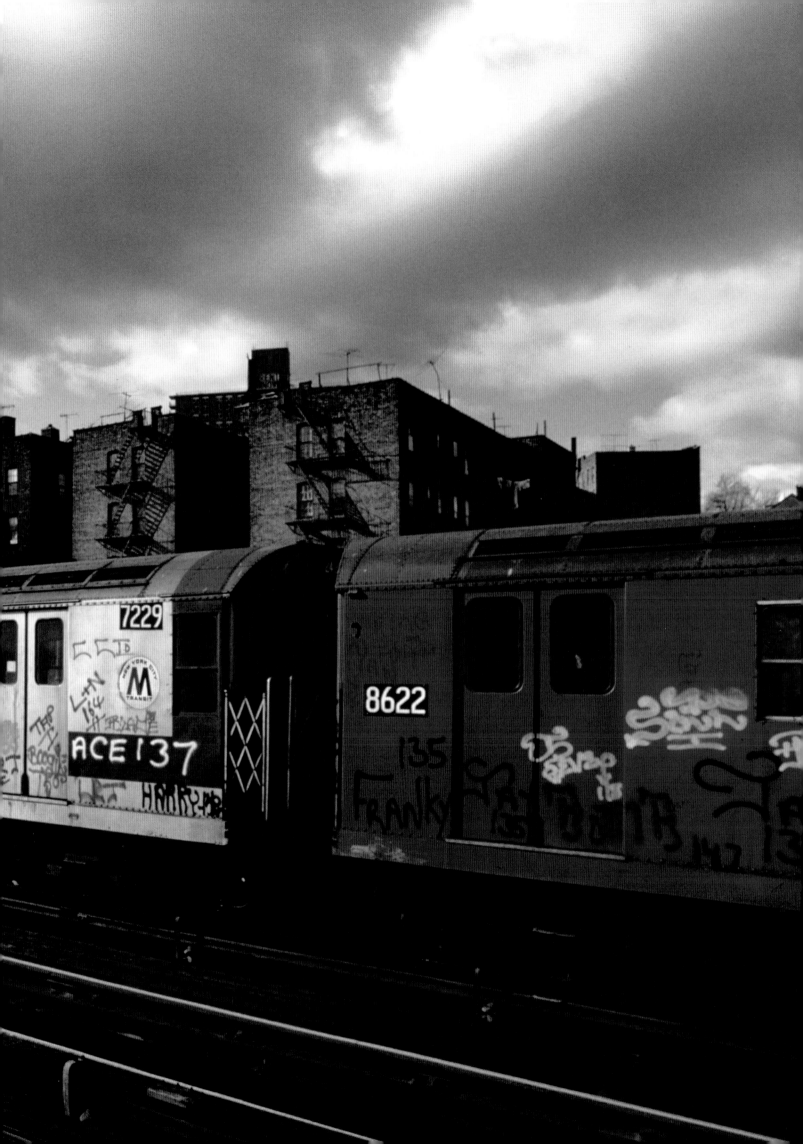

We are building you a new subway,
and giving back your park as
rapidly as possible

The construction method used
allows complete restoration
of natural surroundings

This construction is one link
in the 52 miles of new subways
being built to help make
New York City a better place in
which to live, work, and play

This project is a joint venture
of the State of New York and the
City of New York

State of New York
Nelson A Rock Governor

City of New York
John V Lindsay Mayor

New York City Transit Authority
William J Ronan, Chairman

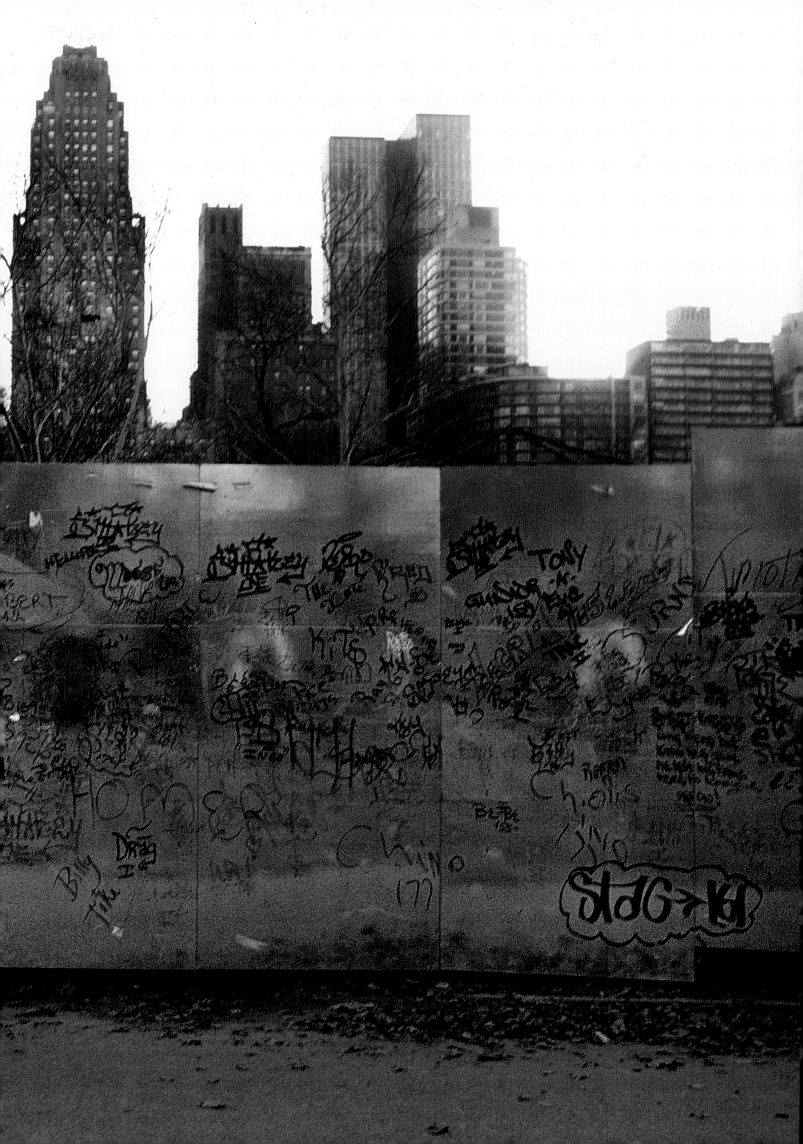

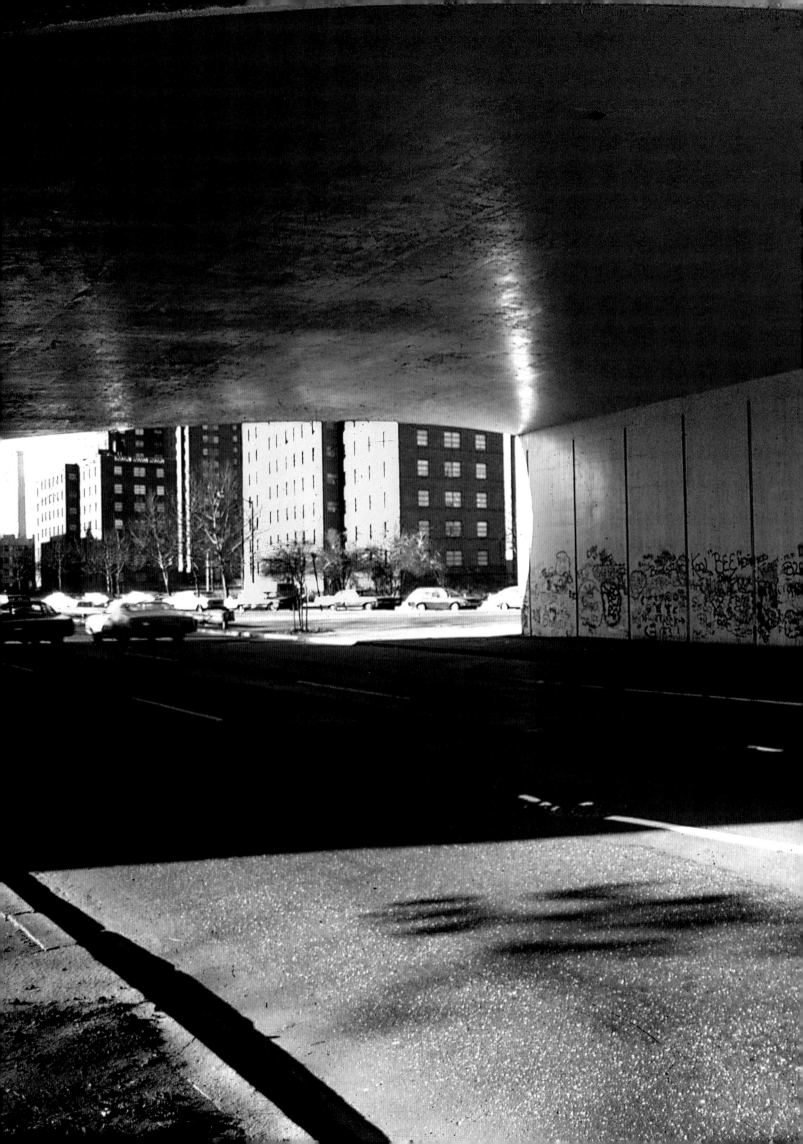

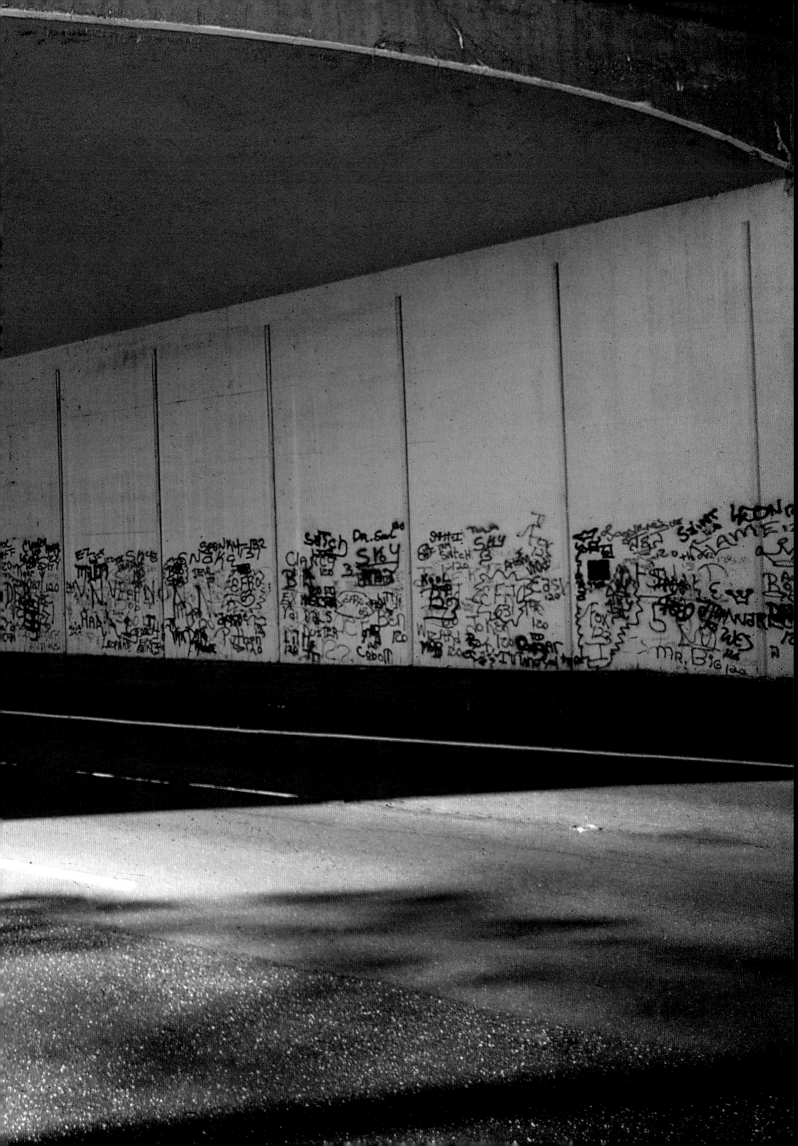

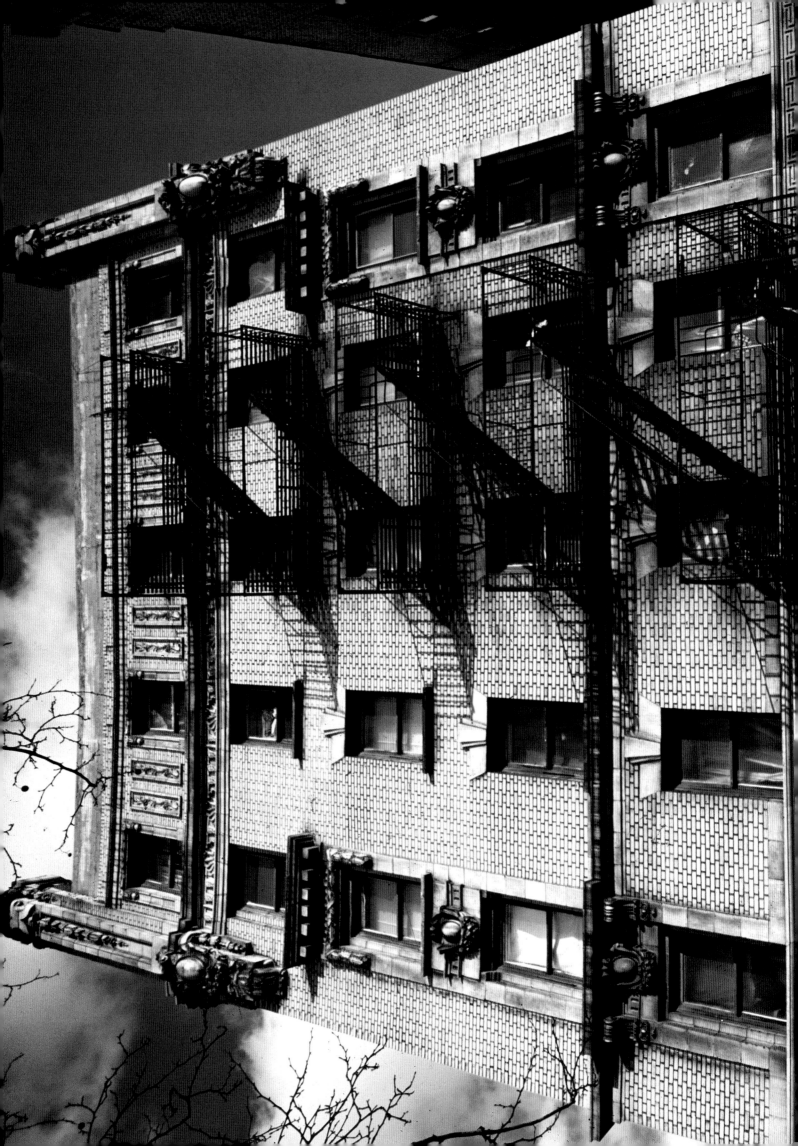

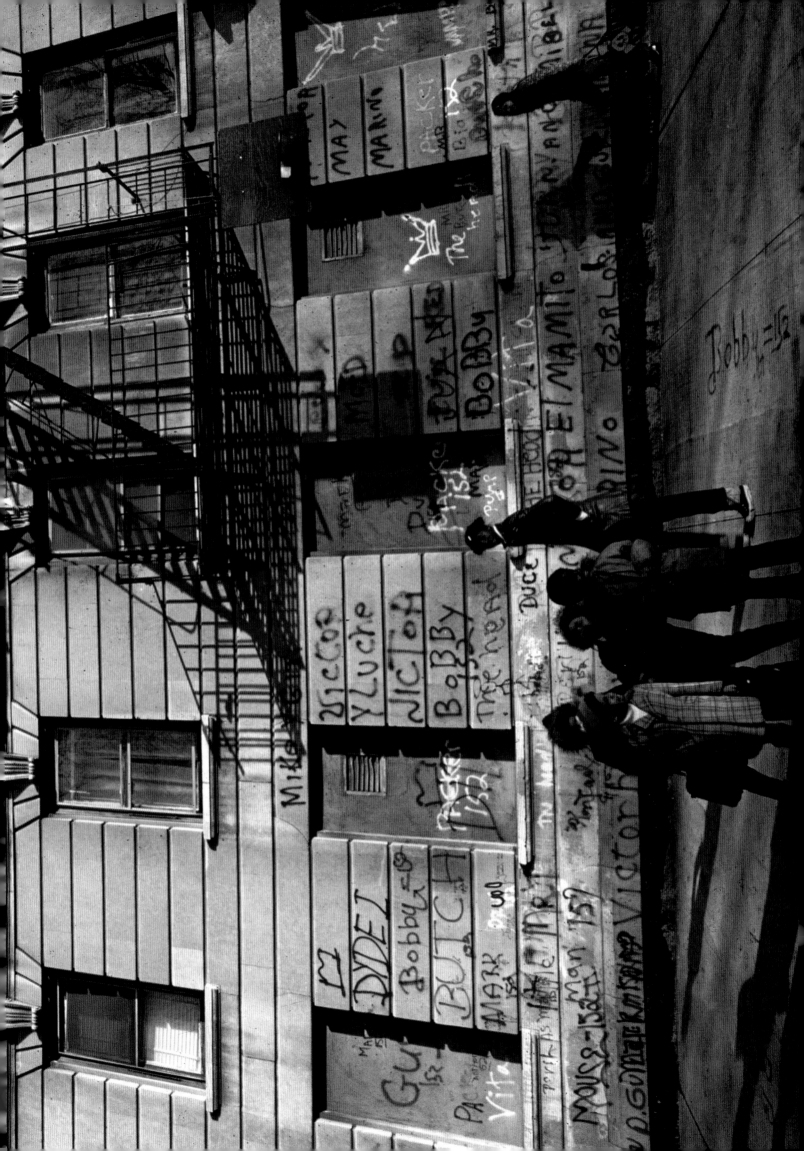

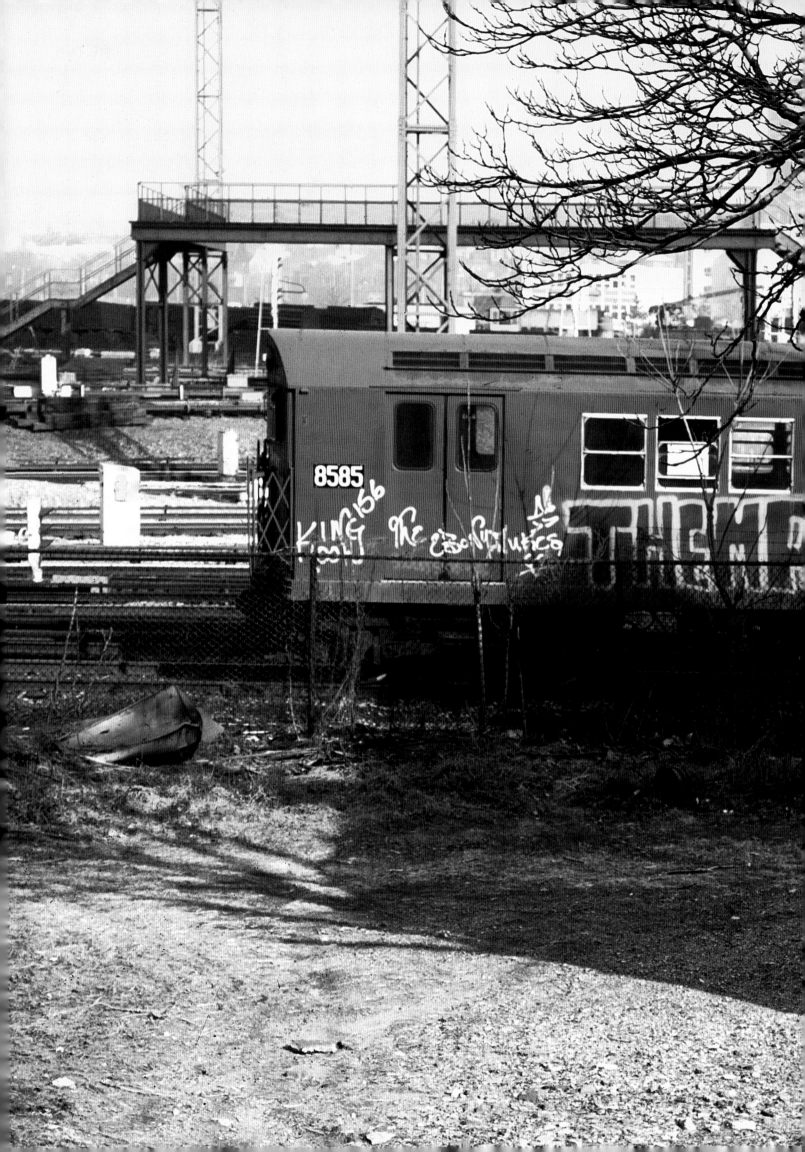

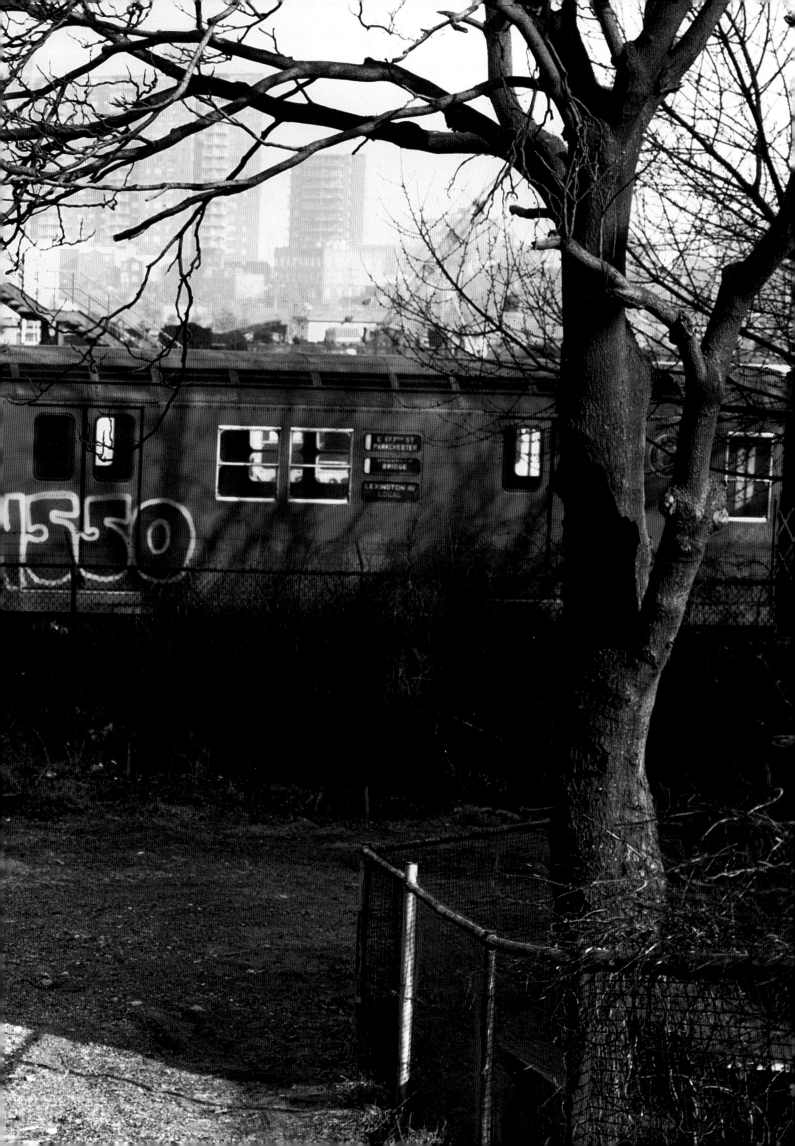

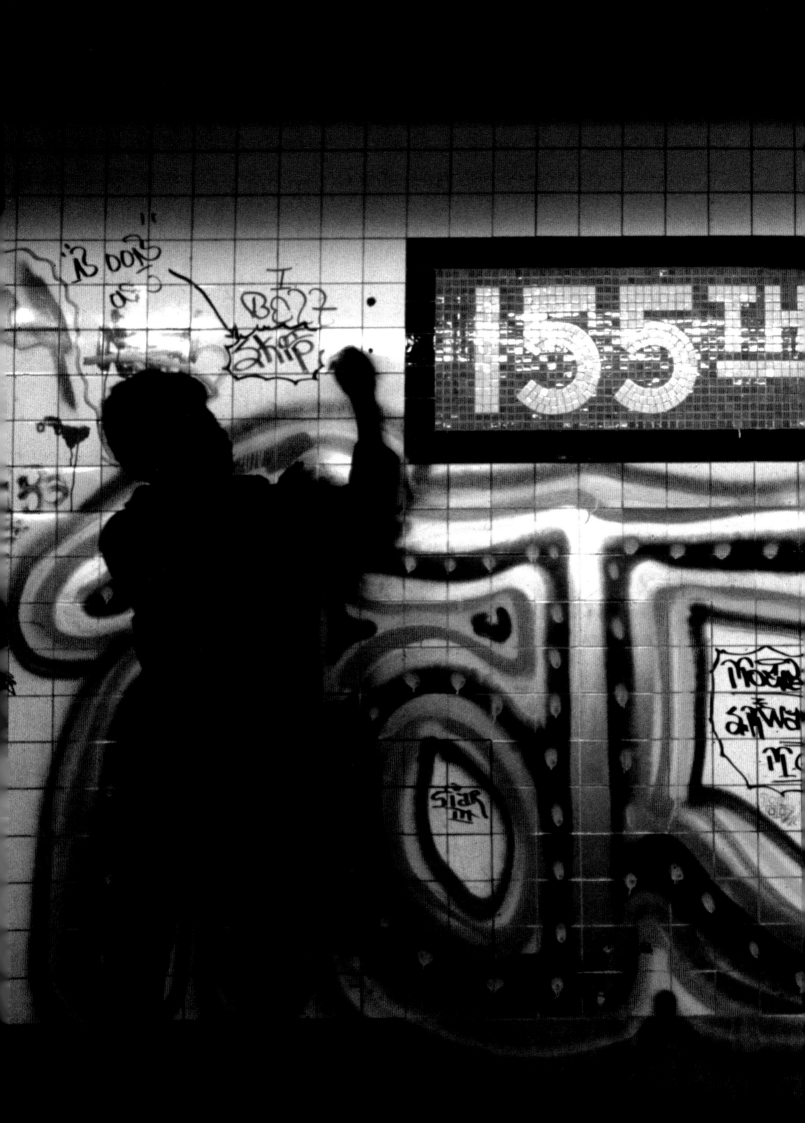

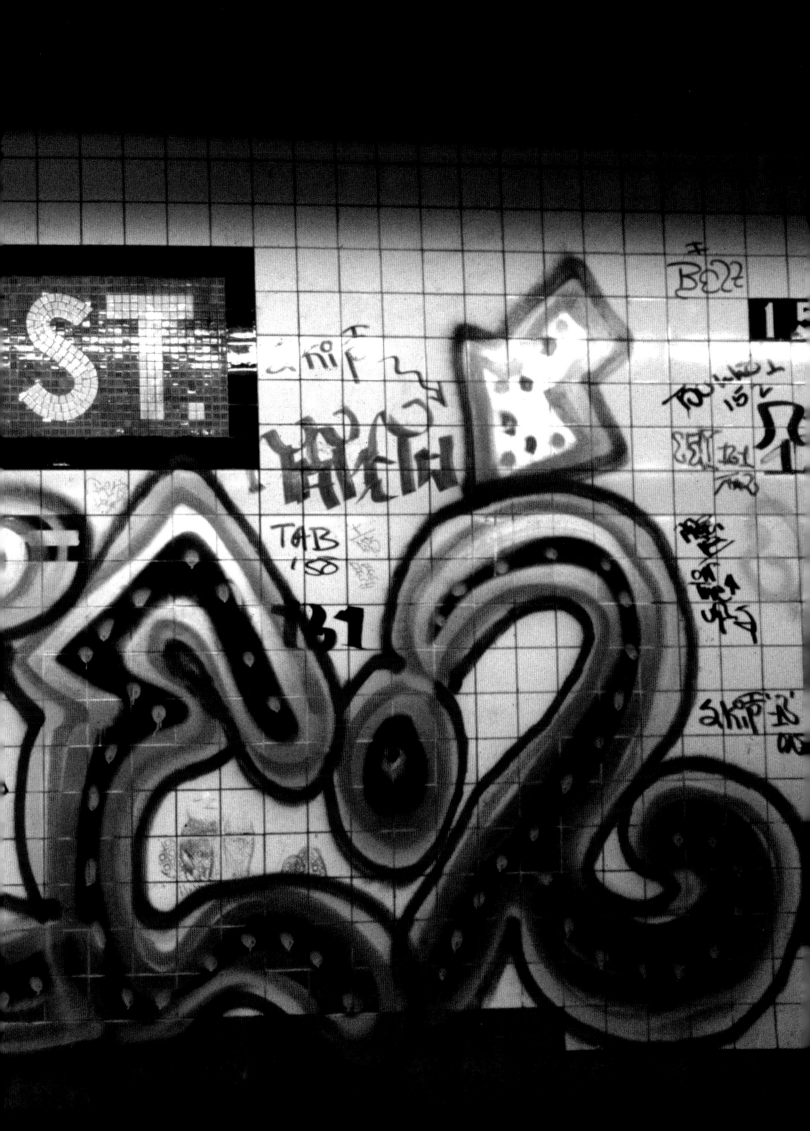

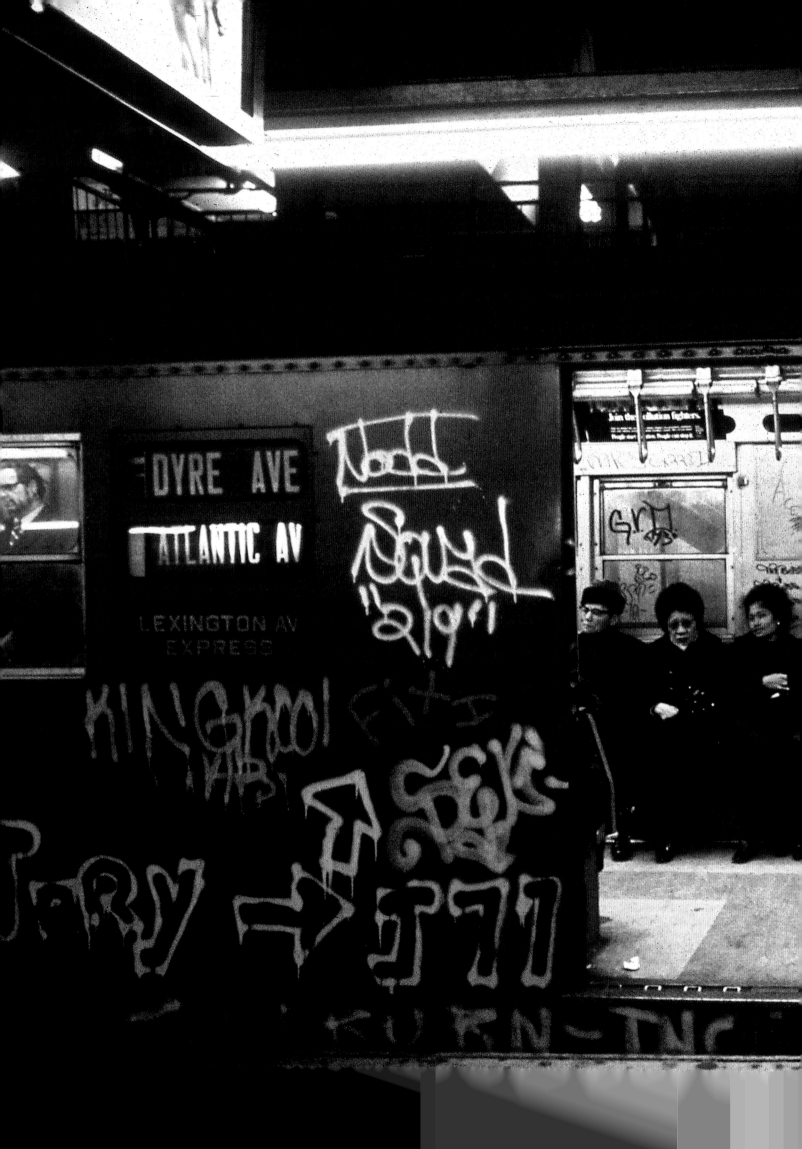

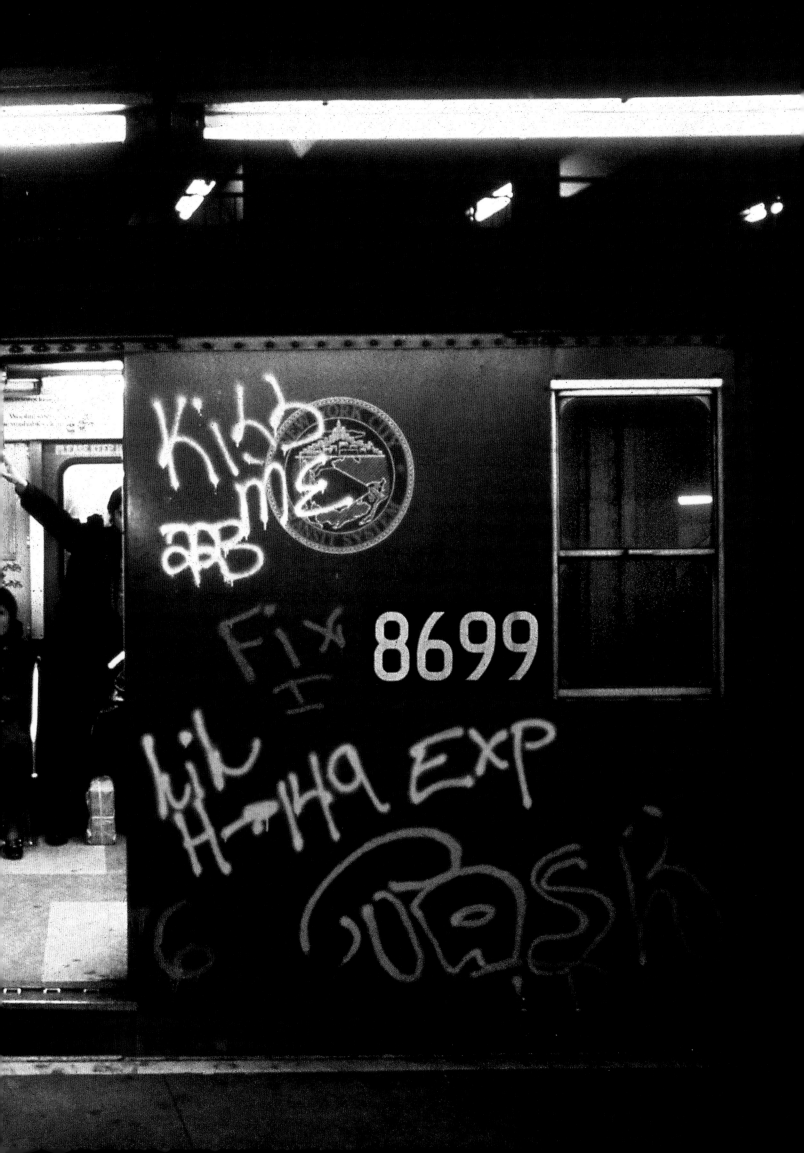

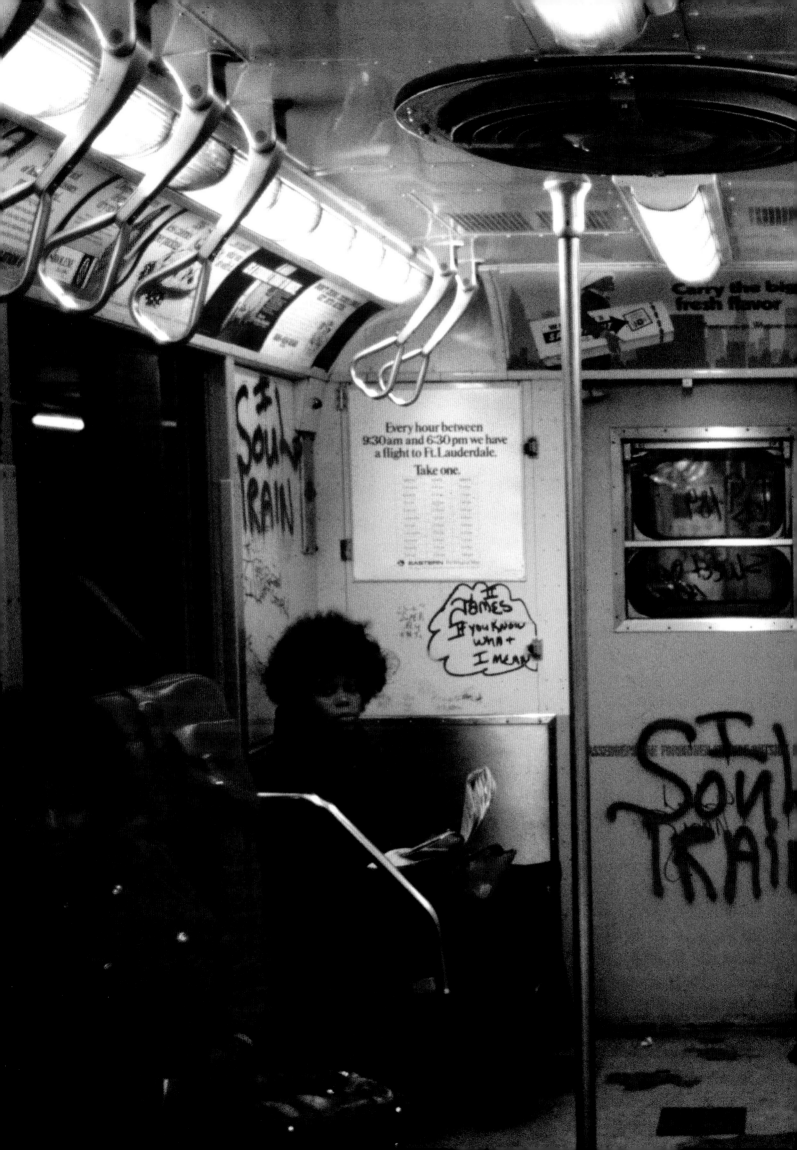

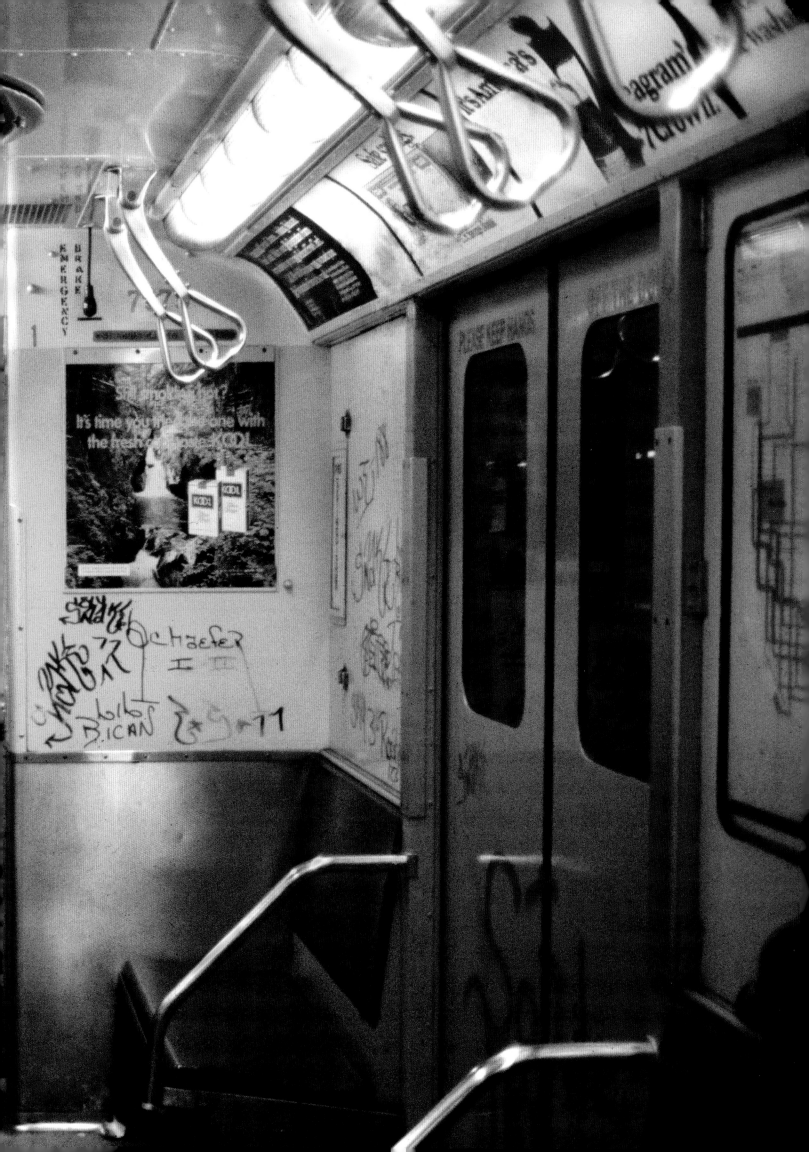

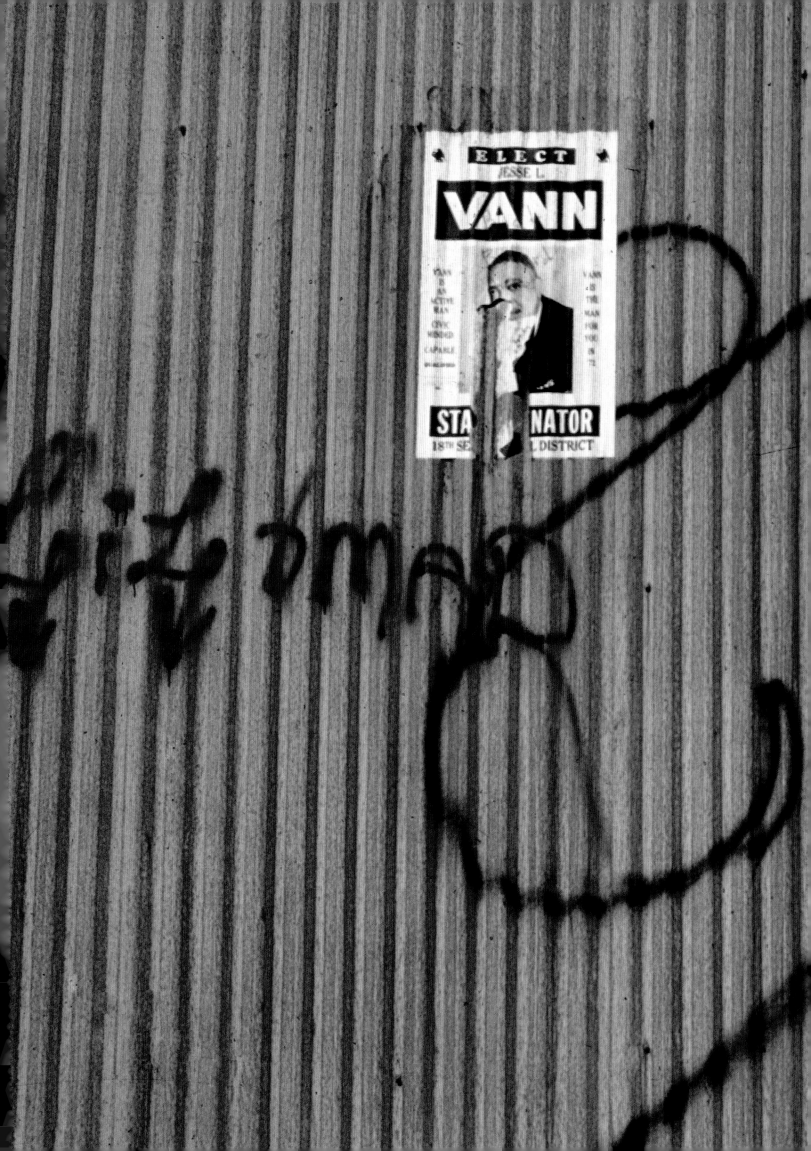

BROOKLYN
HAS
ITS
OWN
NEWSPAPER

Brooklyn Today

On Your Newsstand
September 20th

BROOKLYN
HAS
ITS
OWN
NEWSPAPER

Brooklyn Today

On Your Newsstan
September 20th

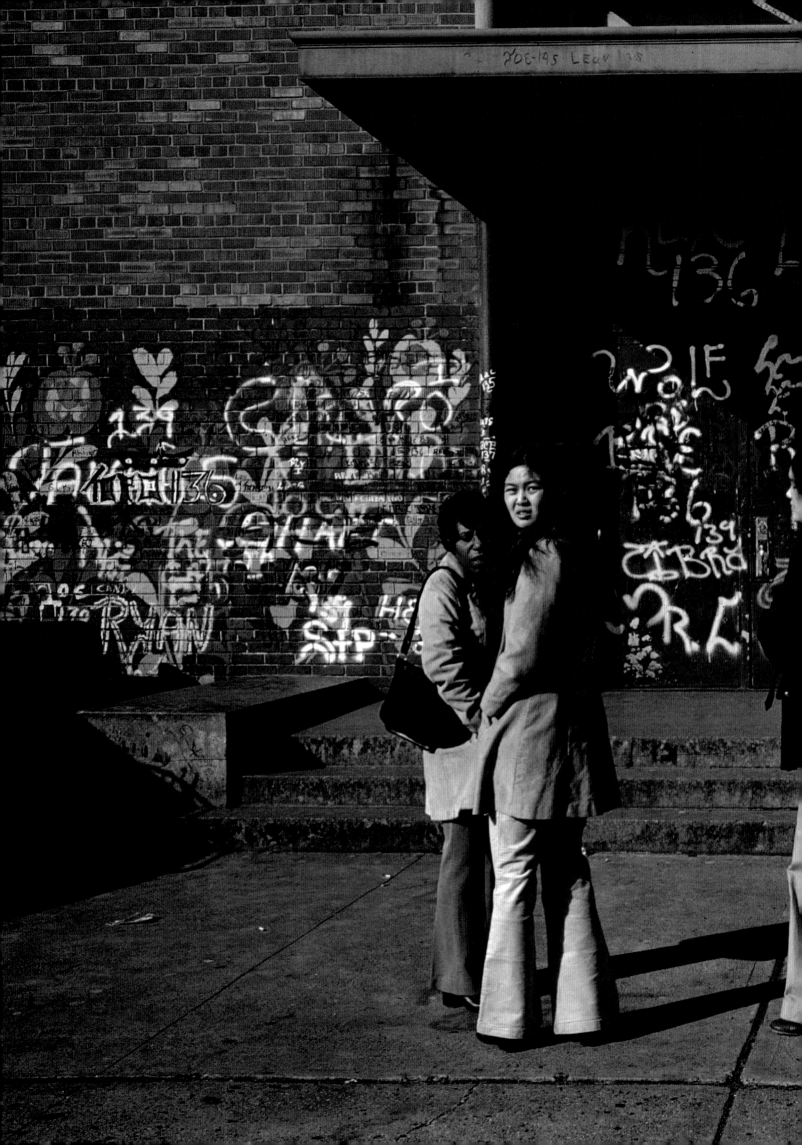

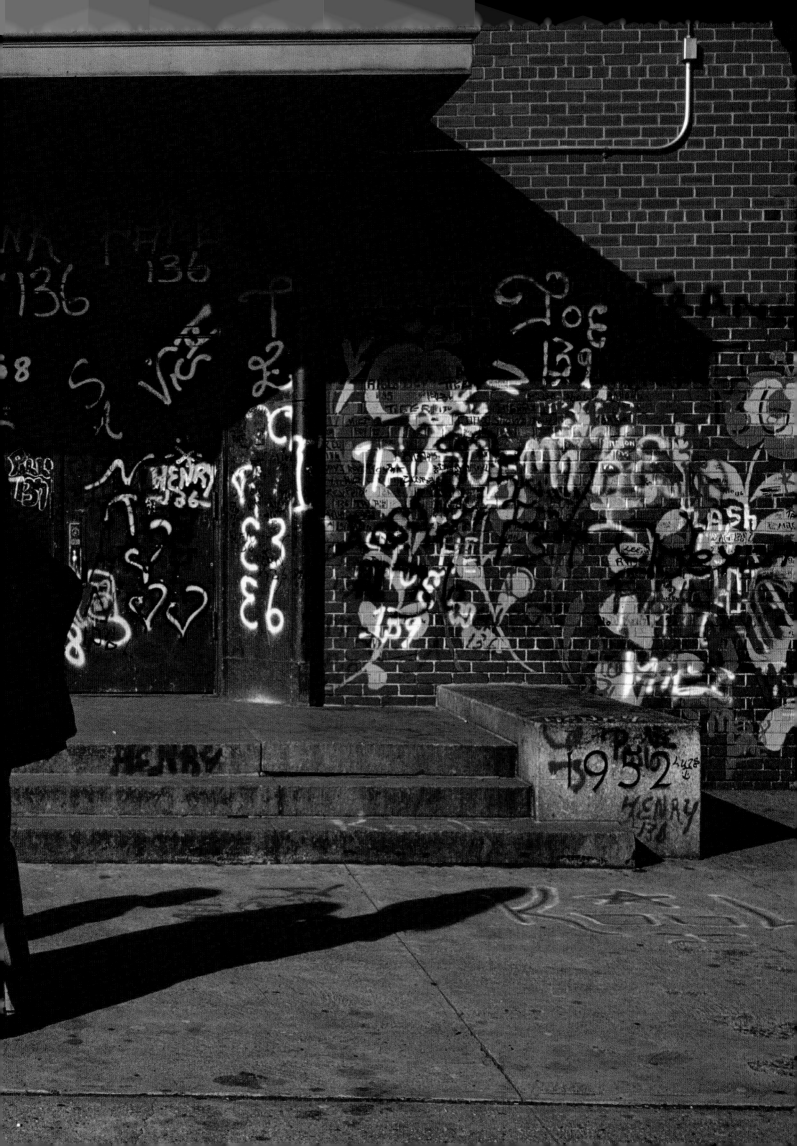

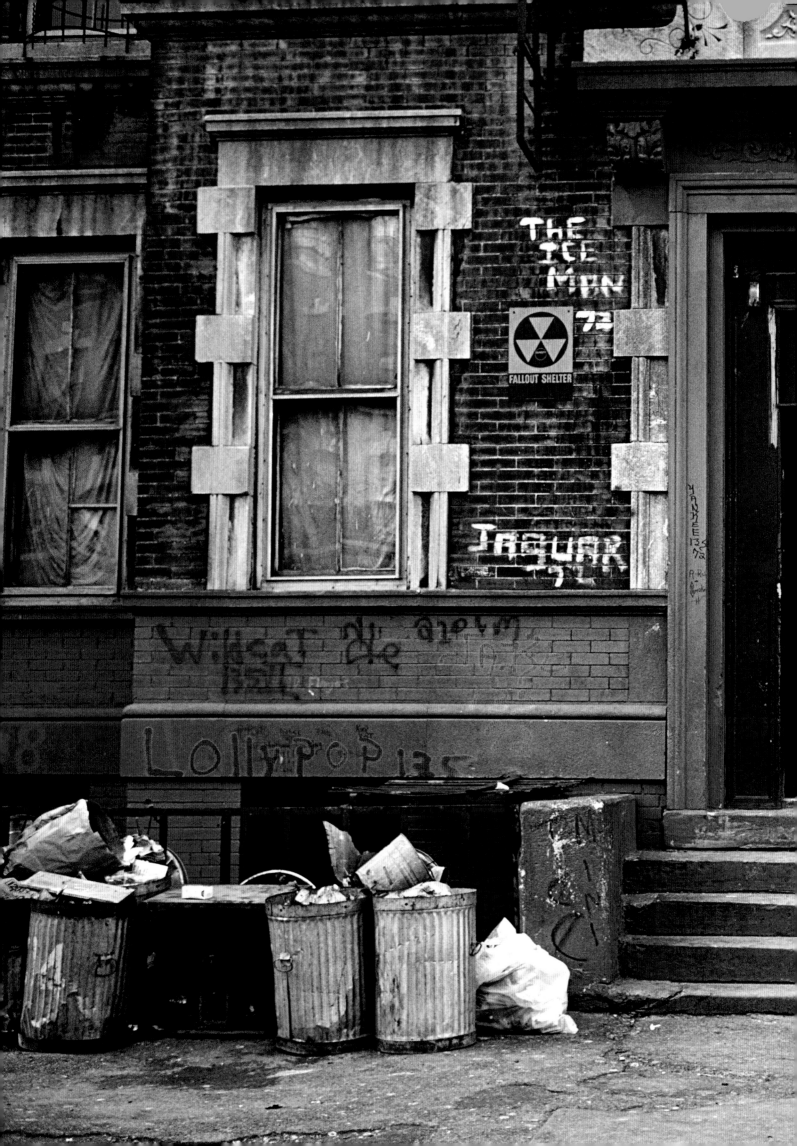

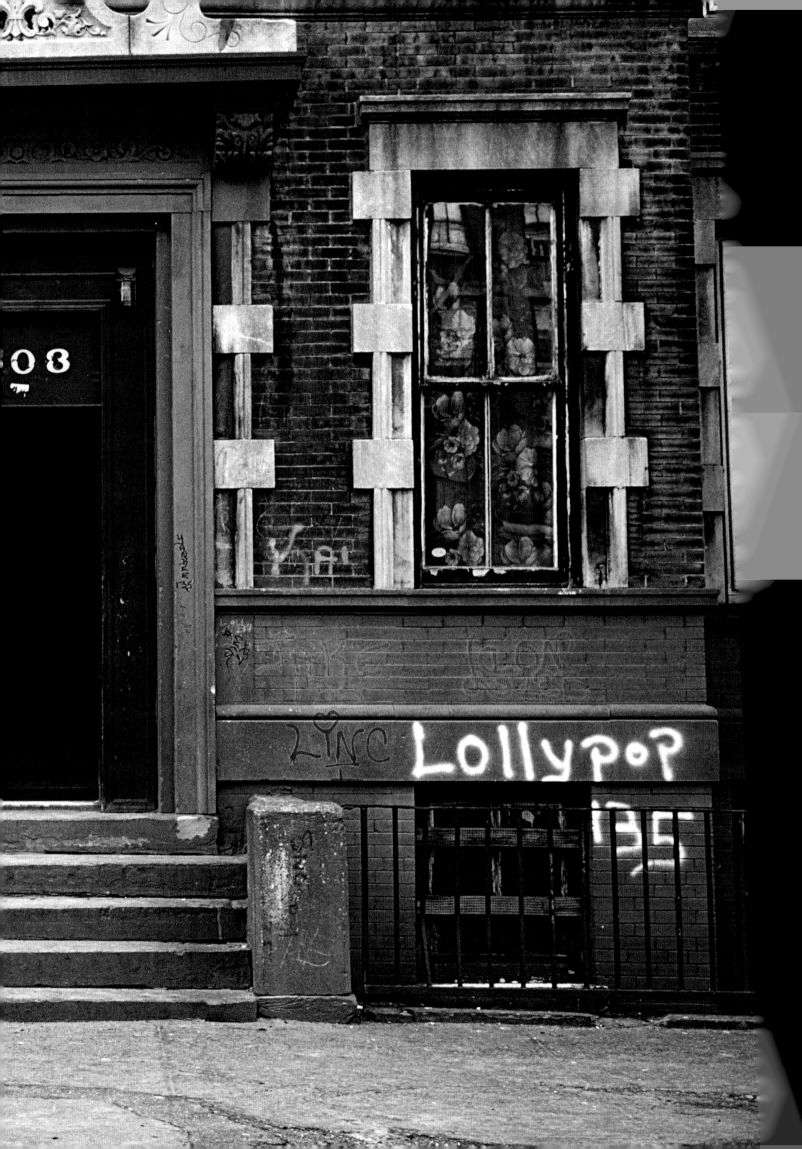

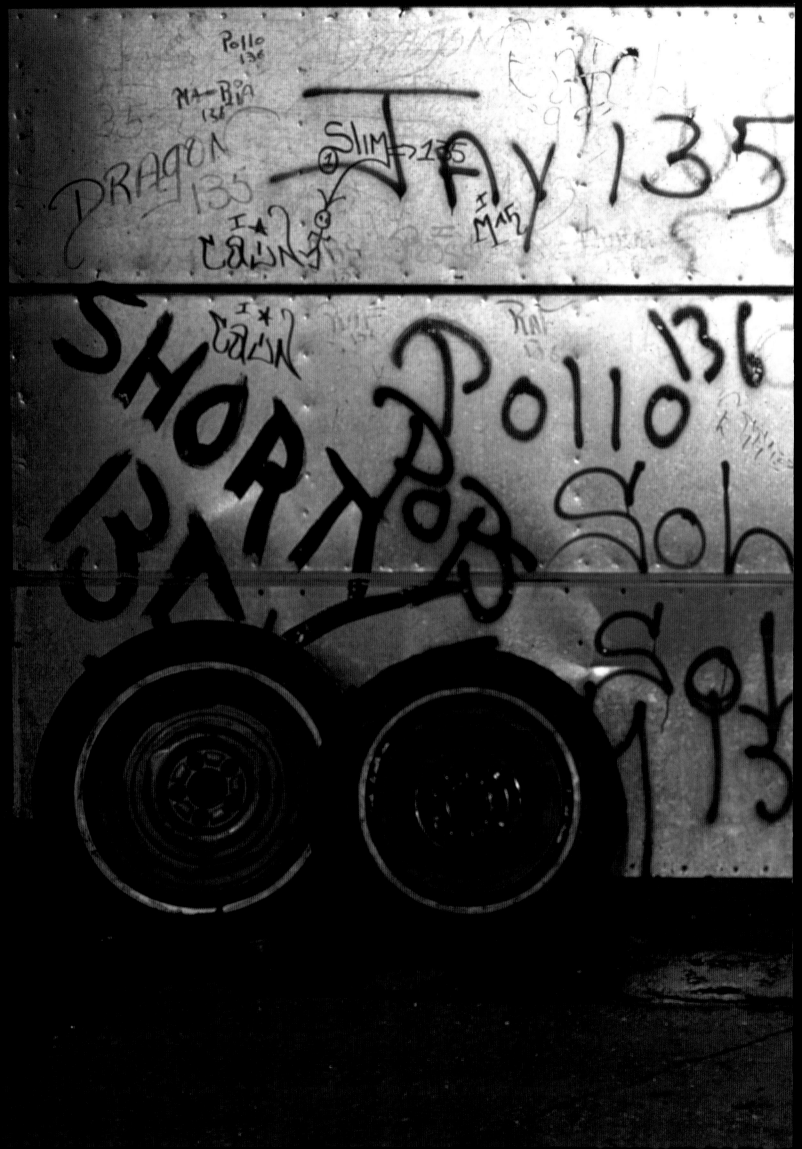

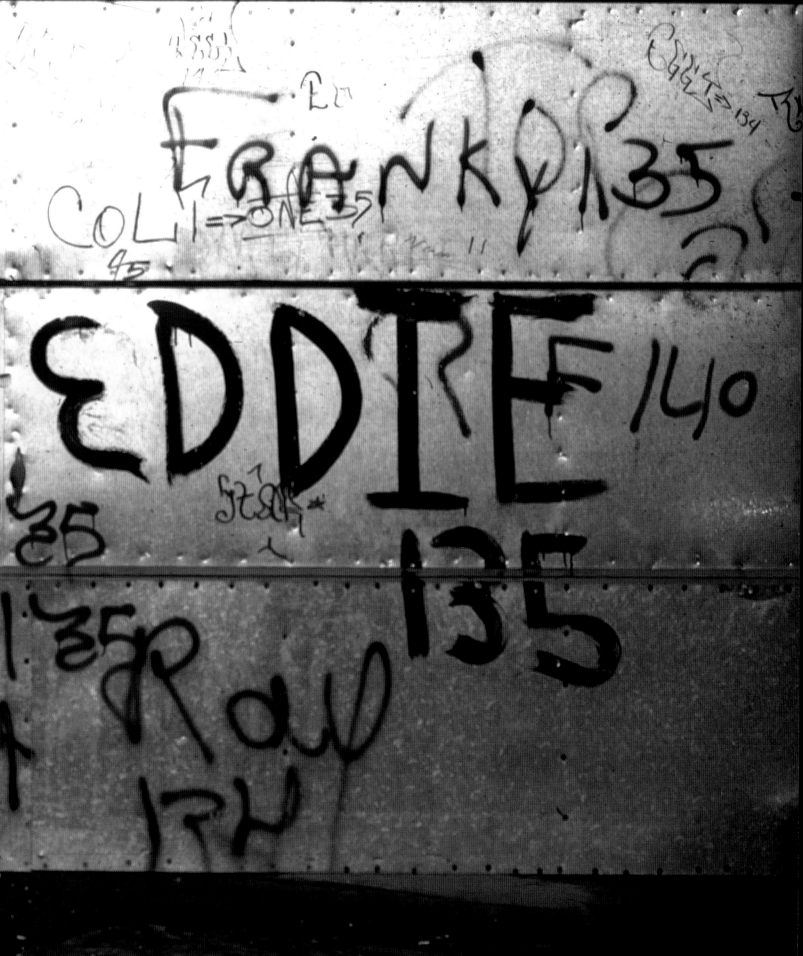

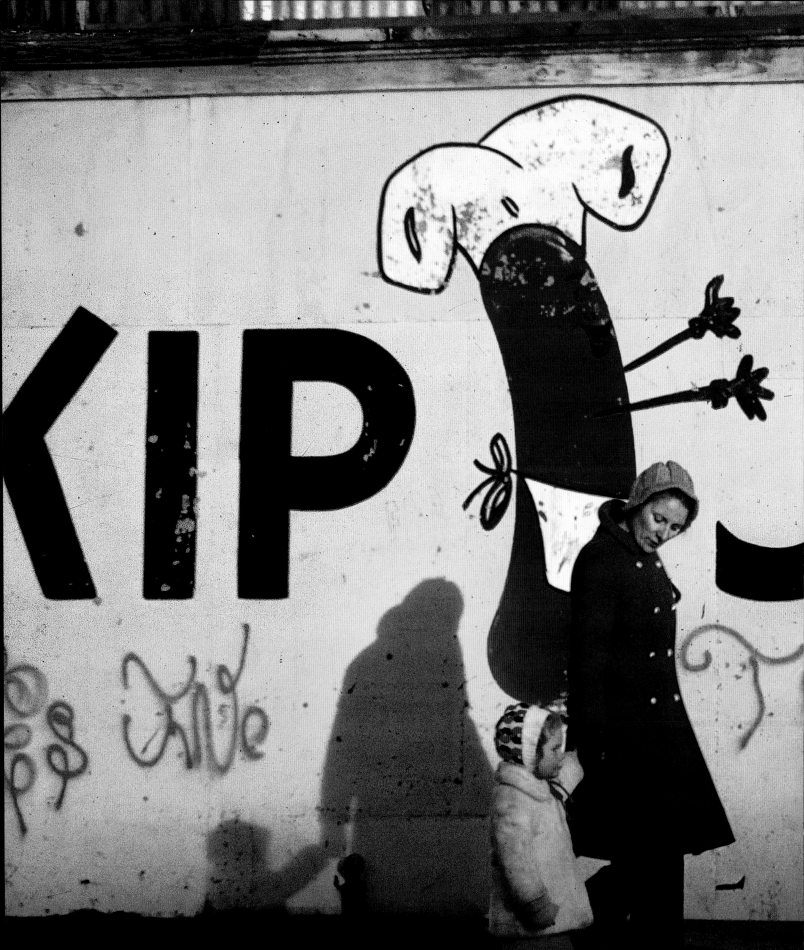

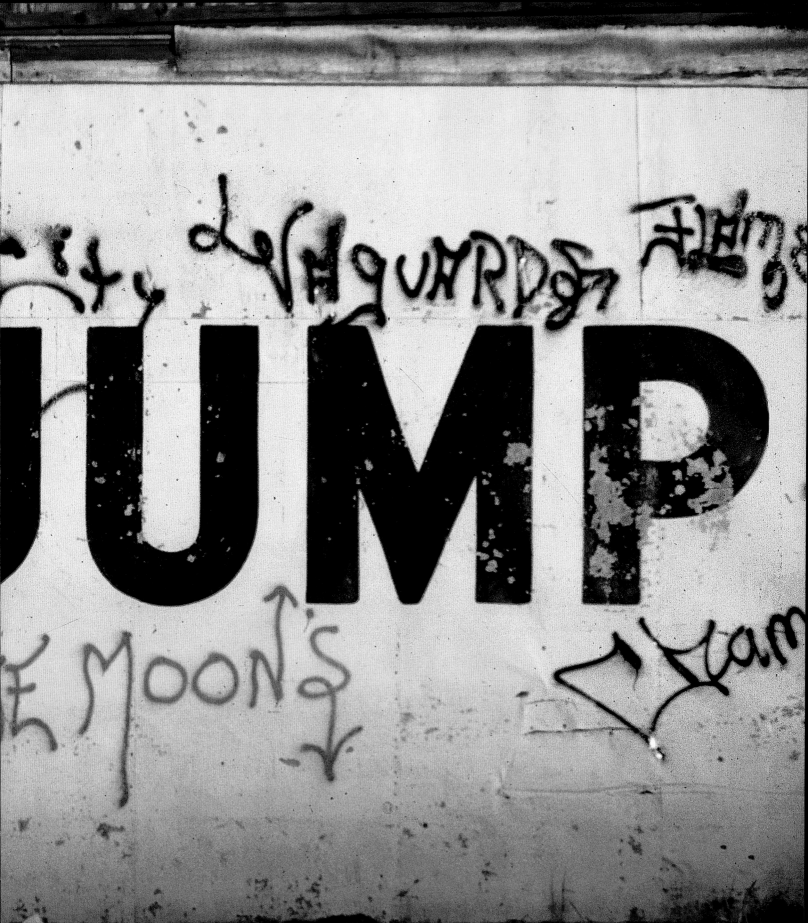

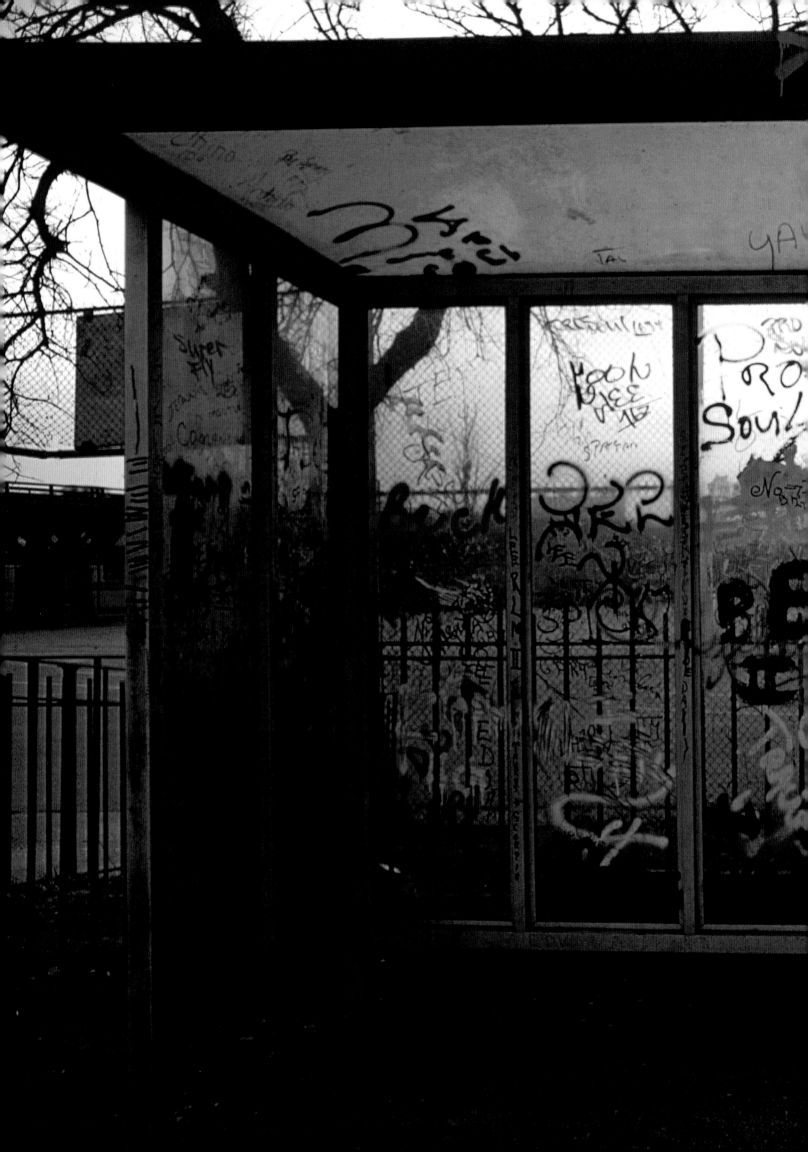

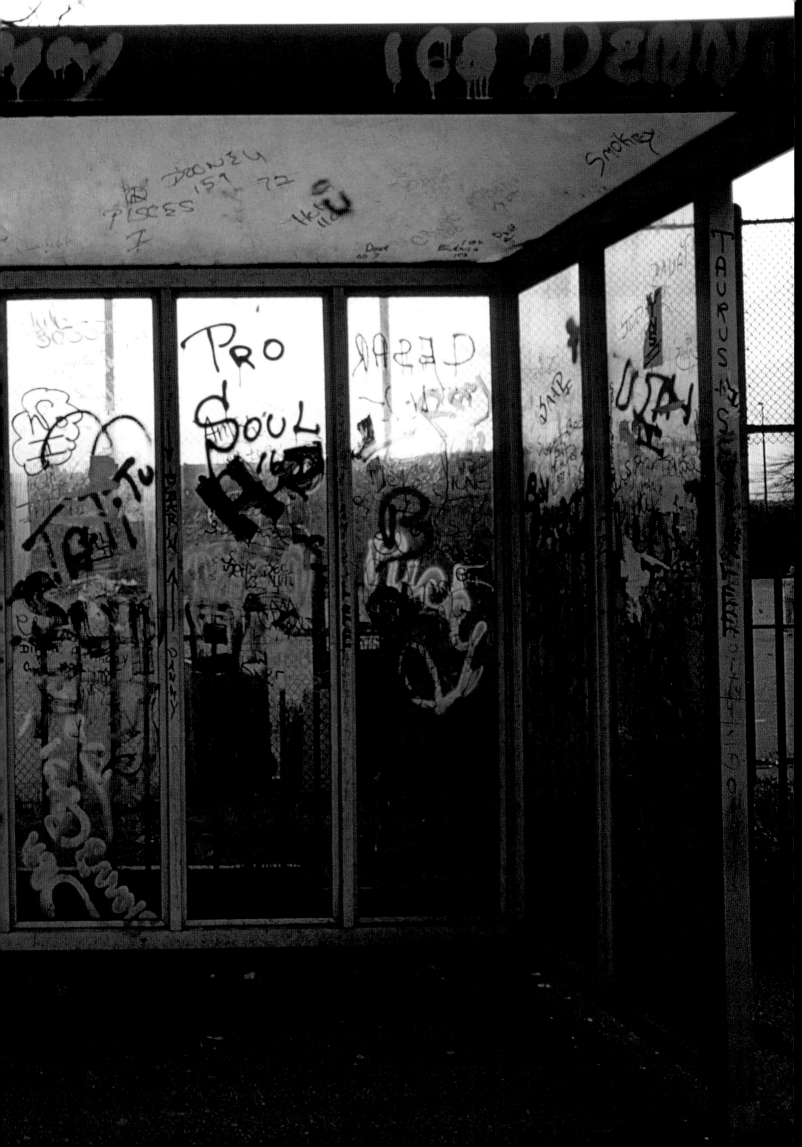

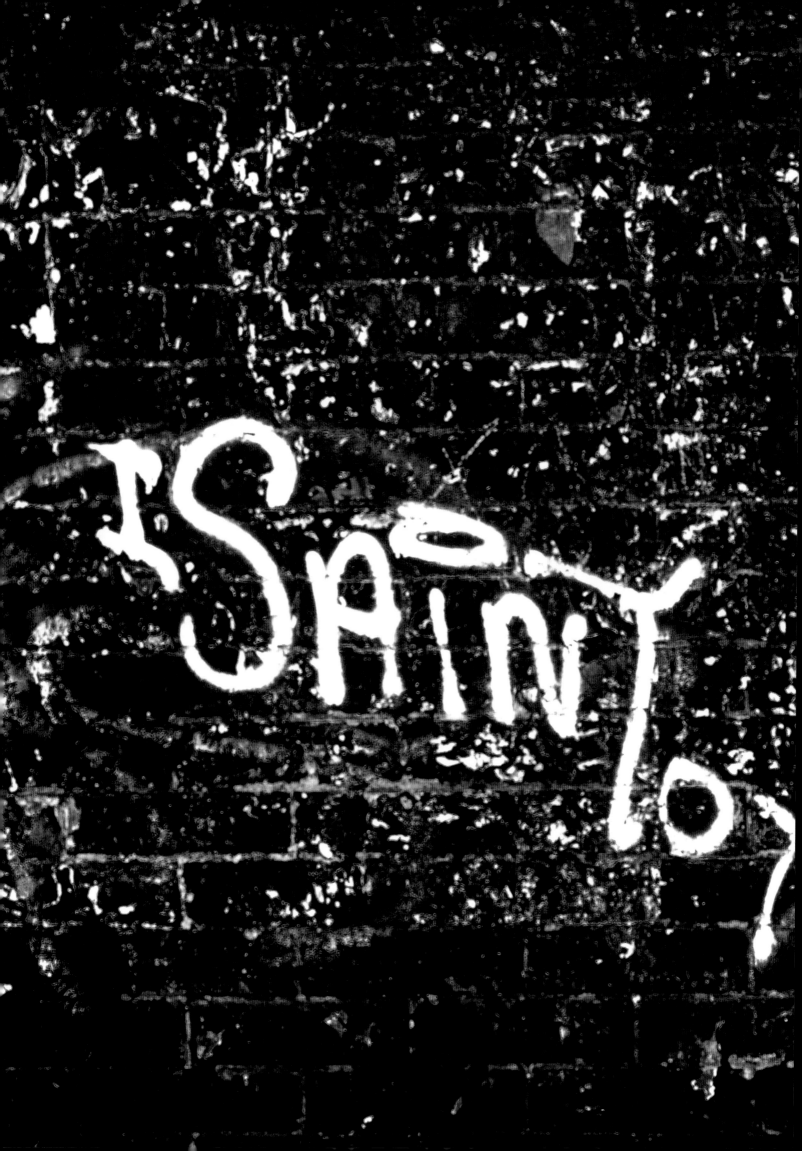

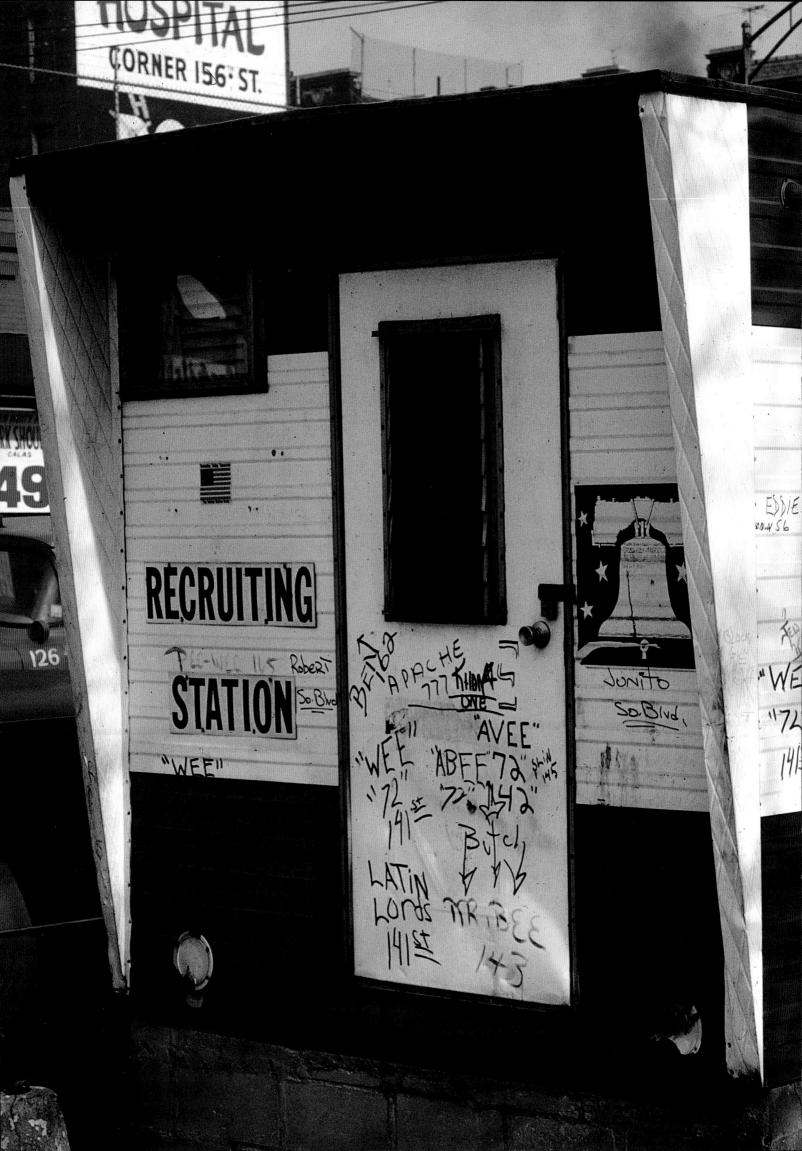

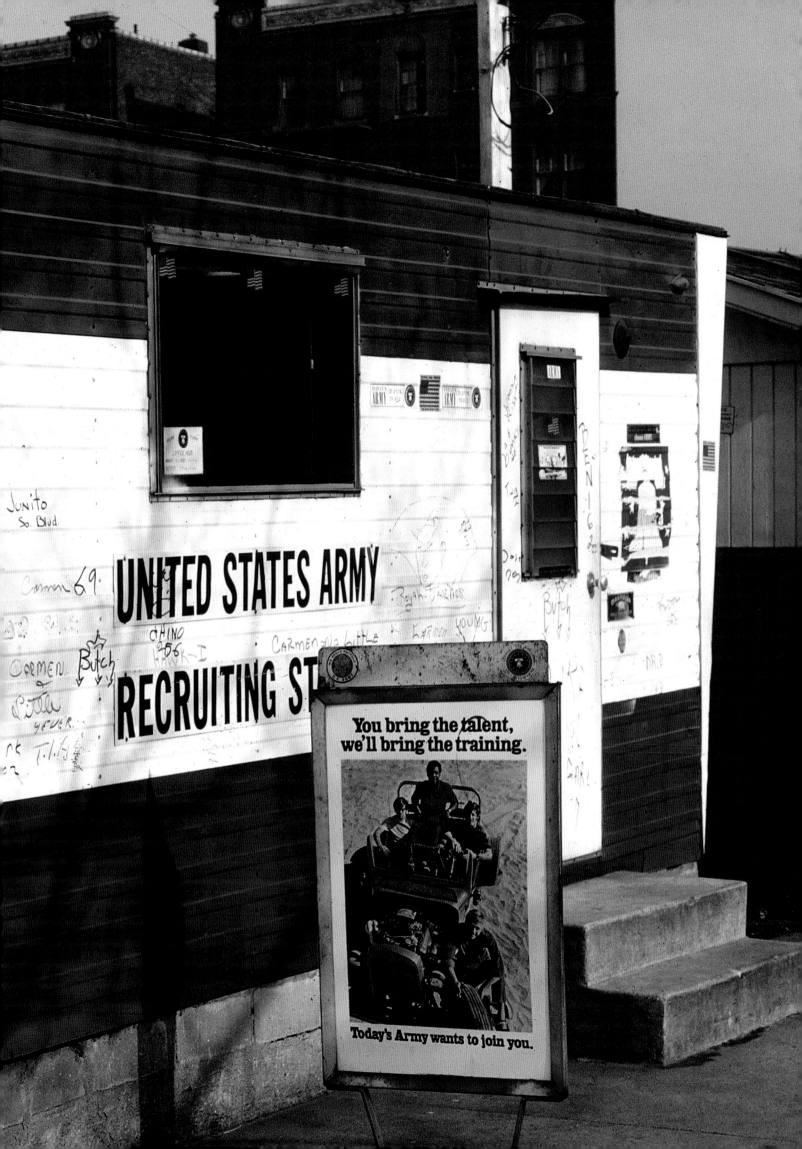

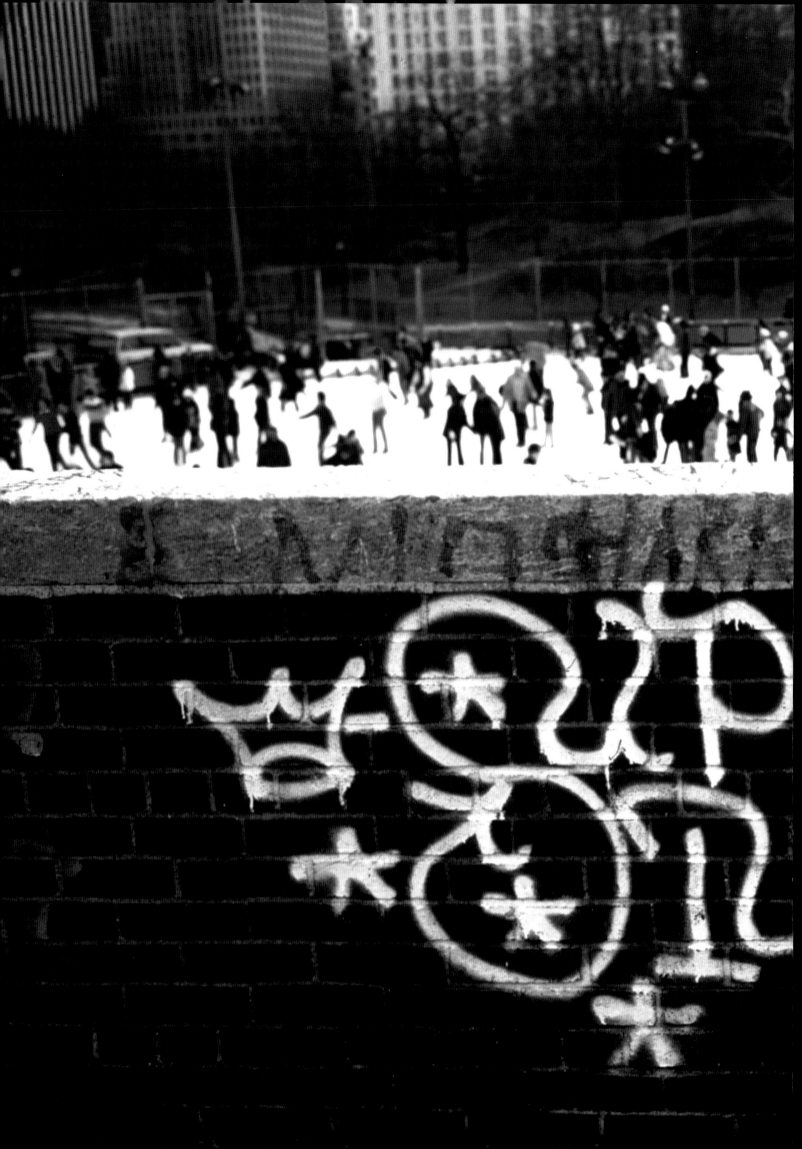

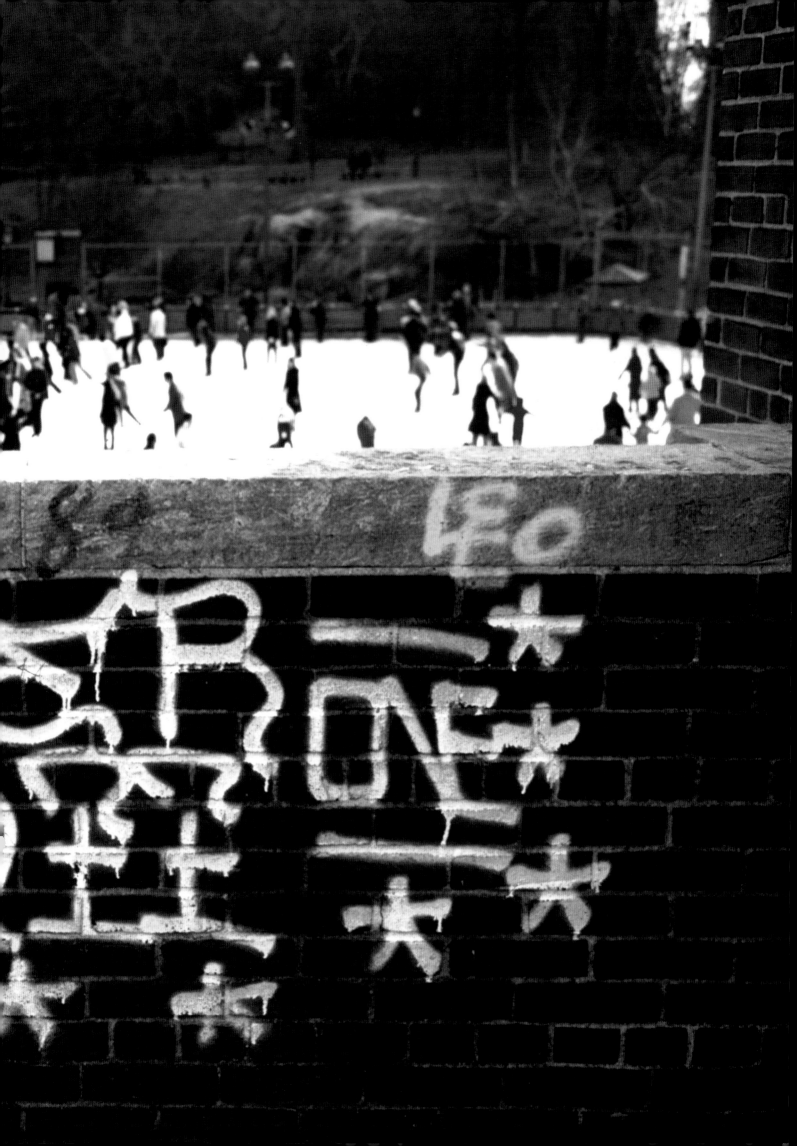

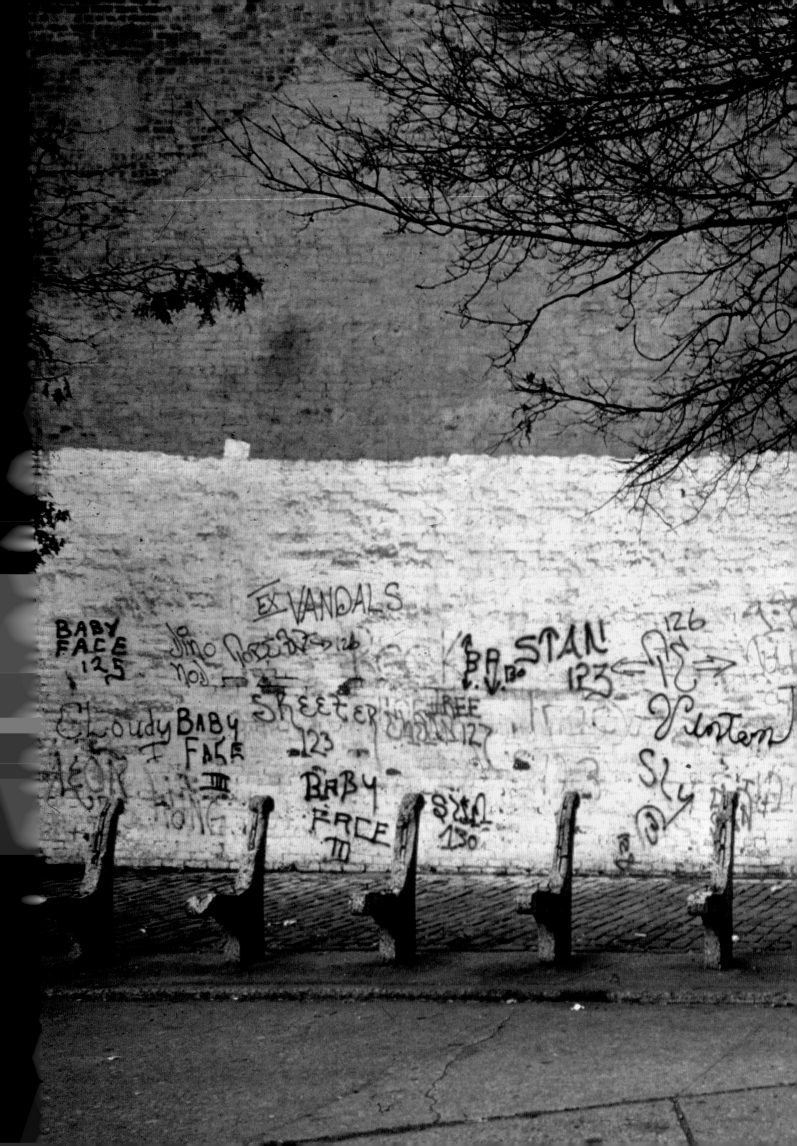

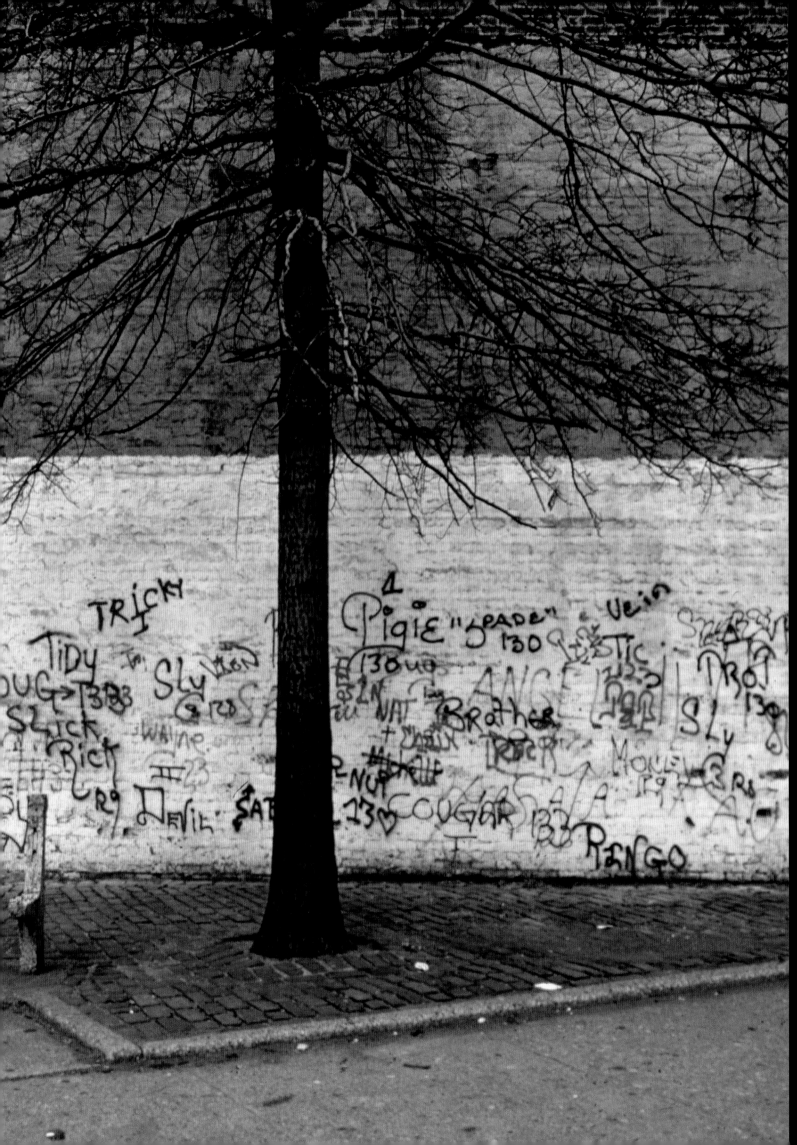

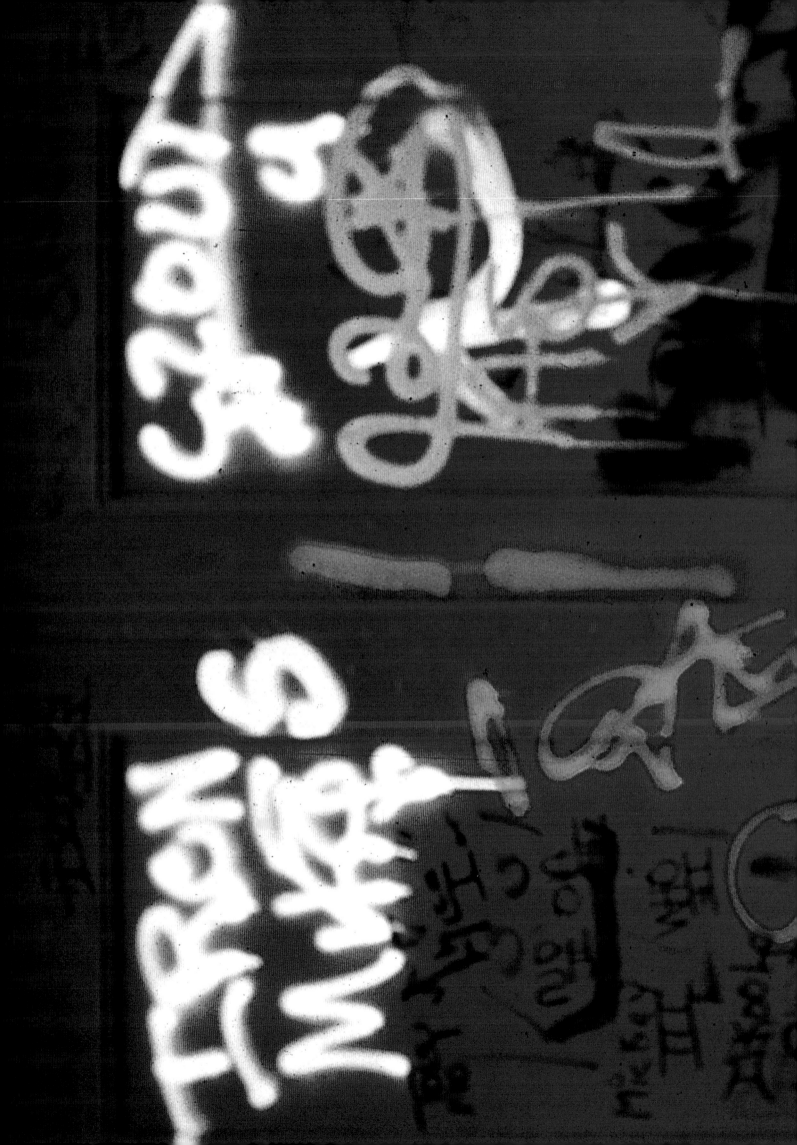

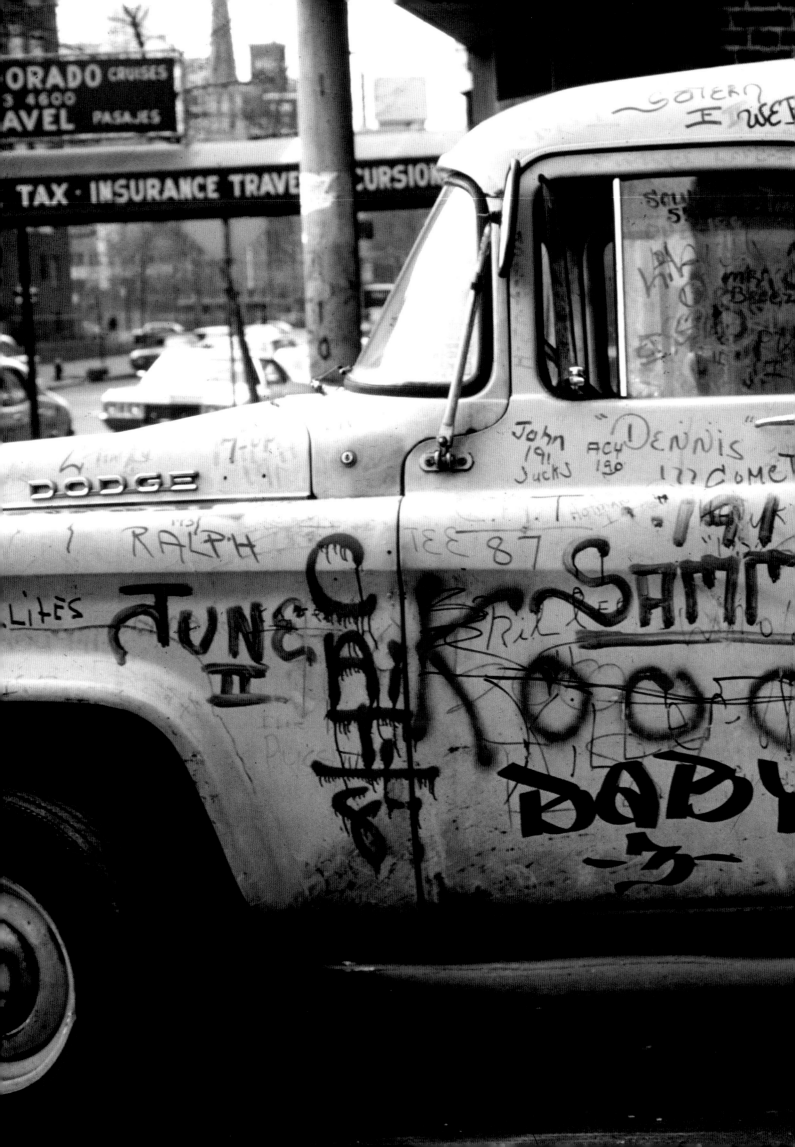

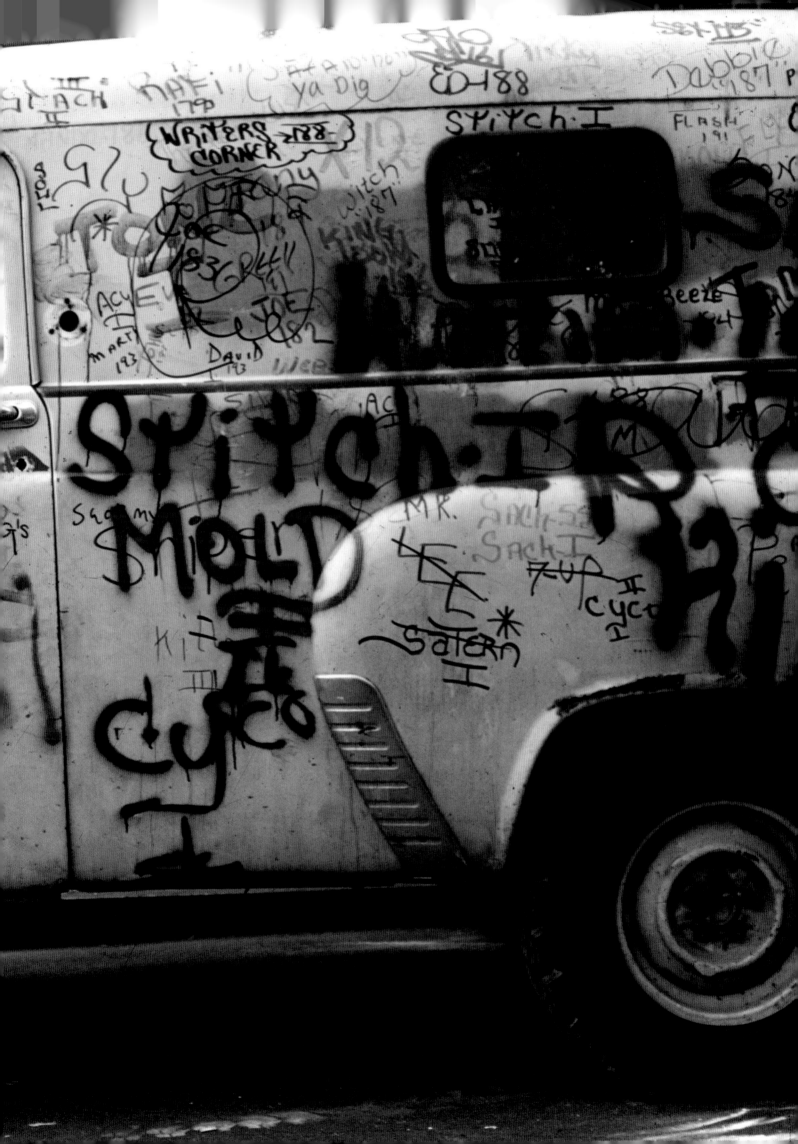

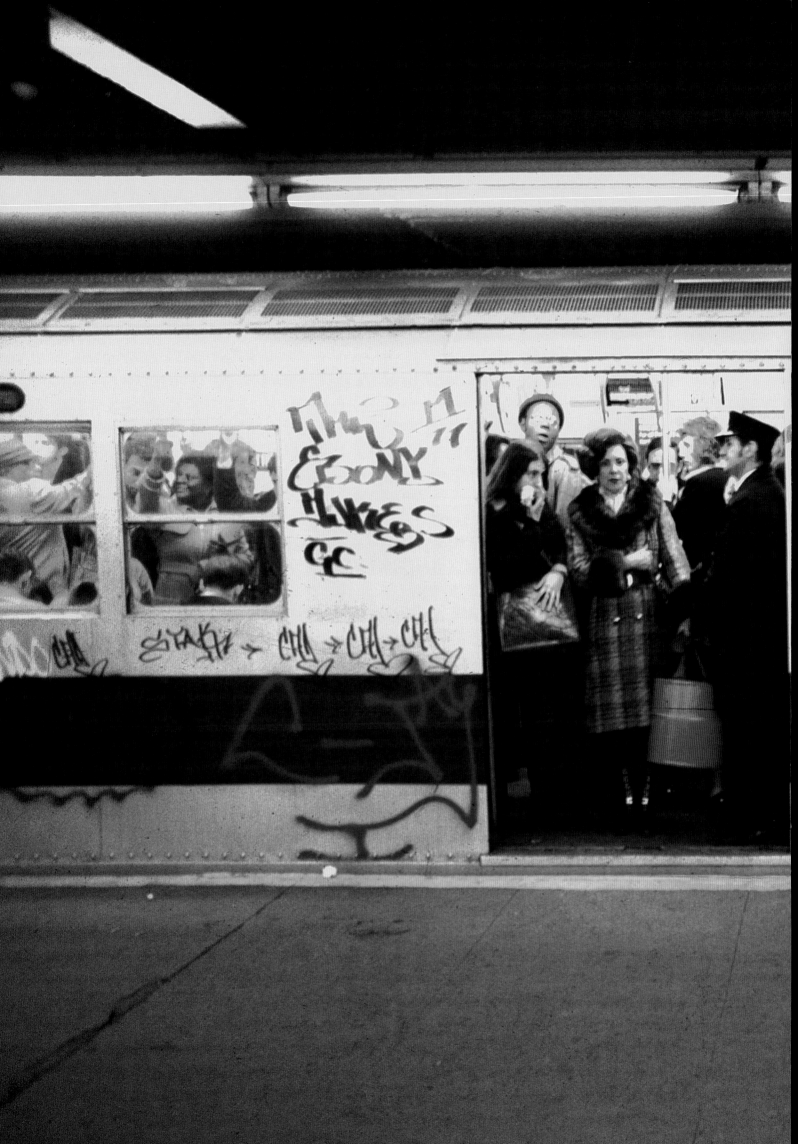

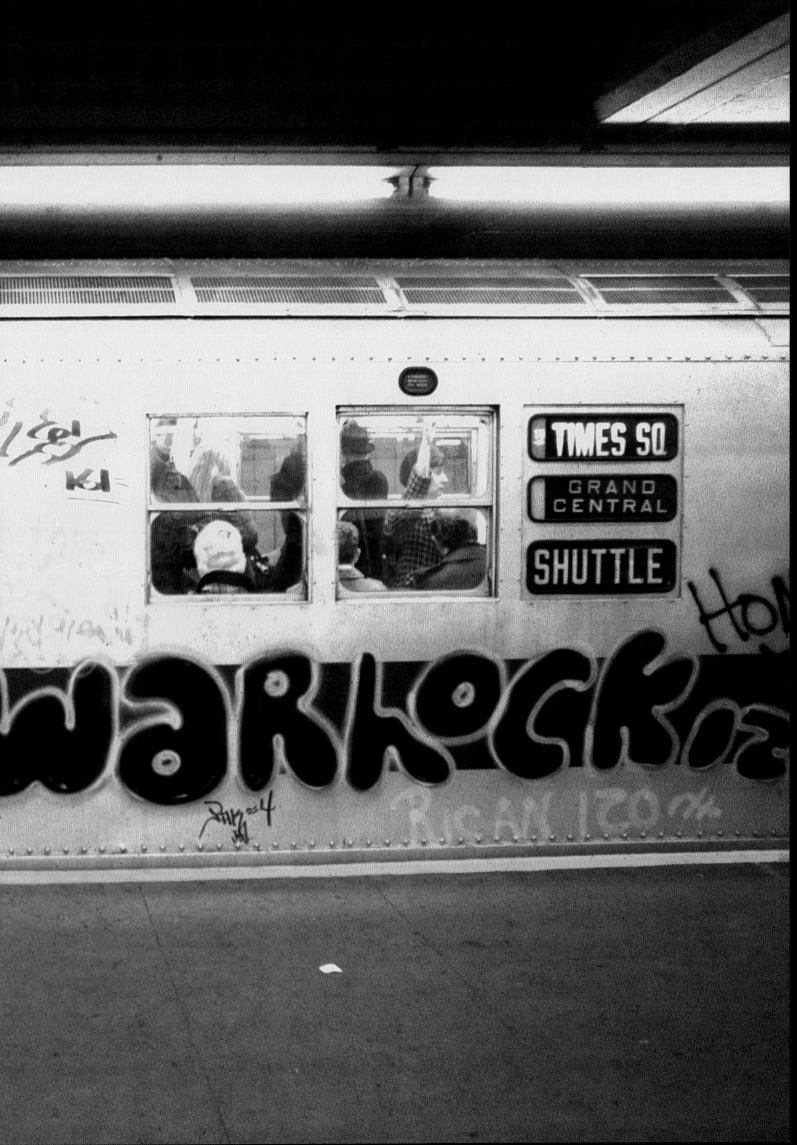

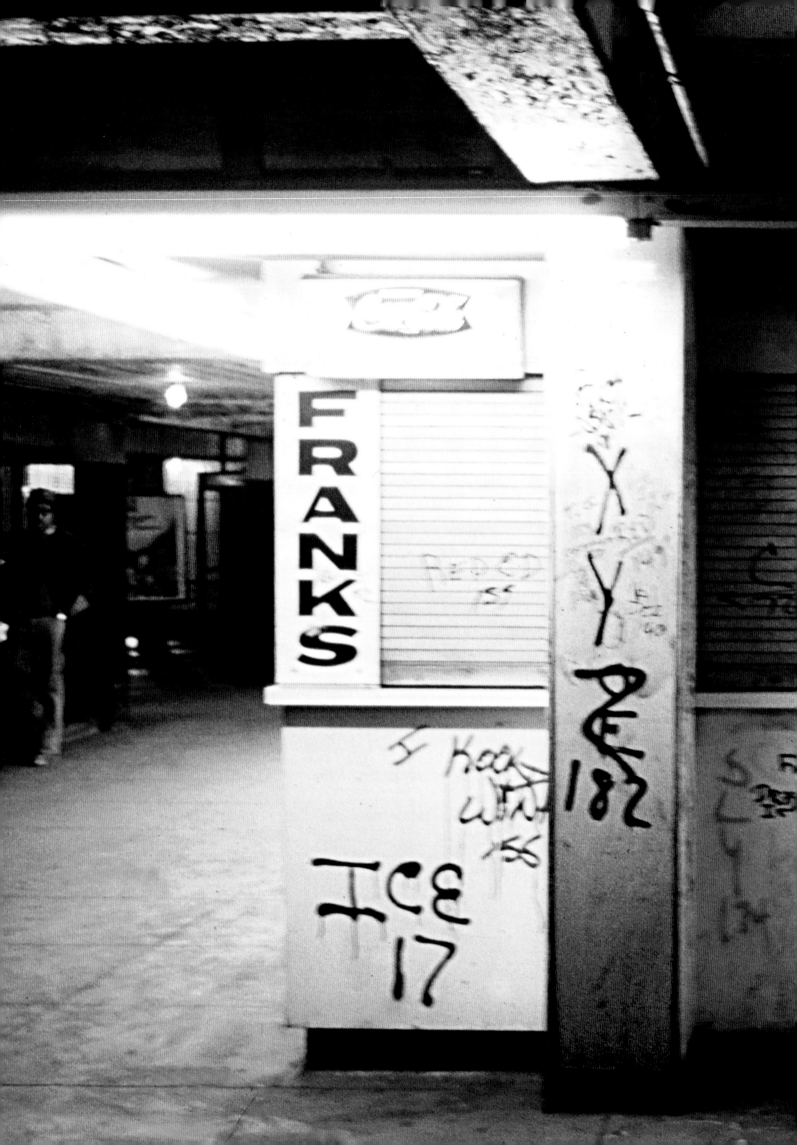

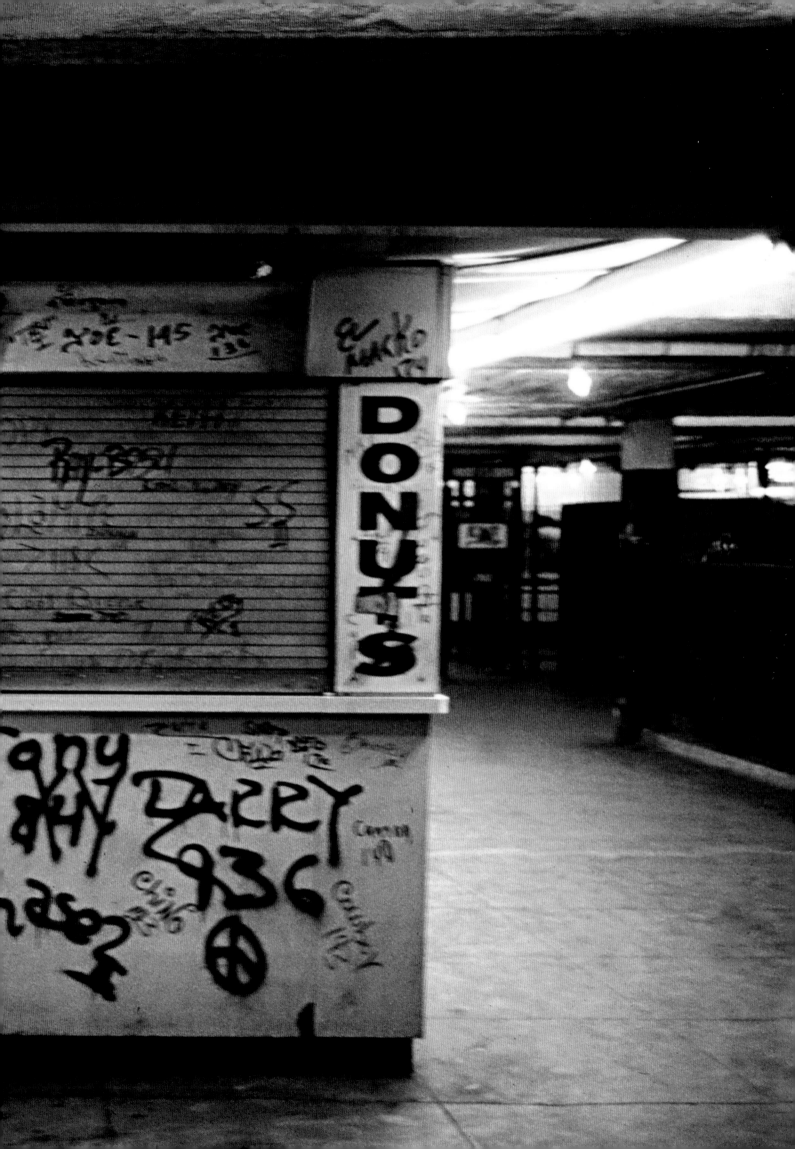

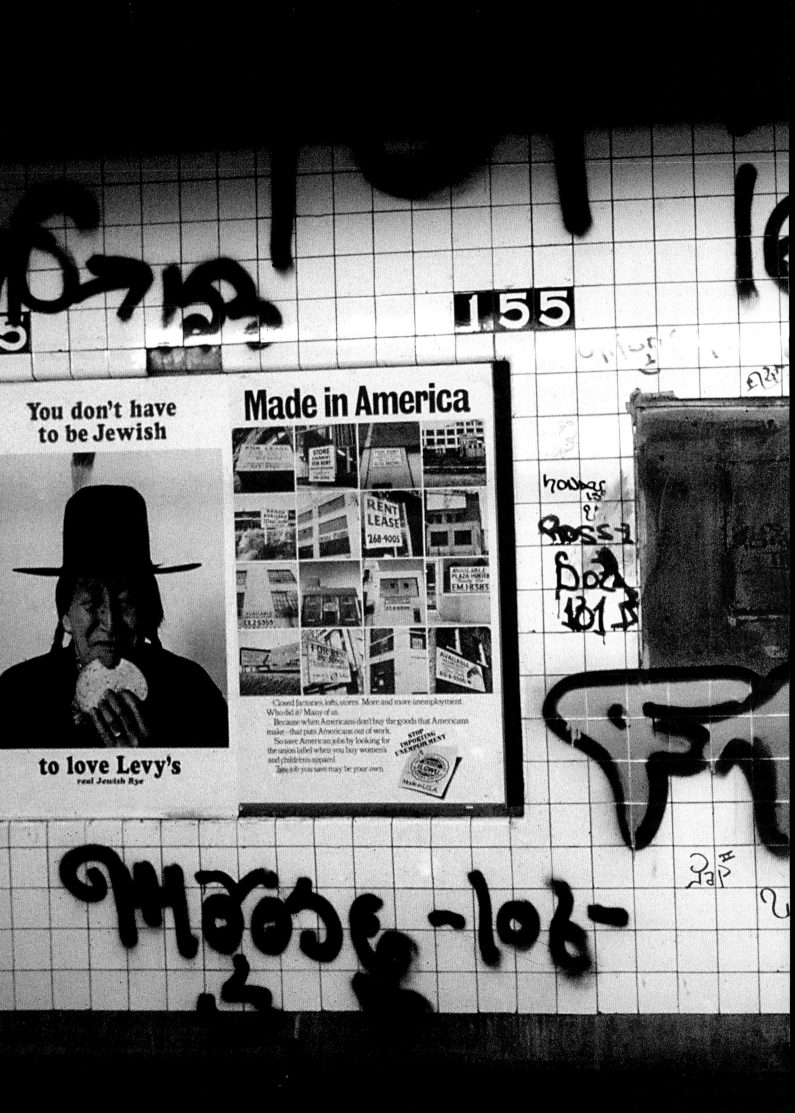

"I got my job through
The New York Times"
First in New York in job advertising

Bookkeeping Assistant

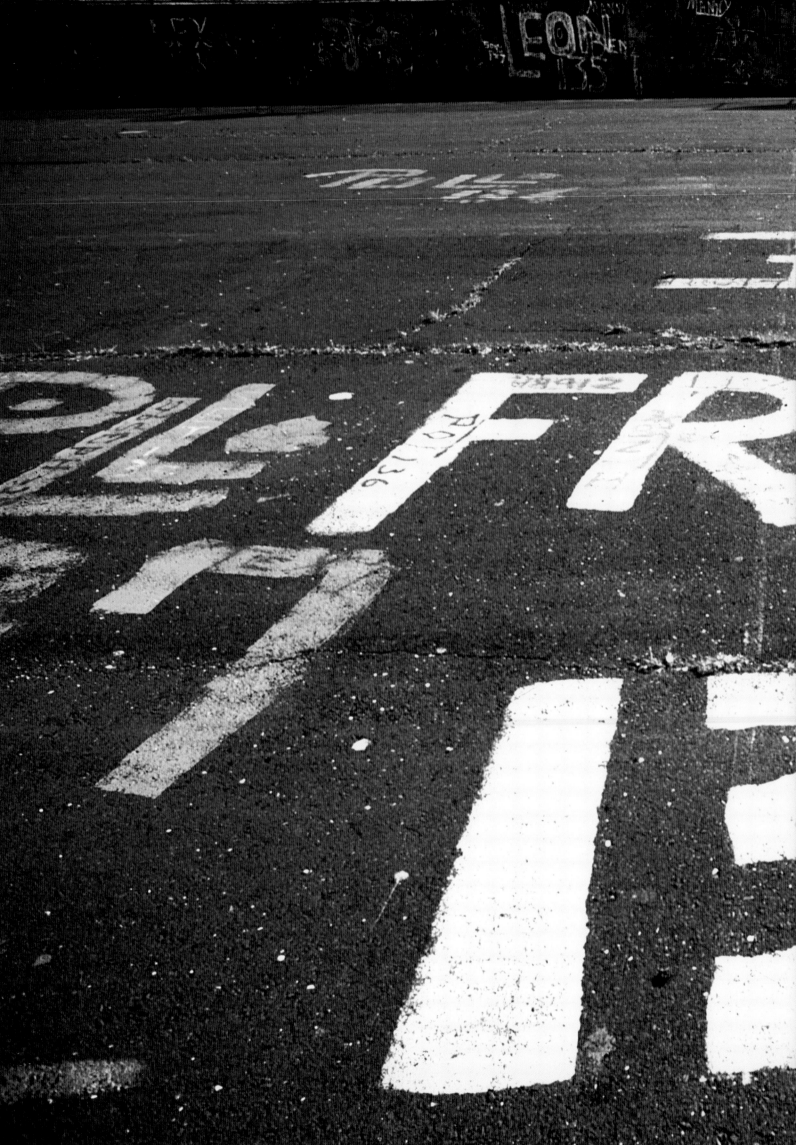

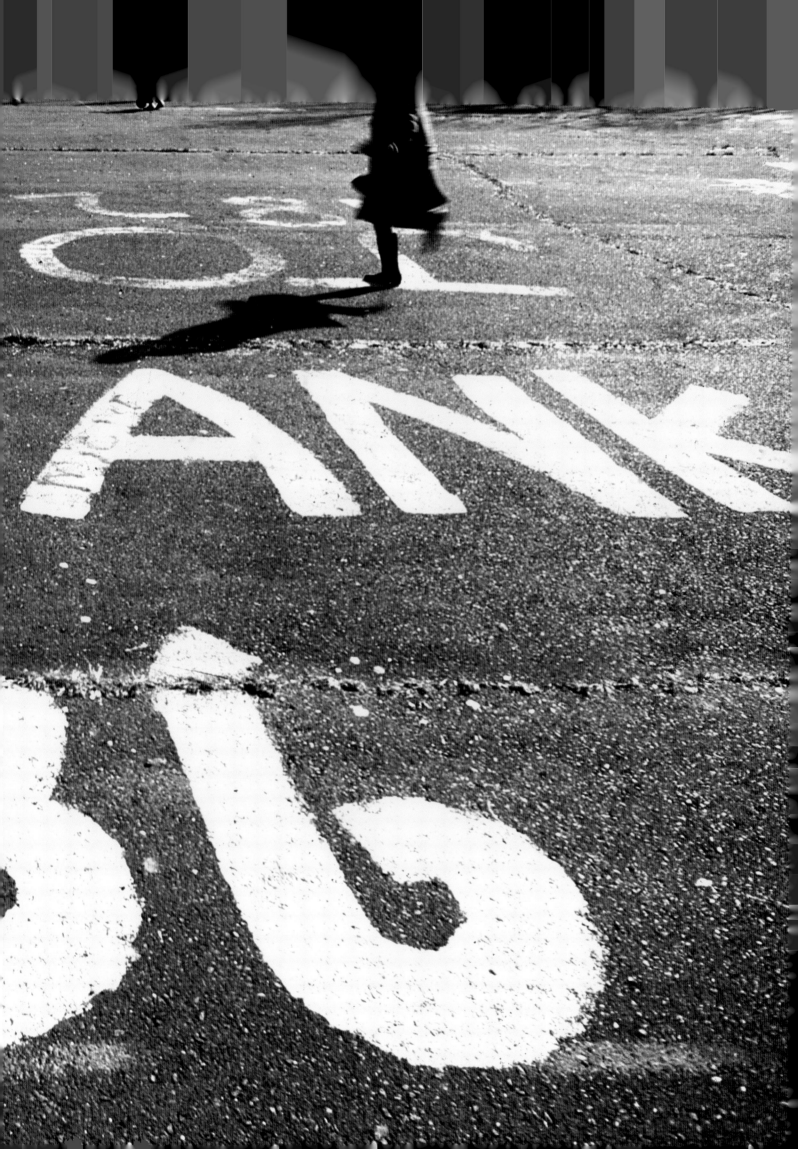

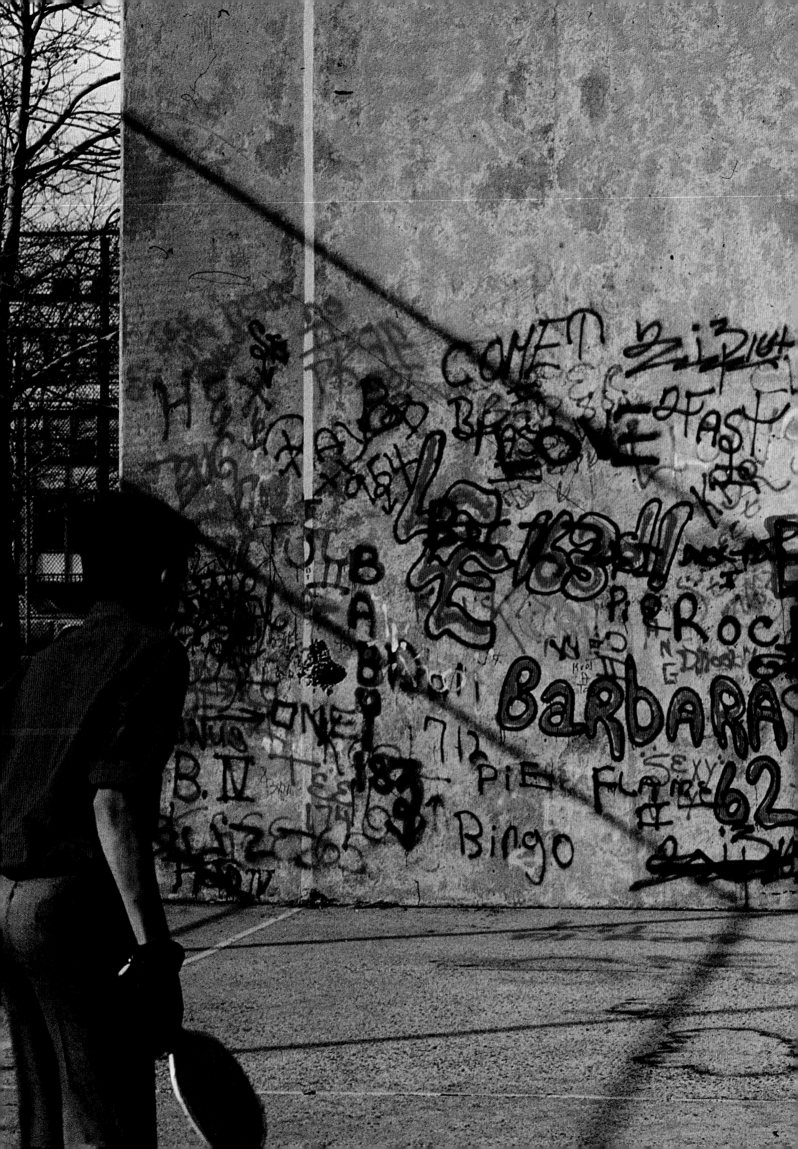

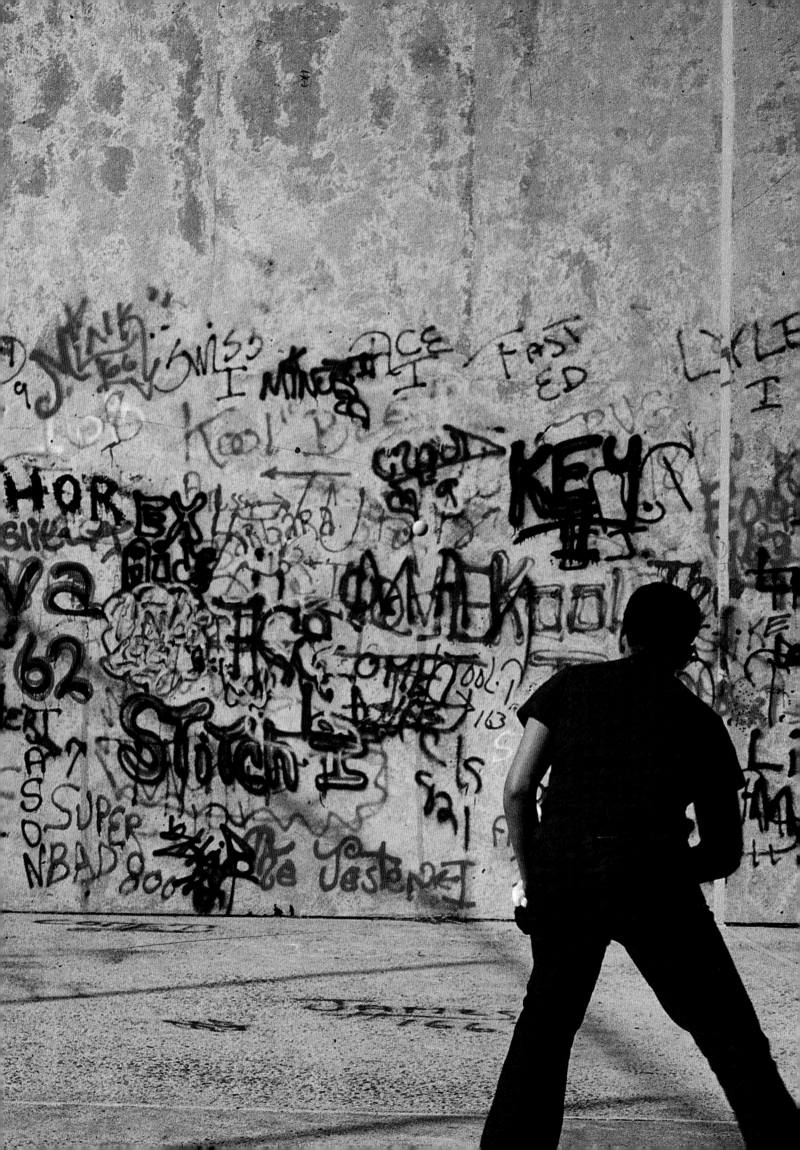

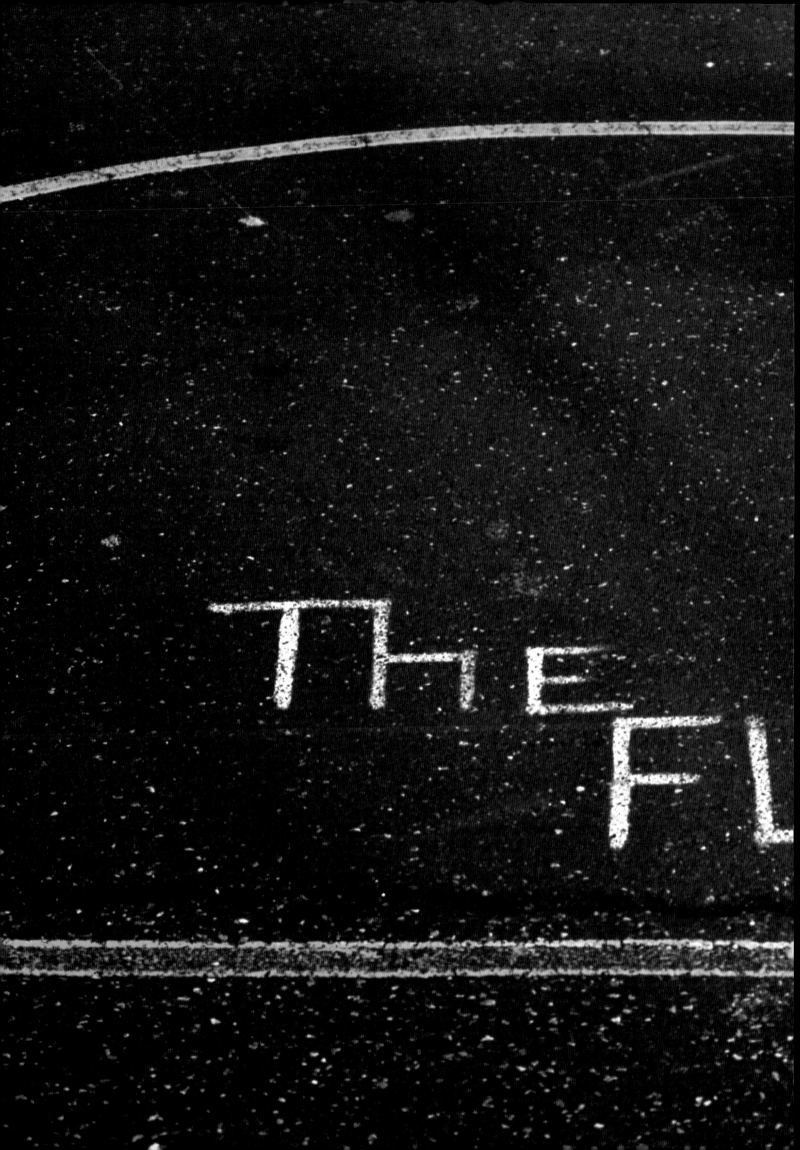

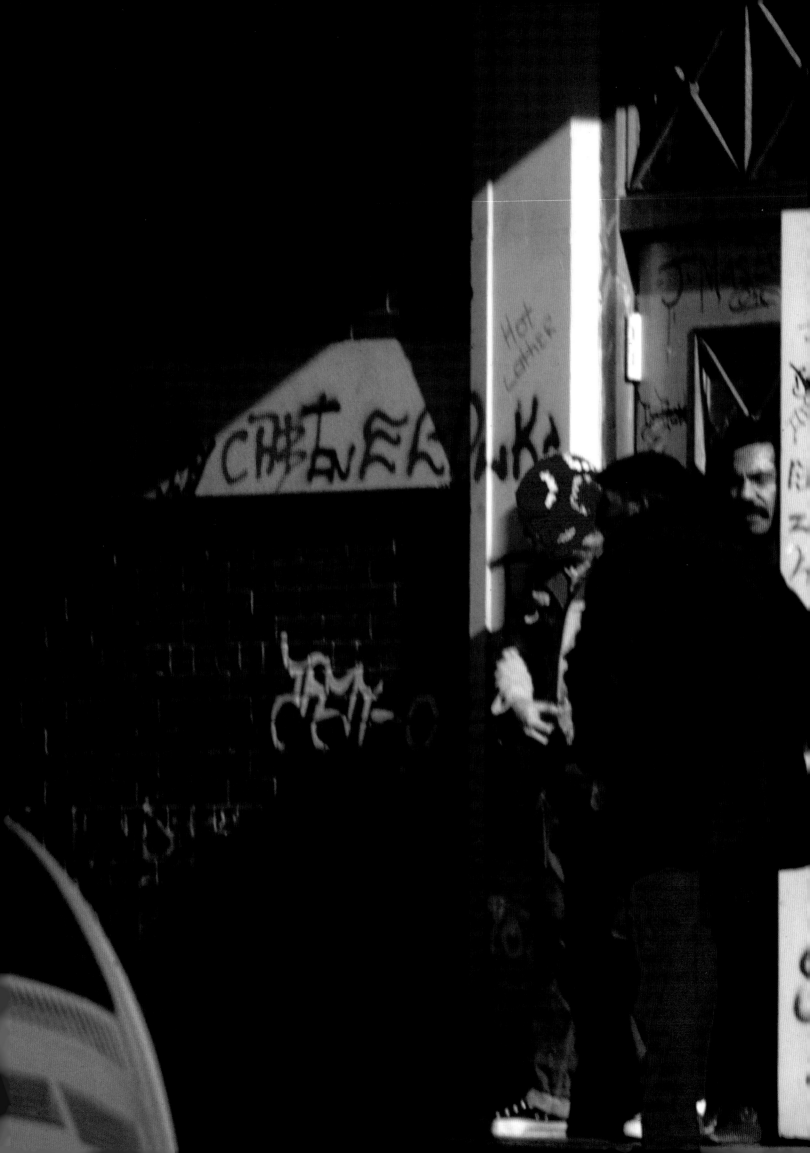

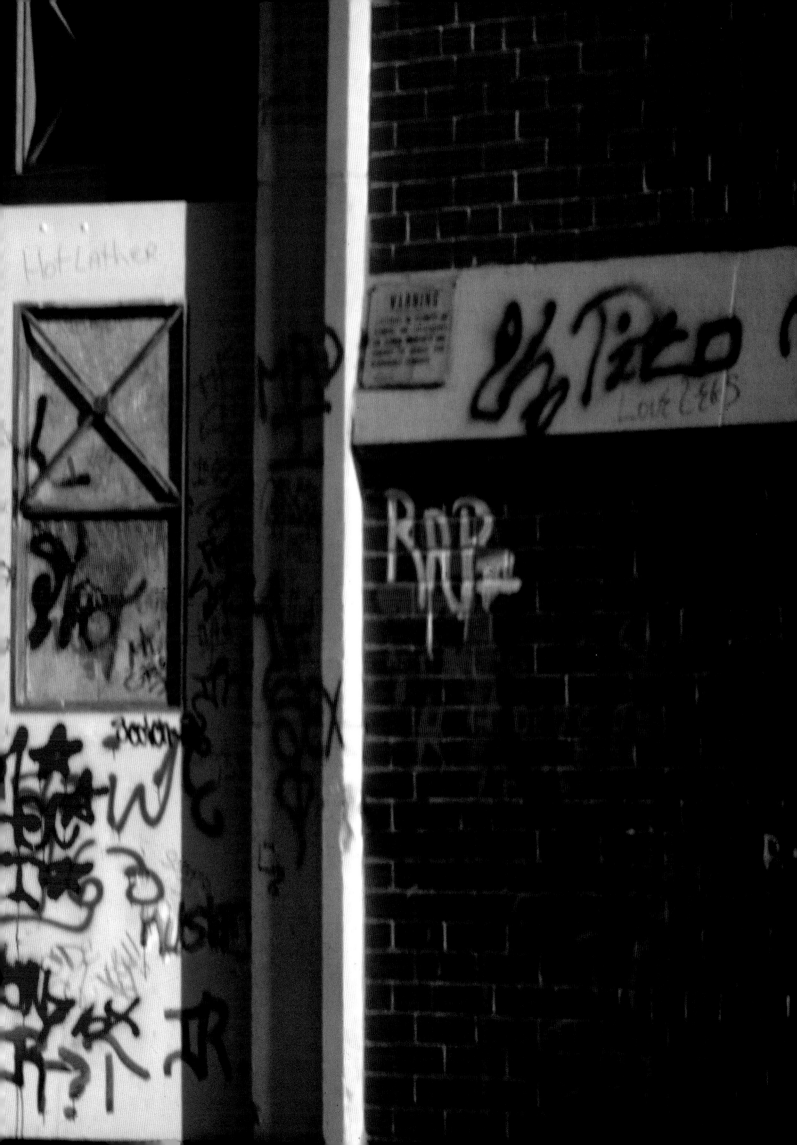

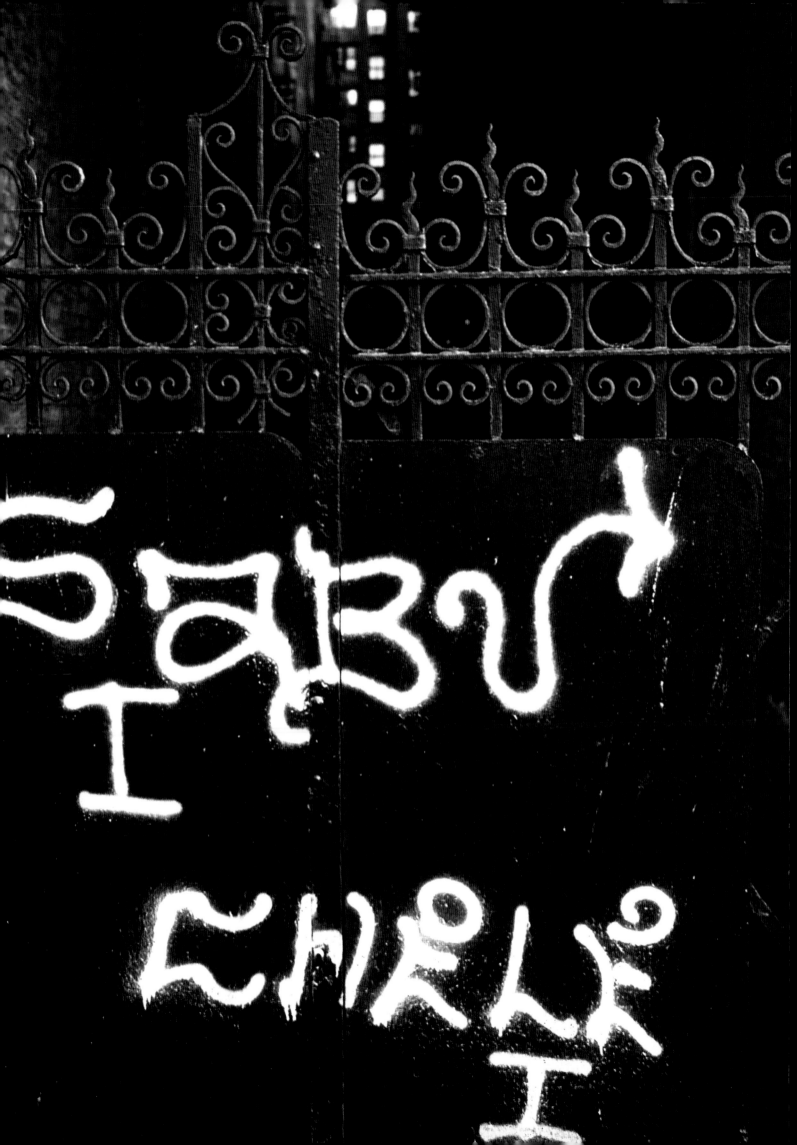

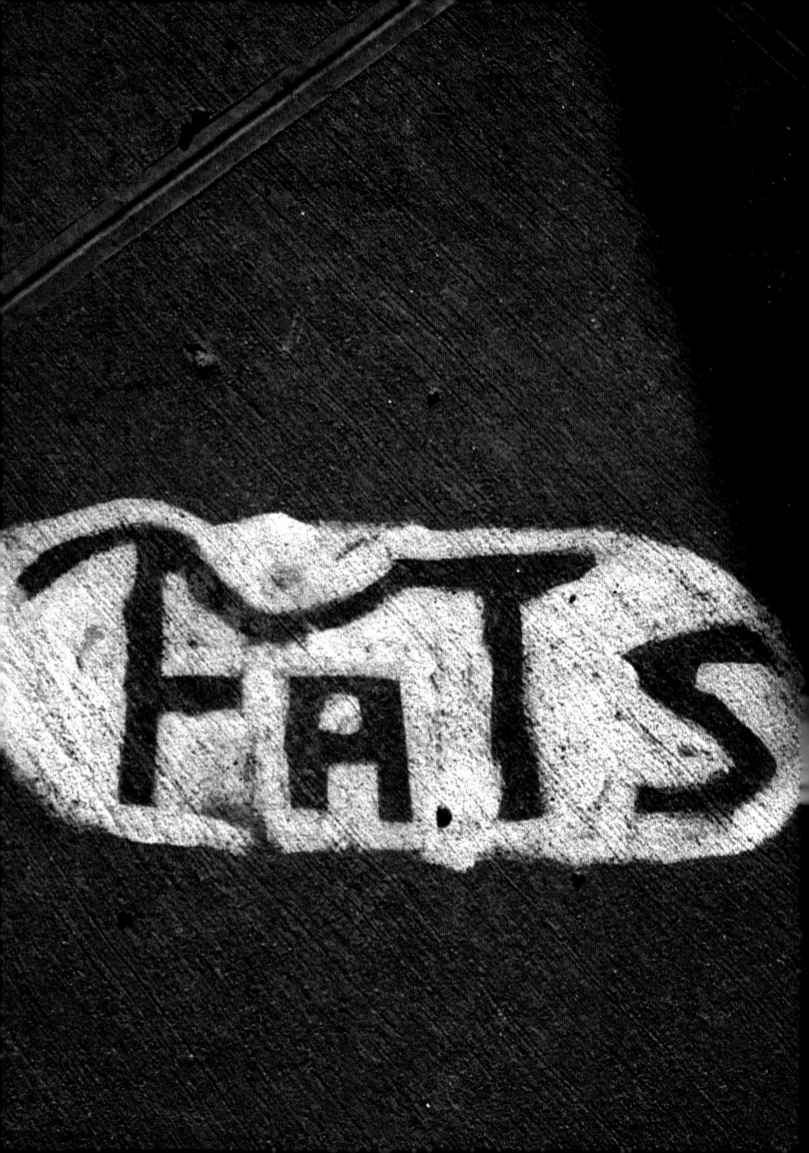

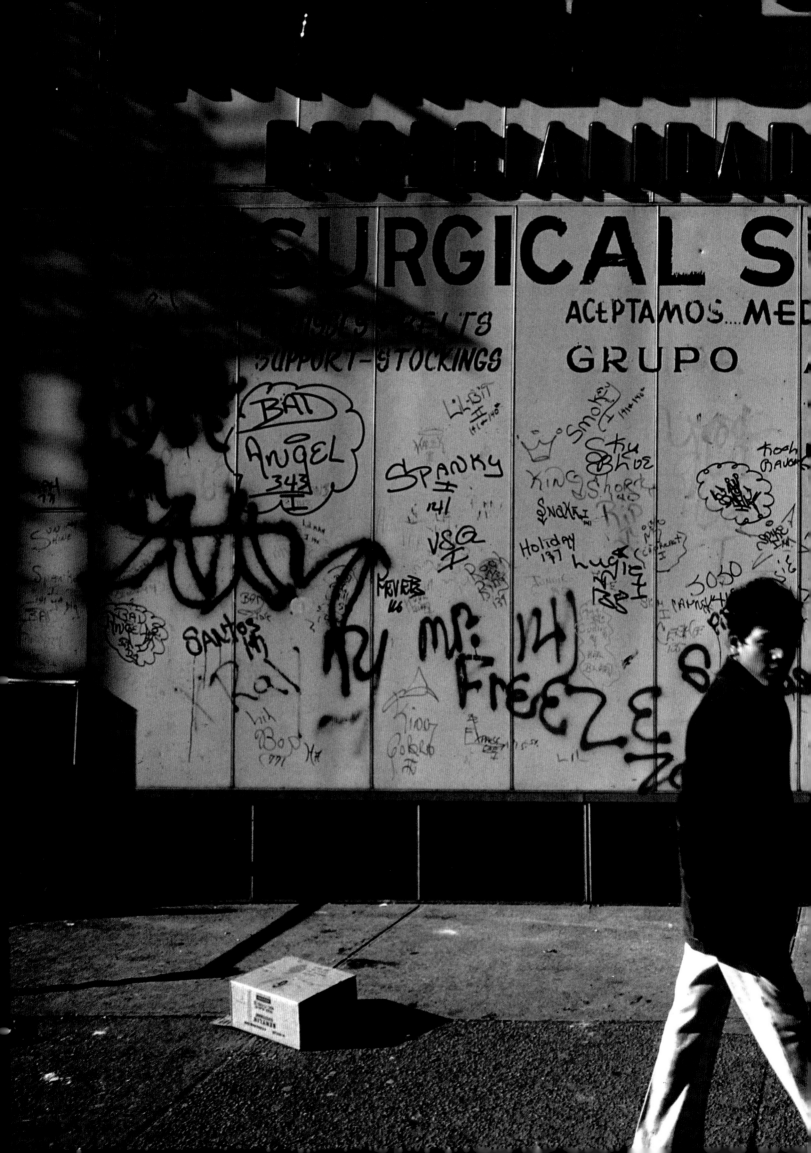

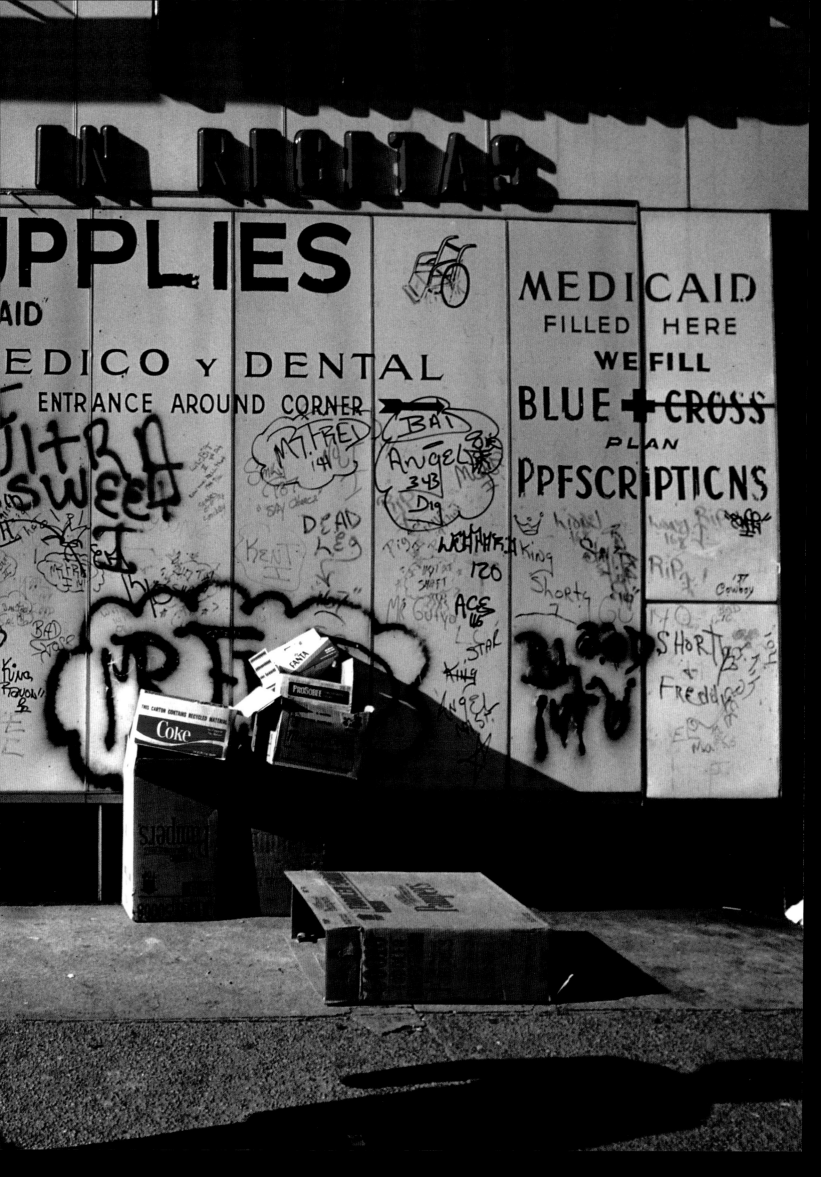

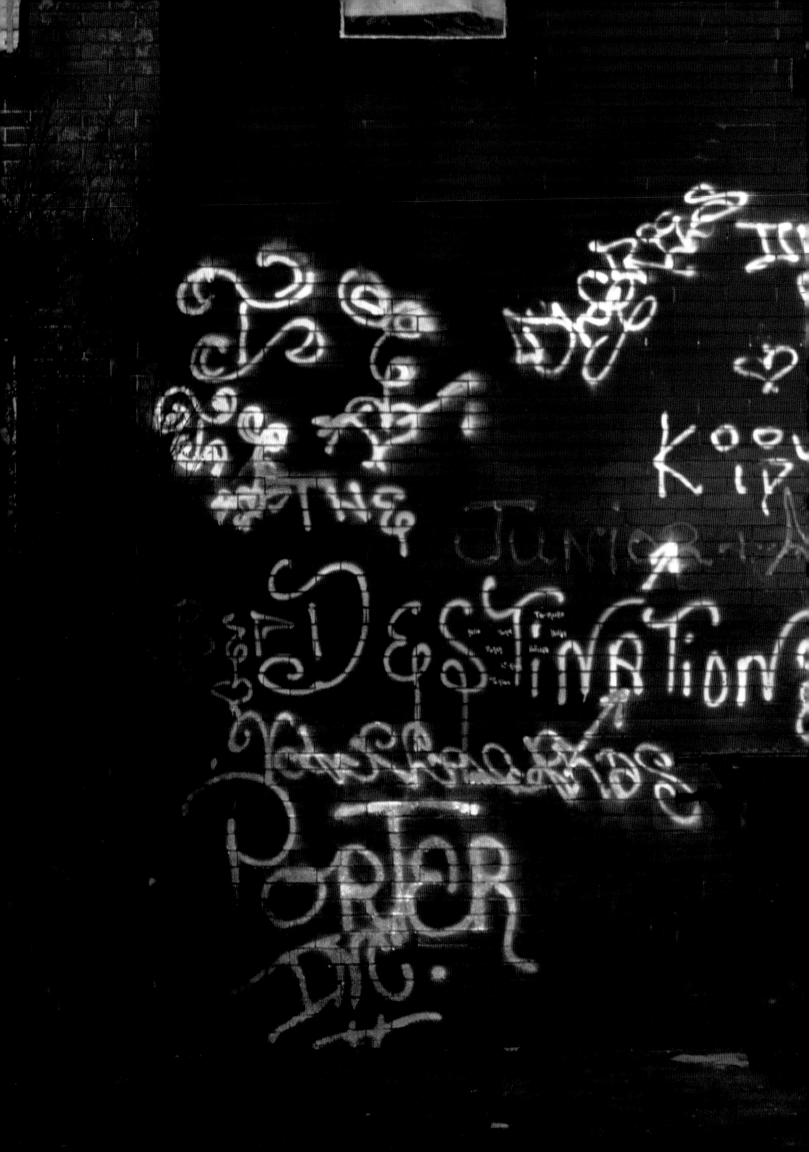

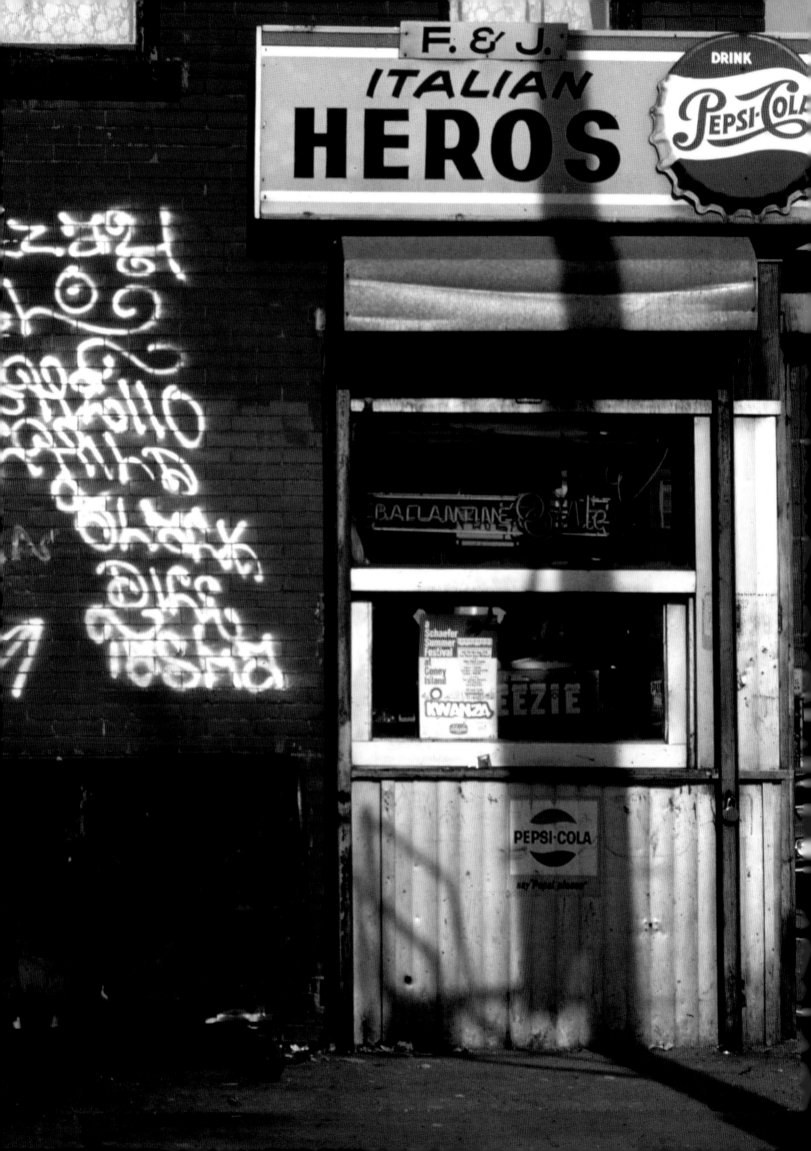

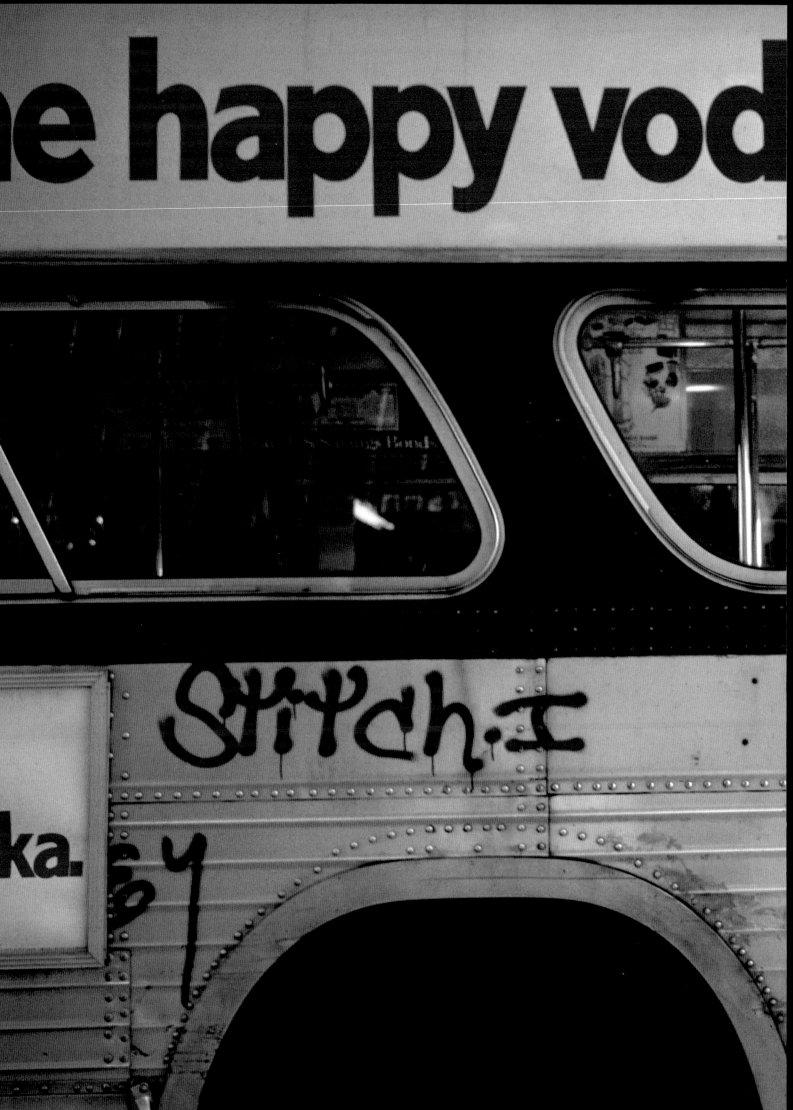

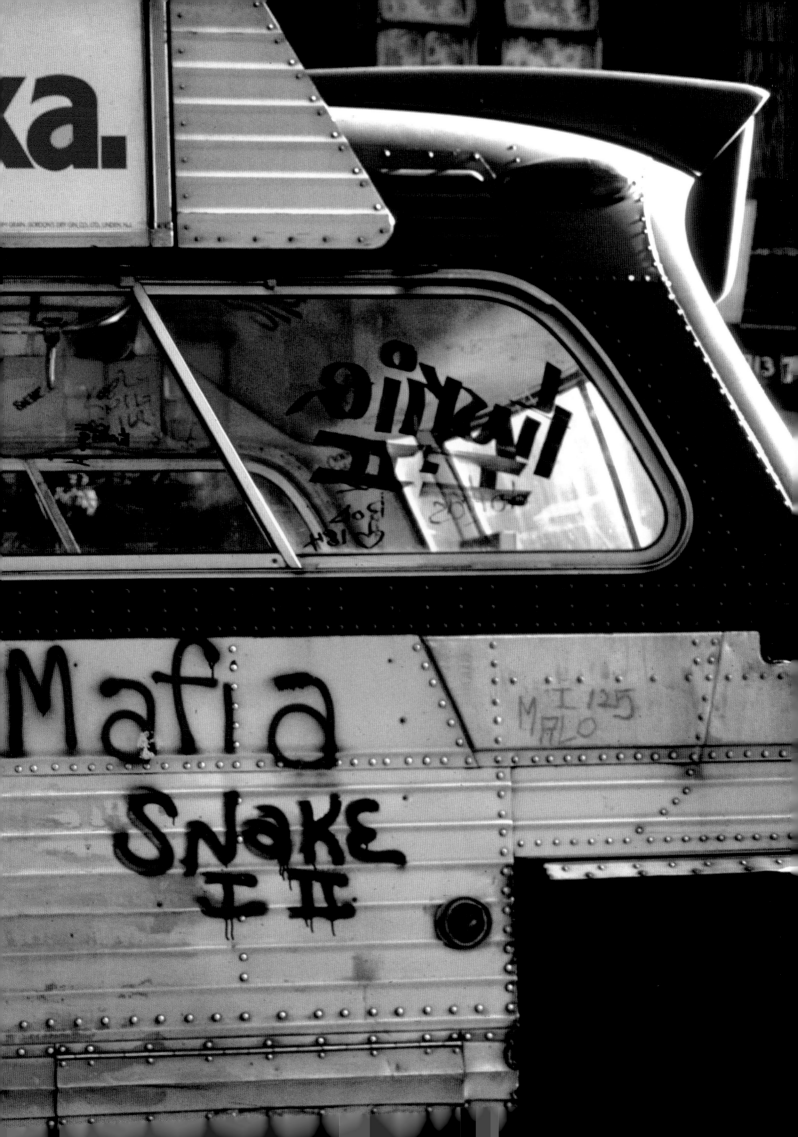

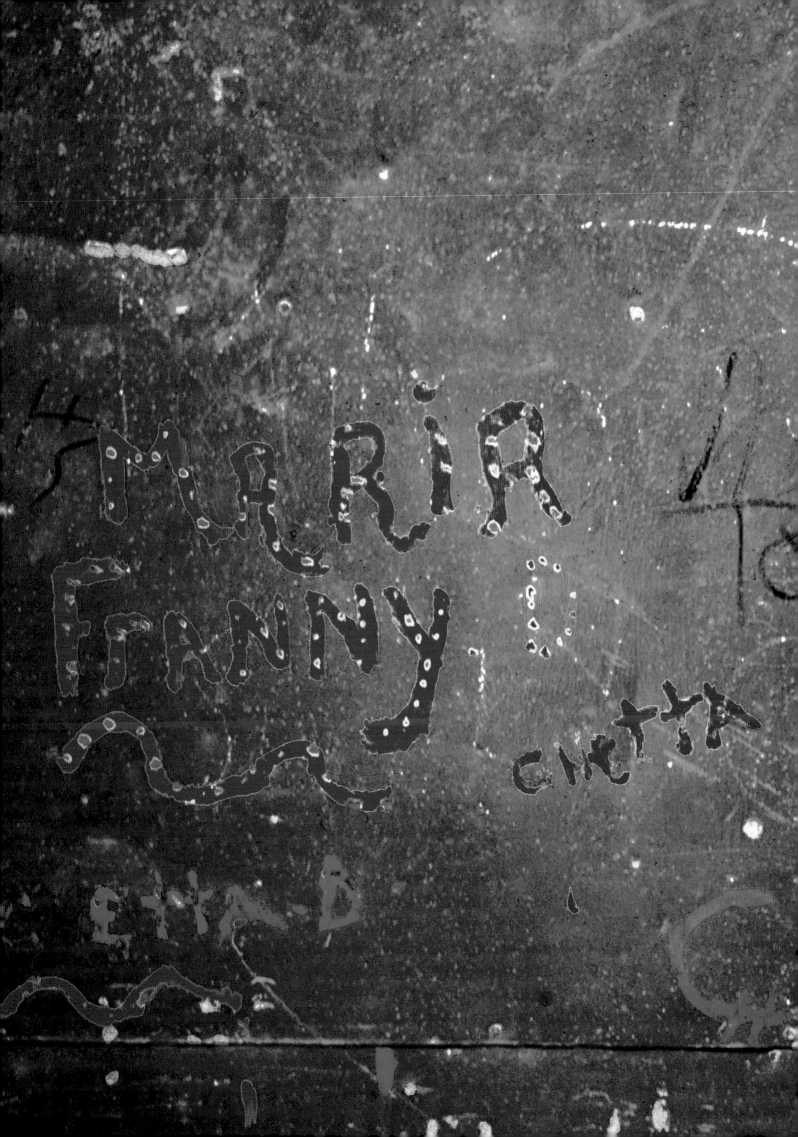

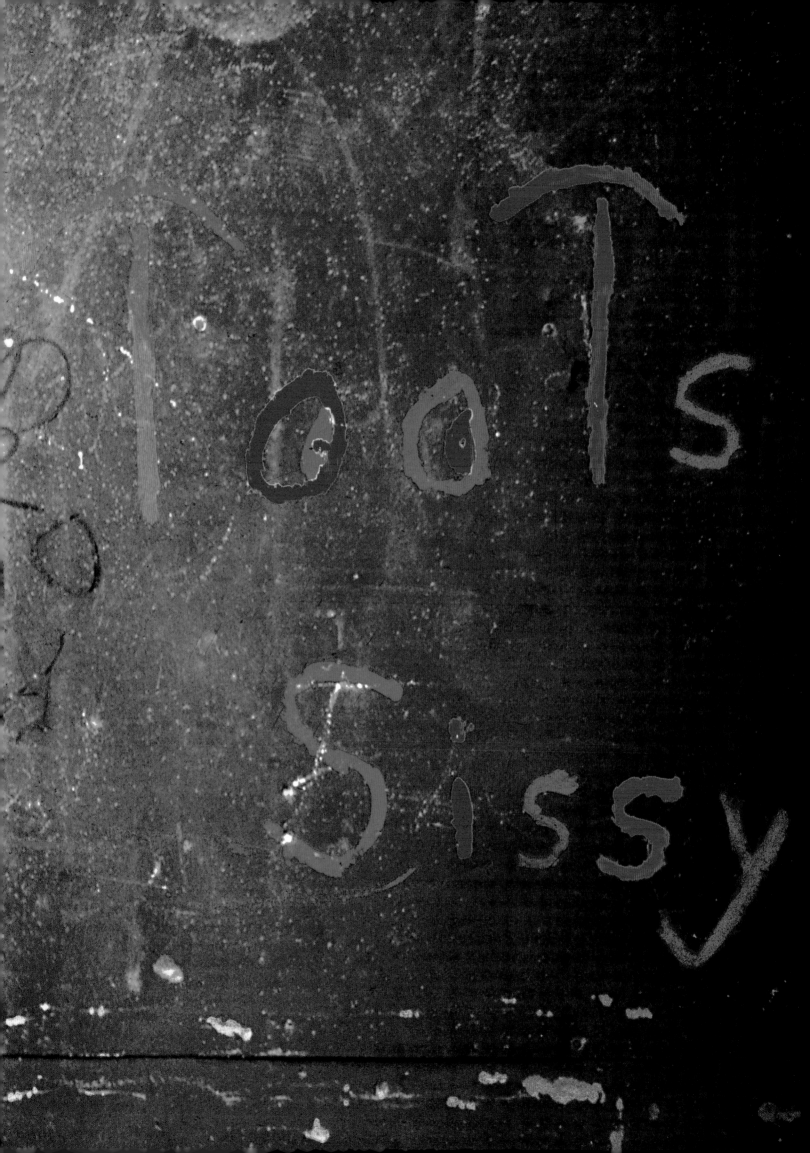

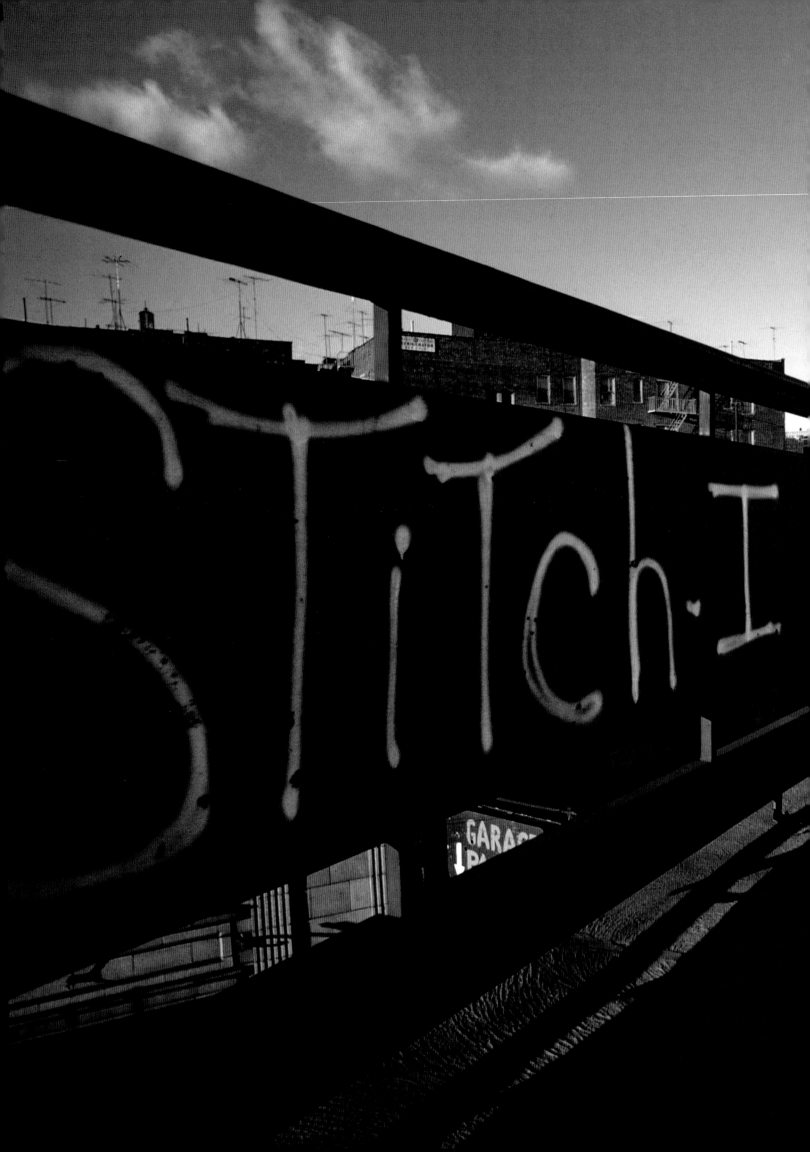

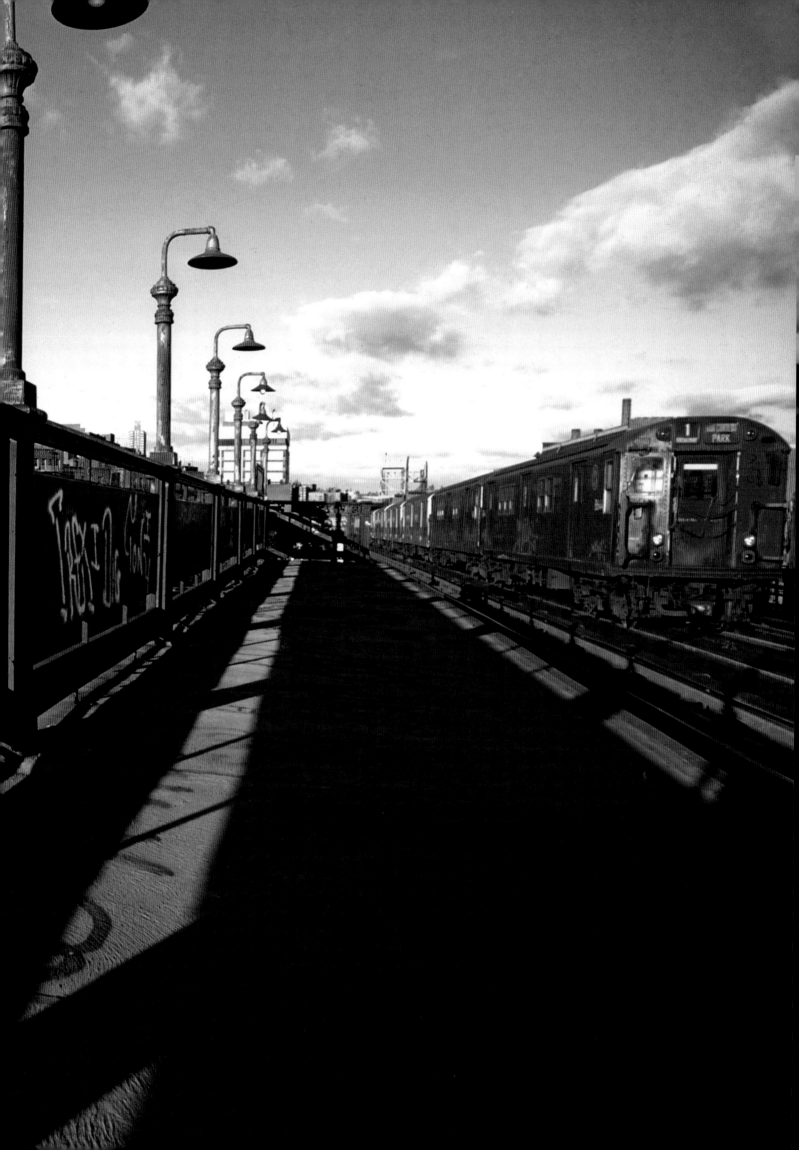

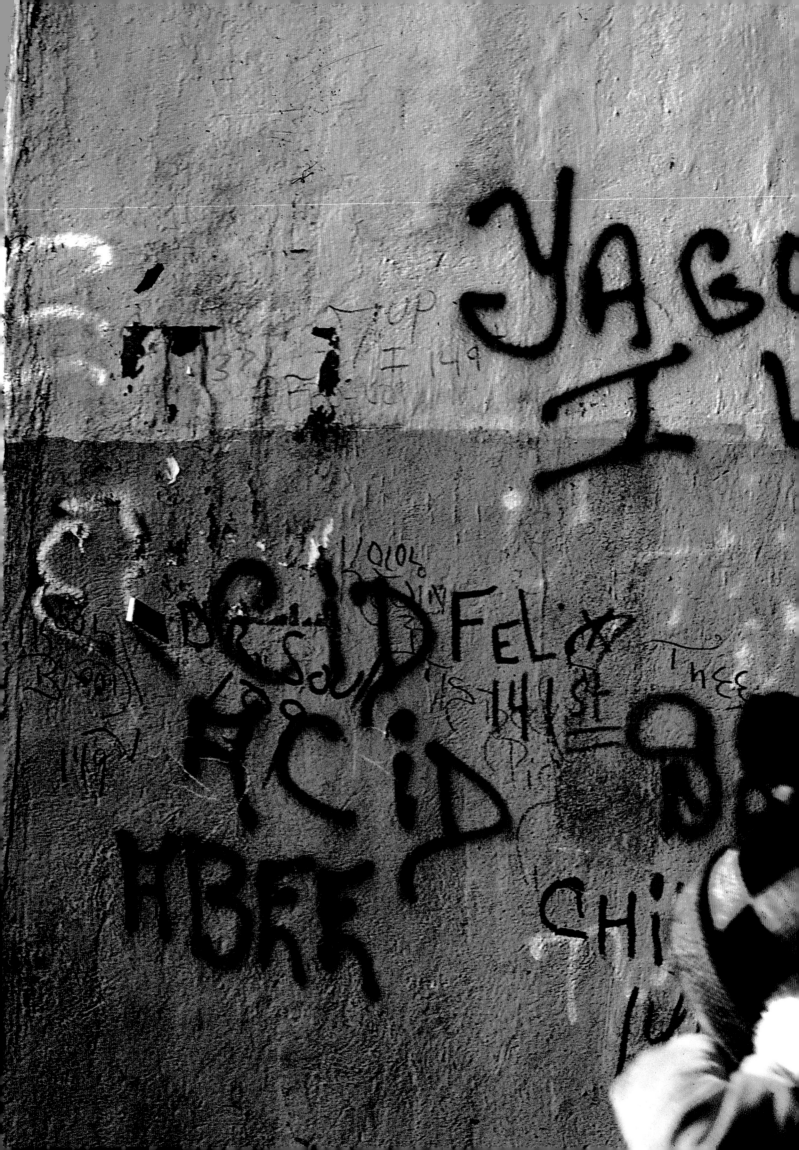

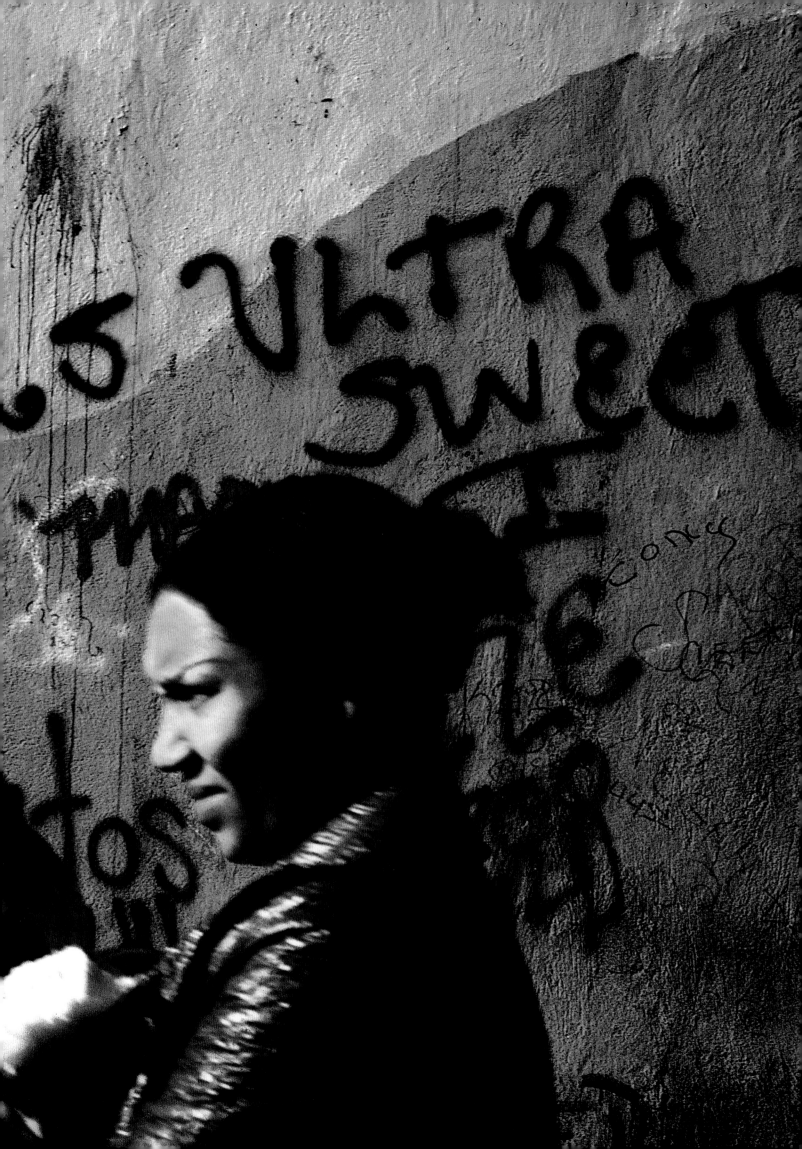

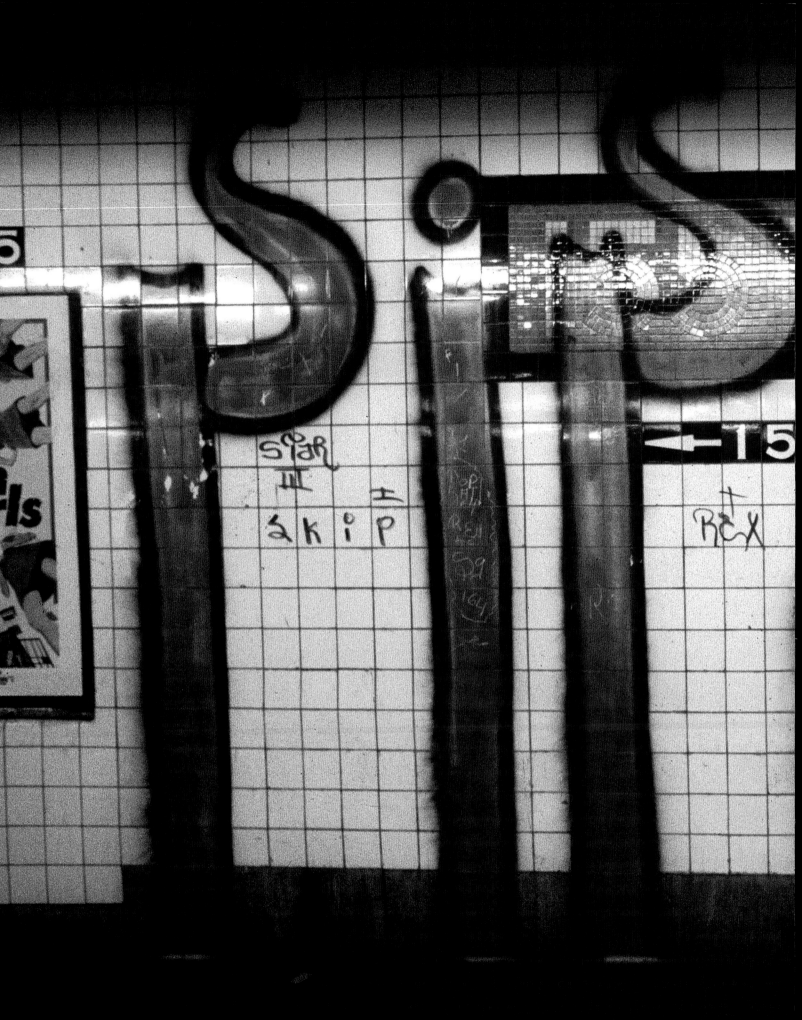

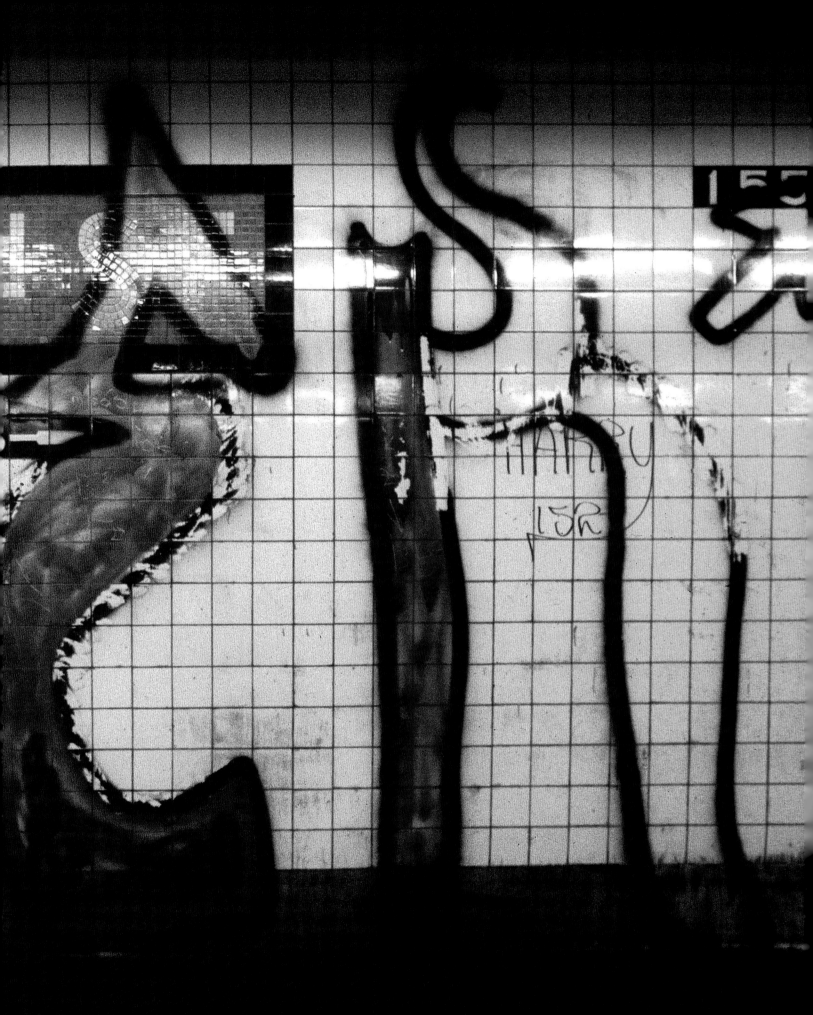

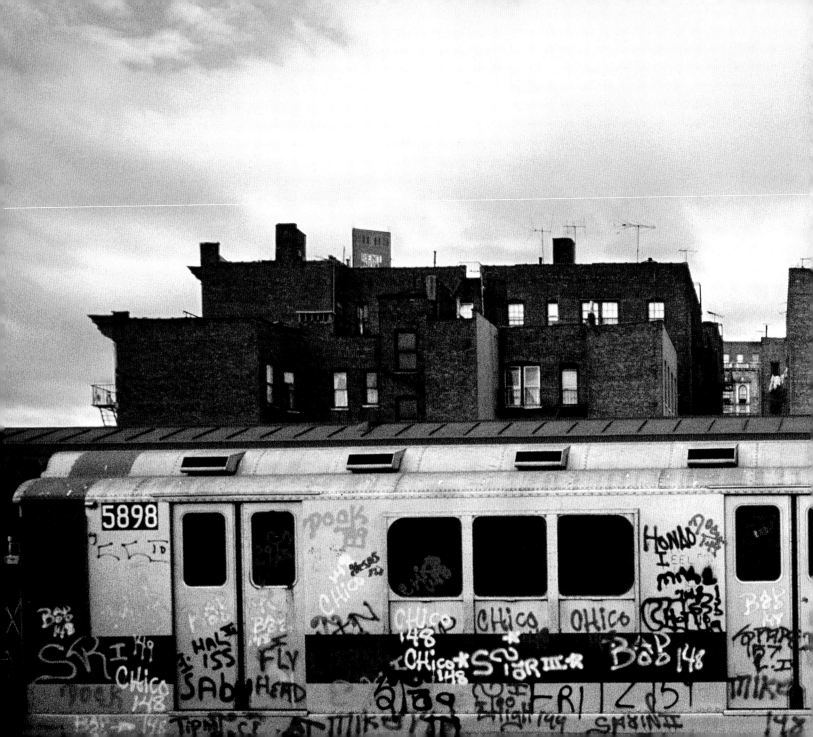

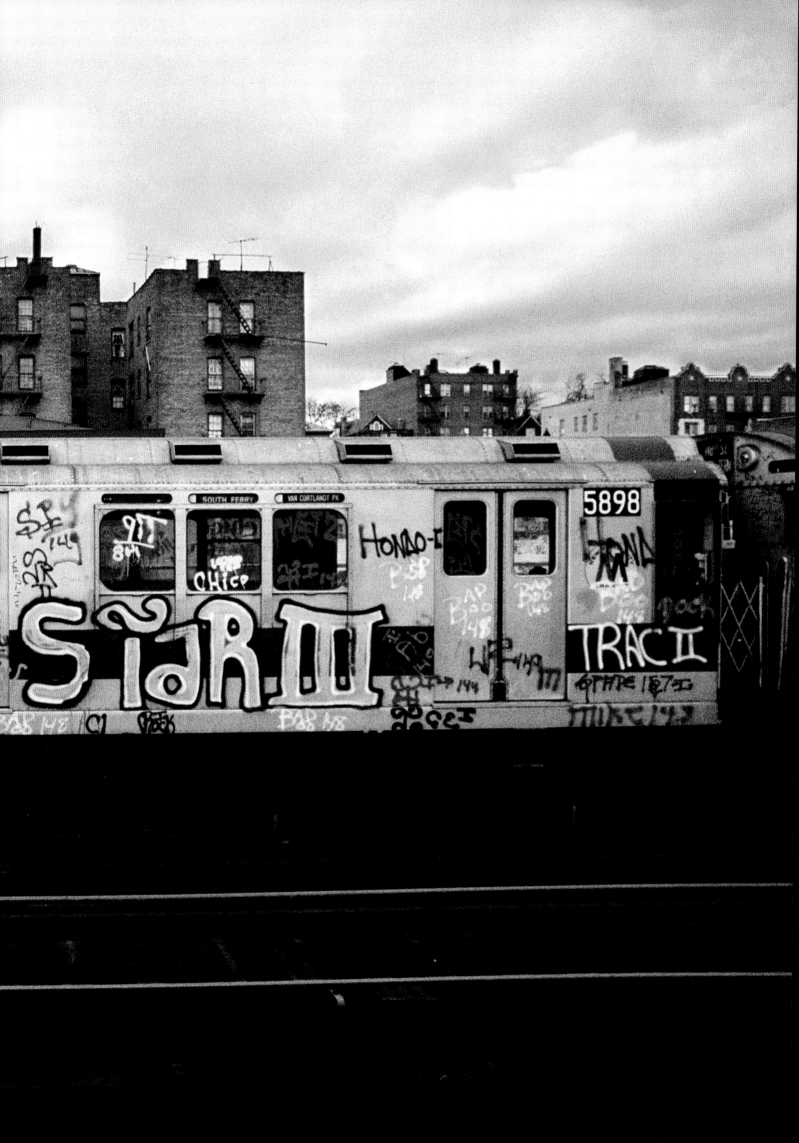

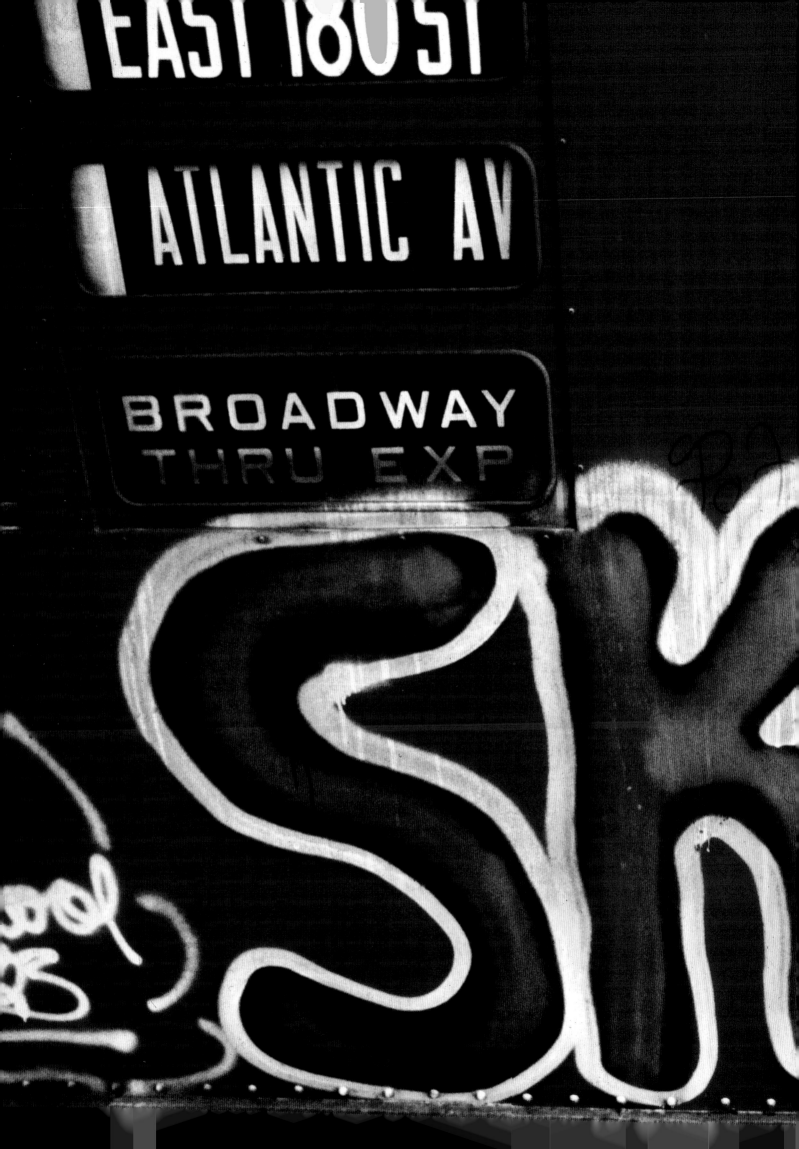

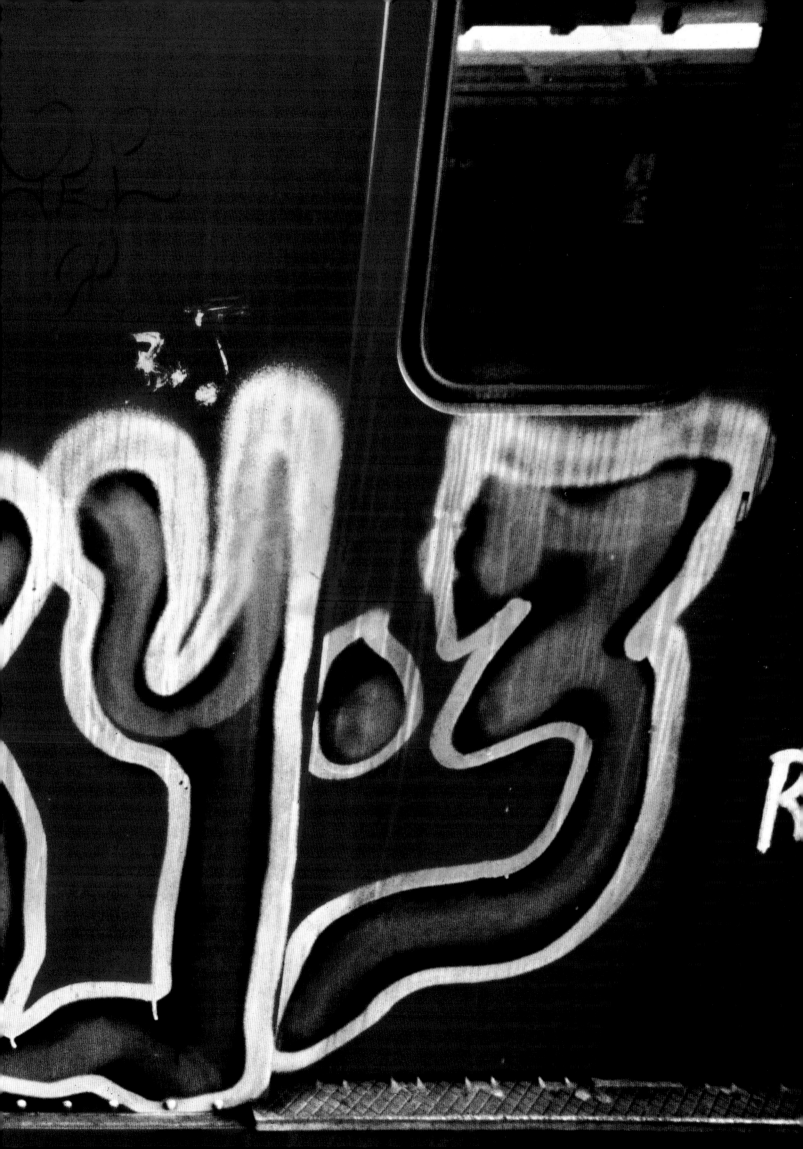

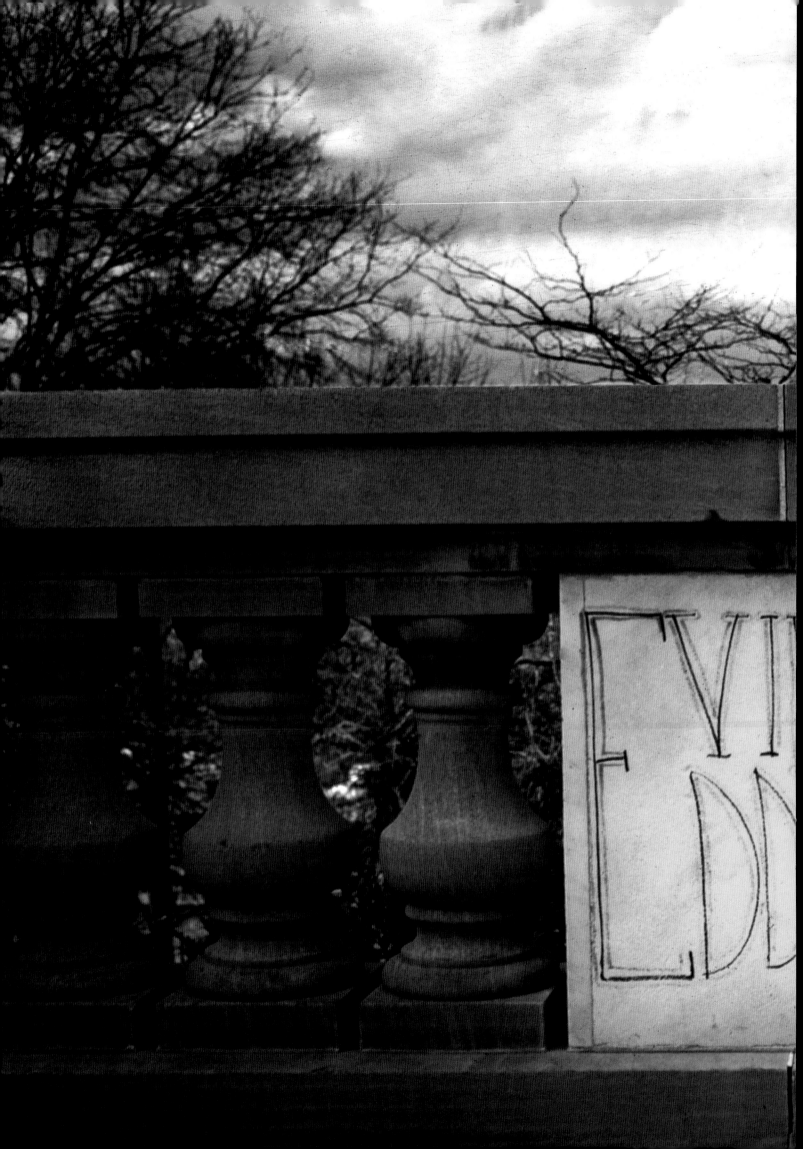

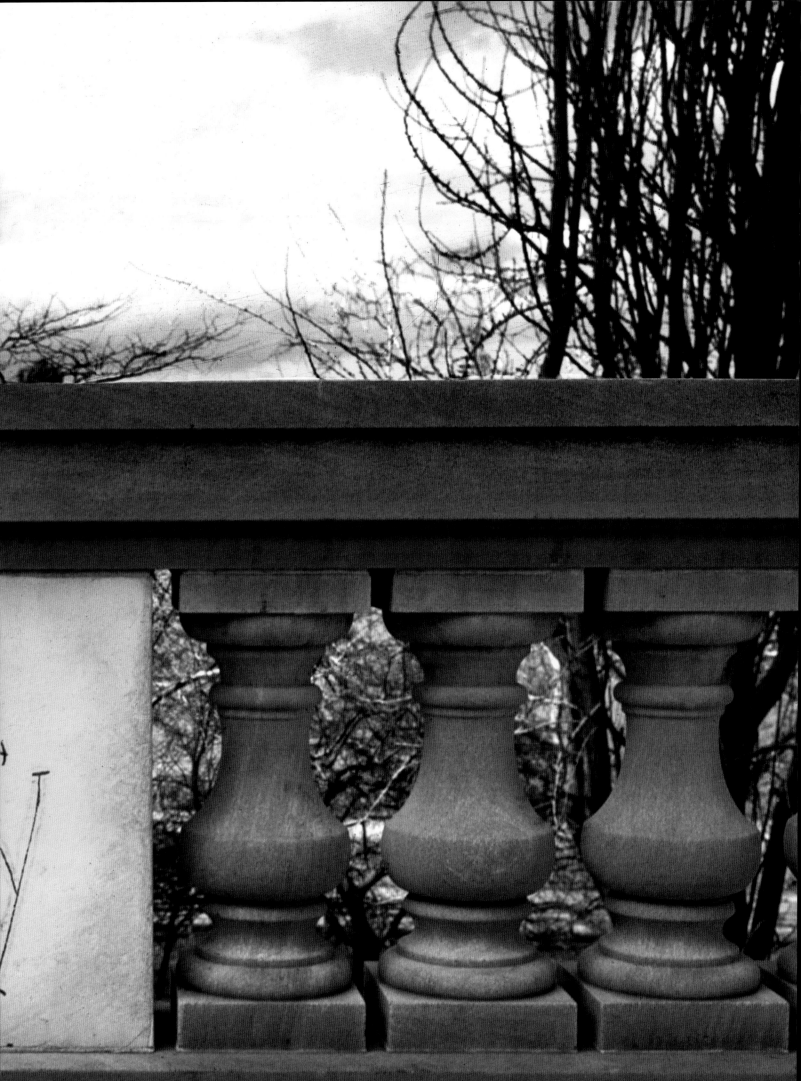

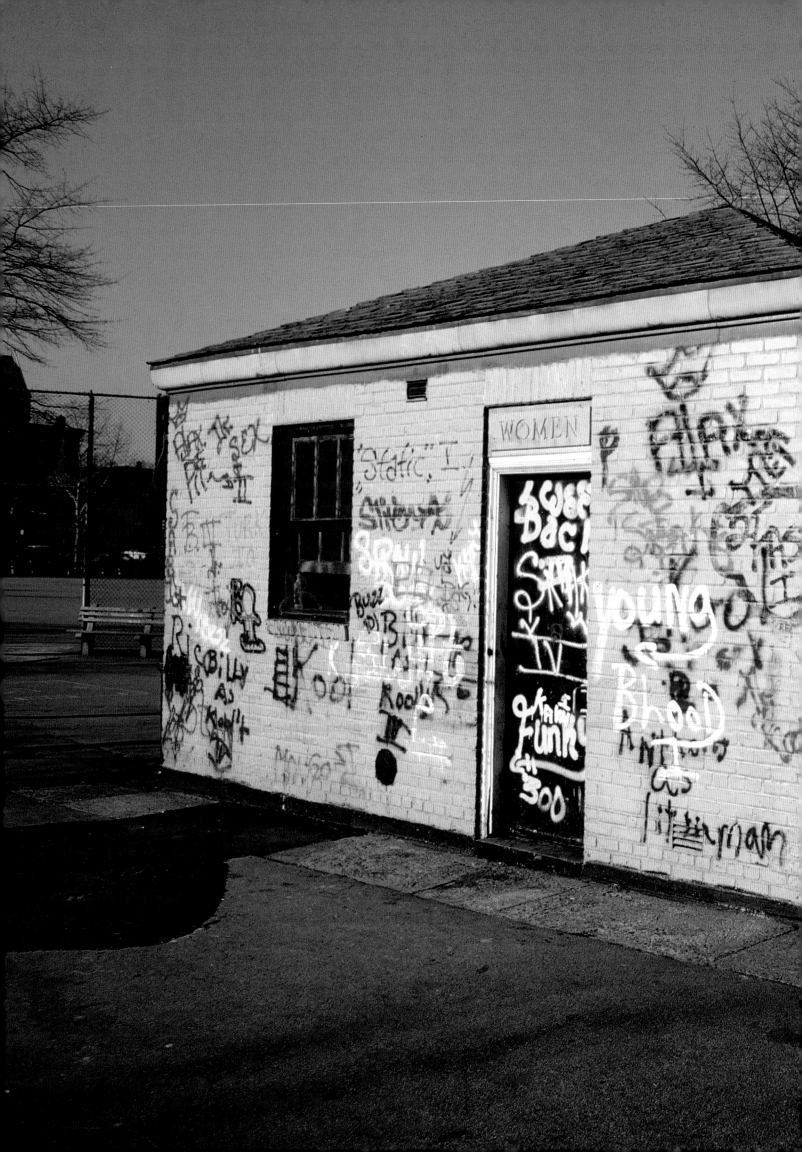

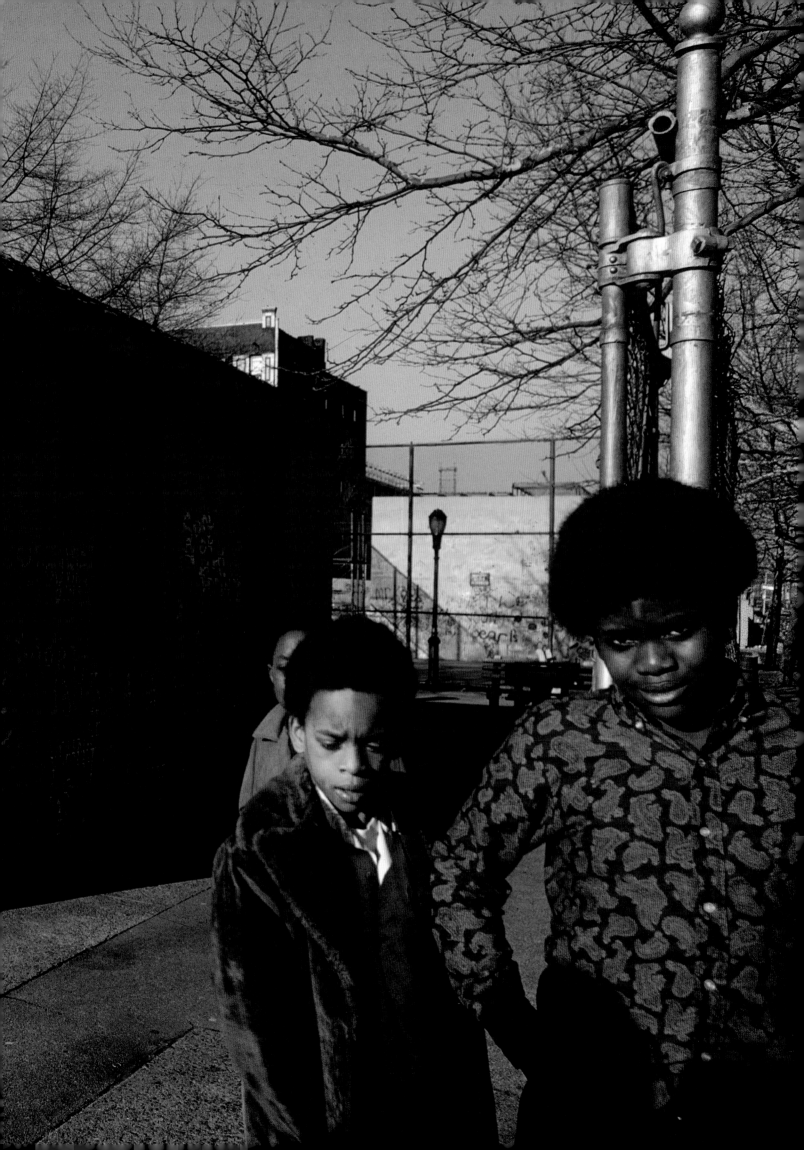

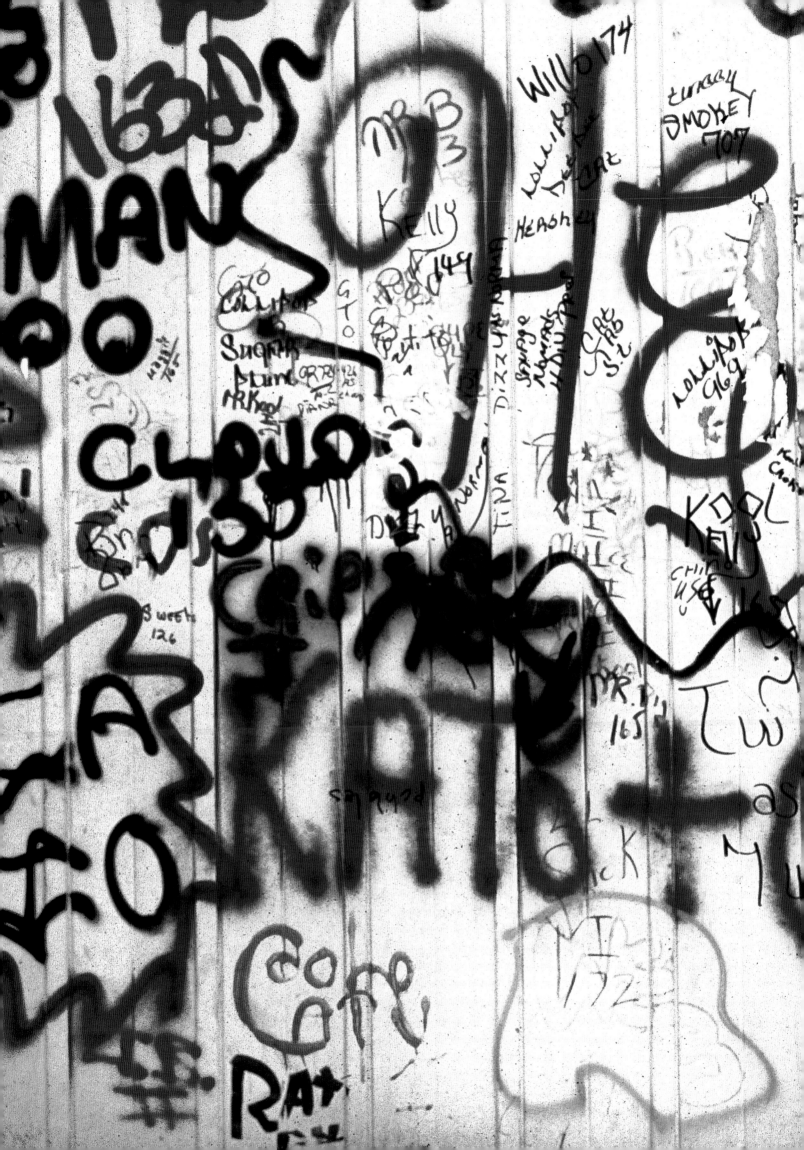

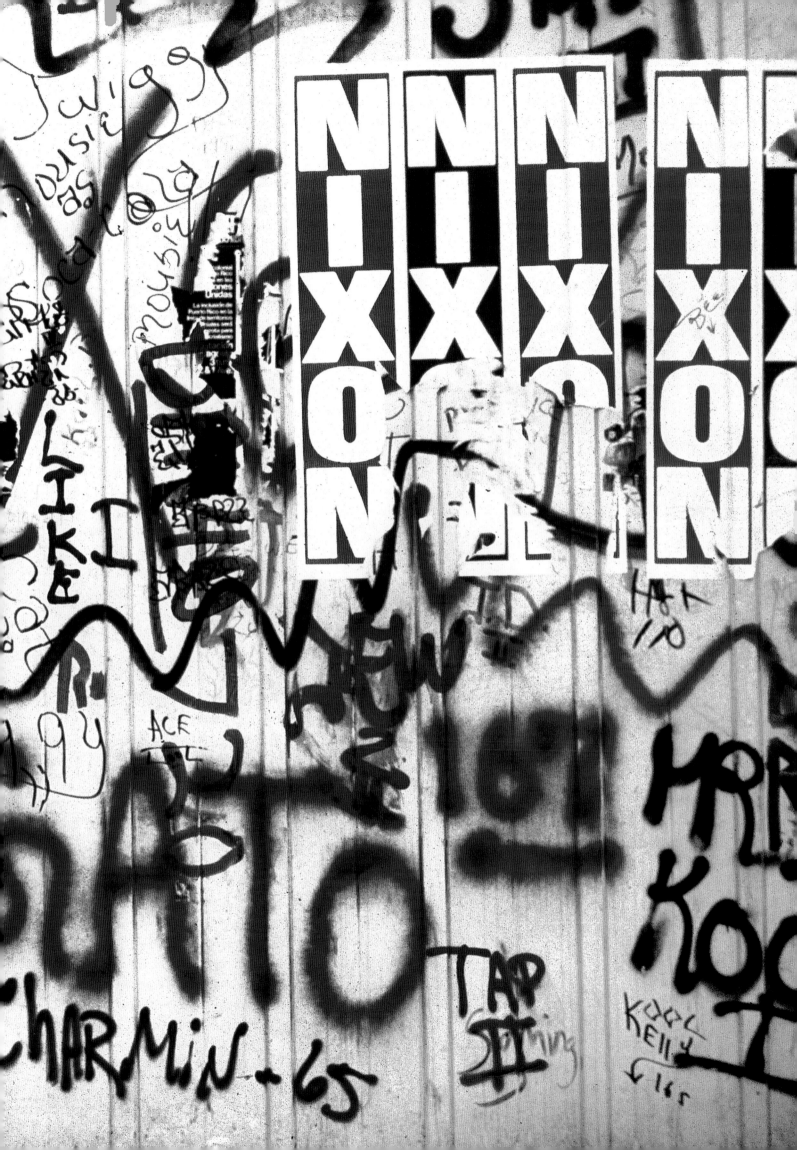

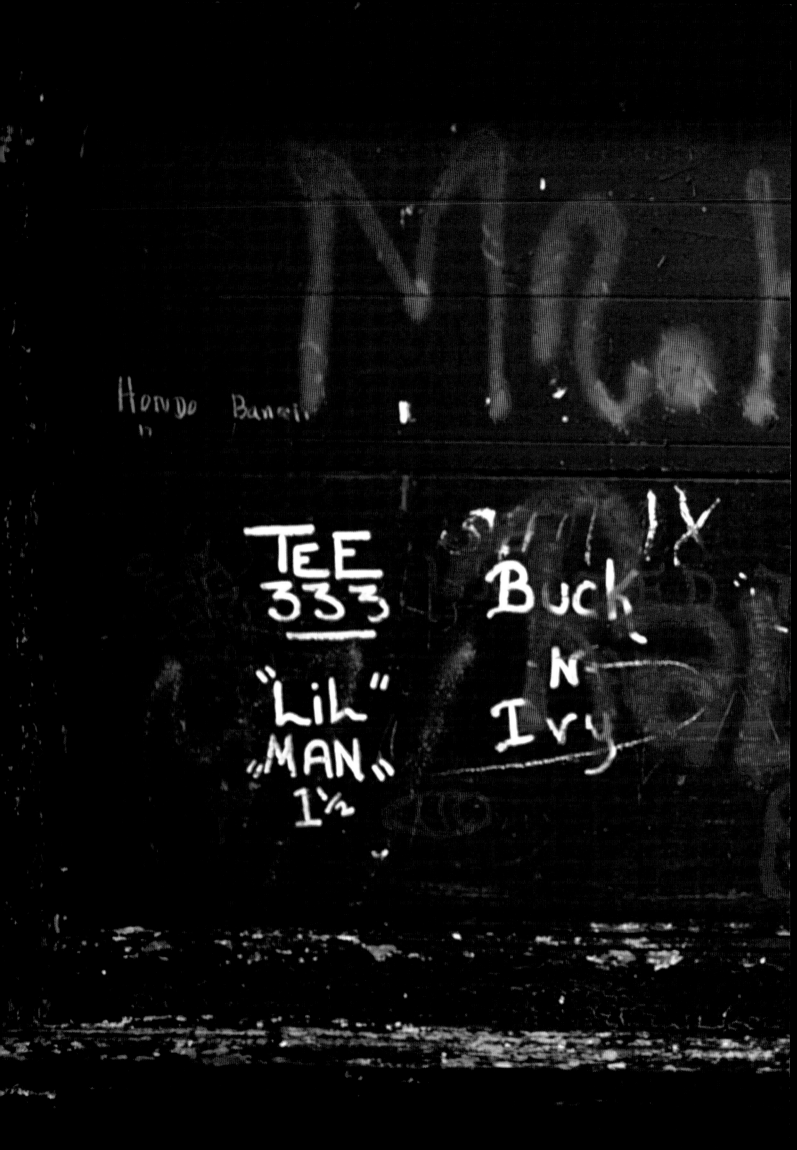

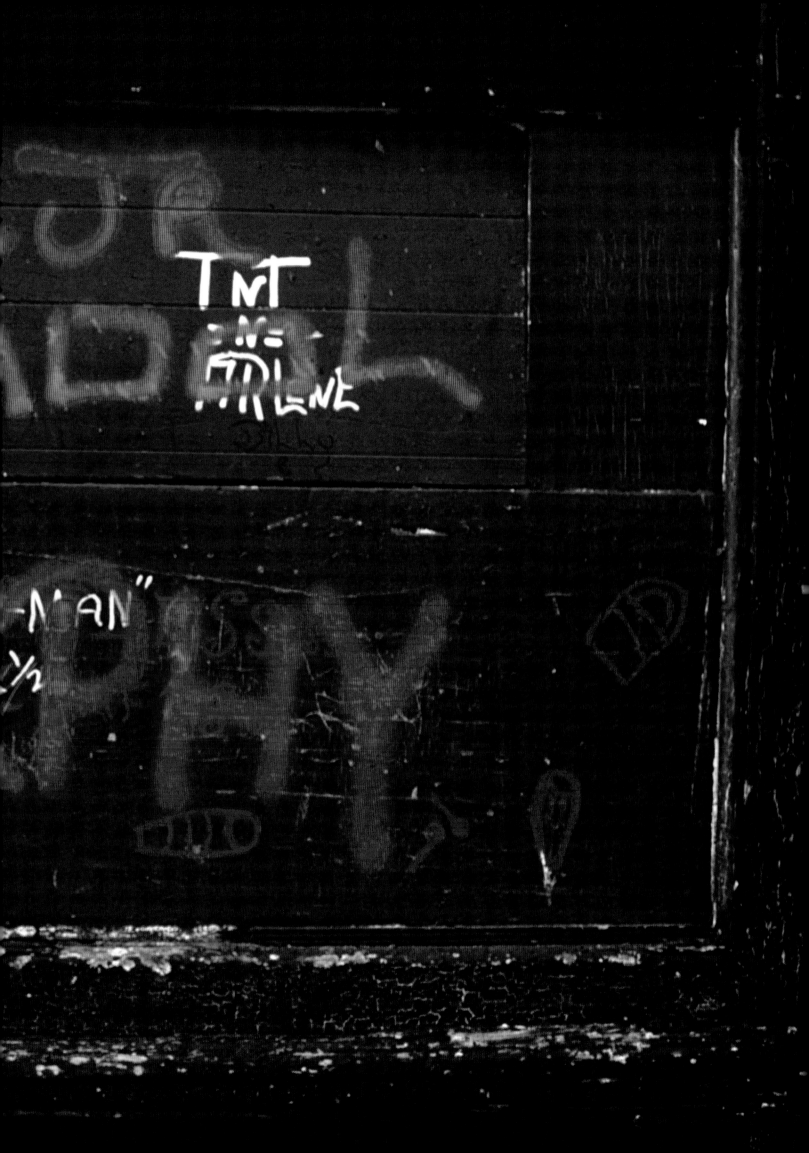

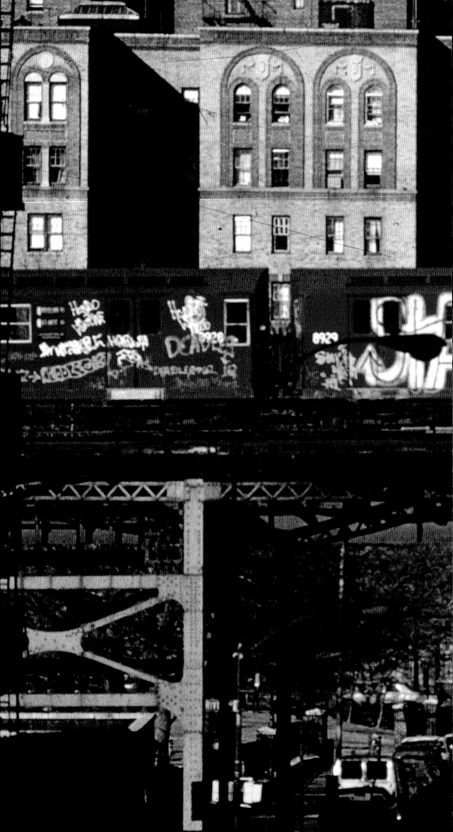

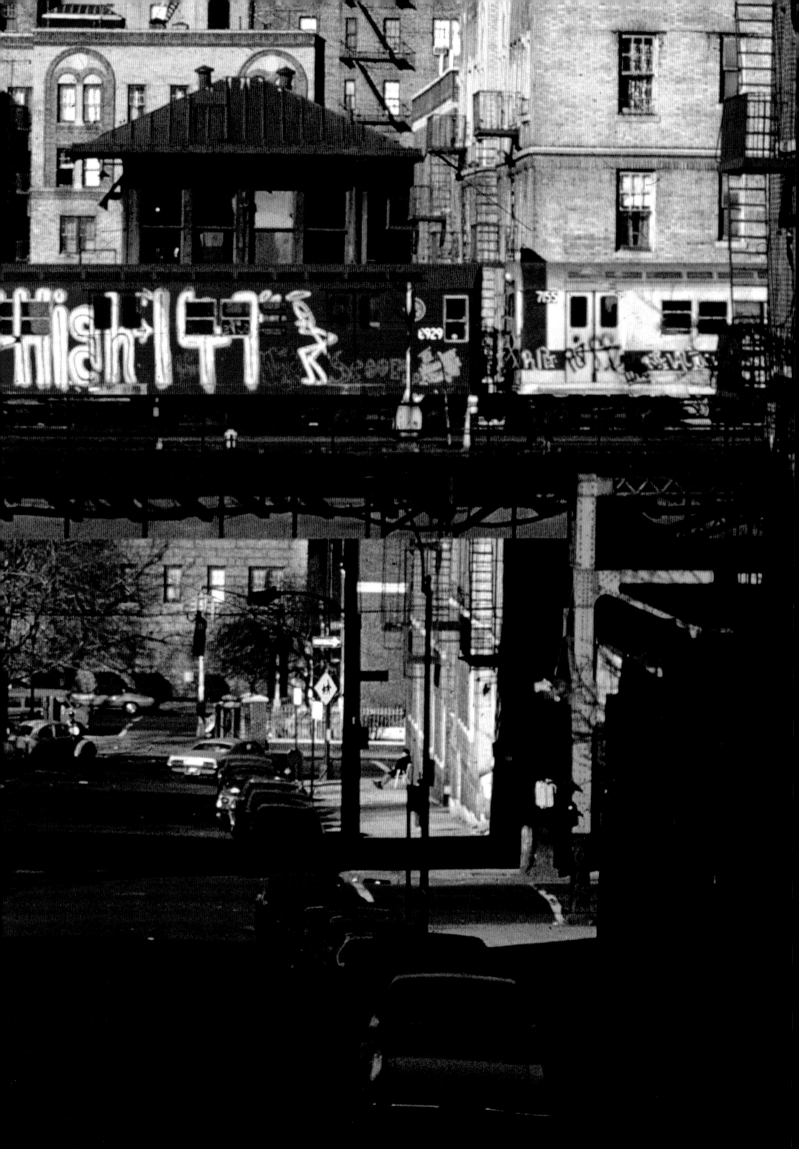

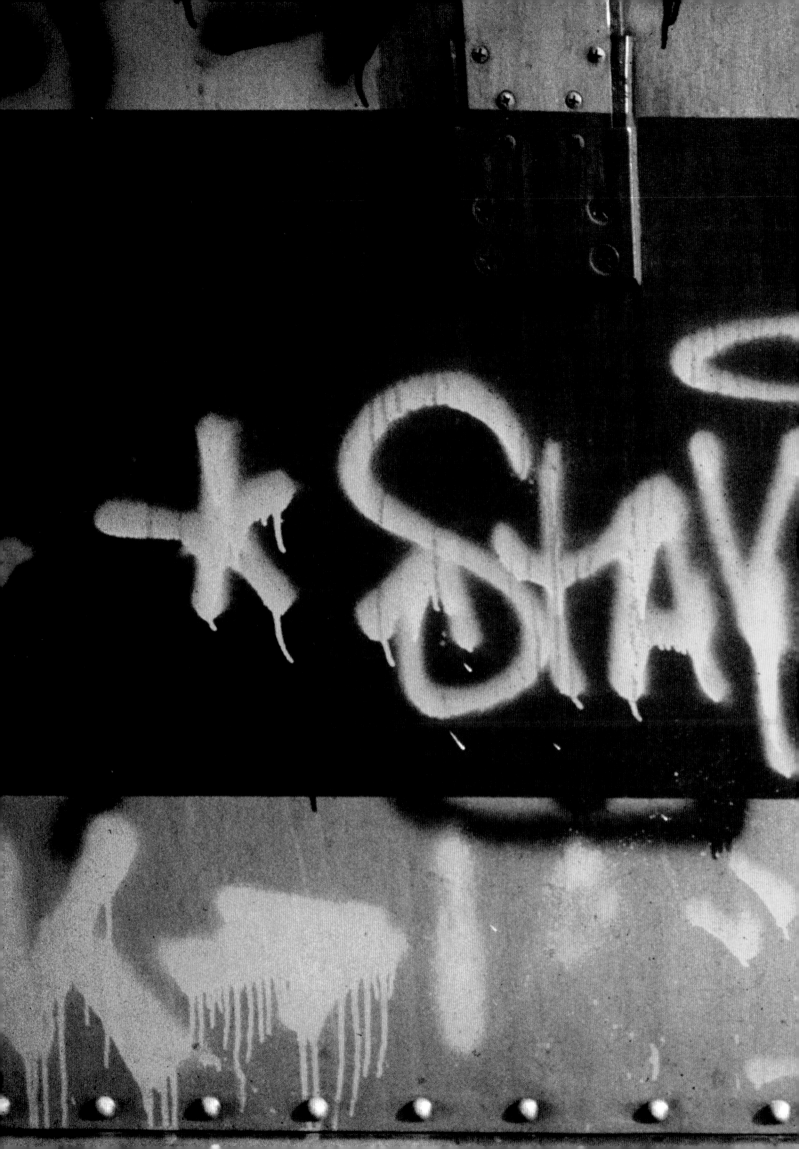

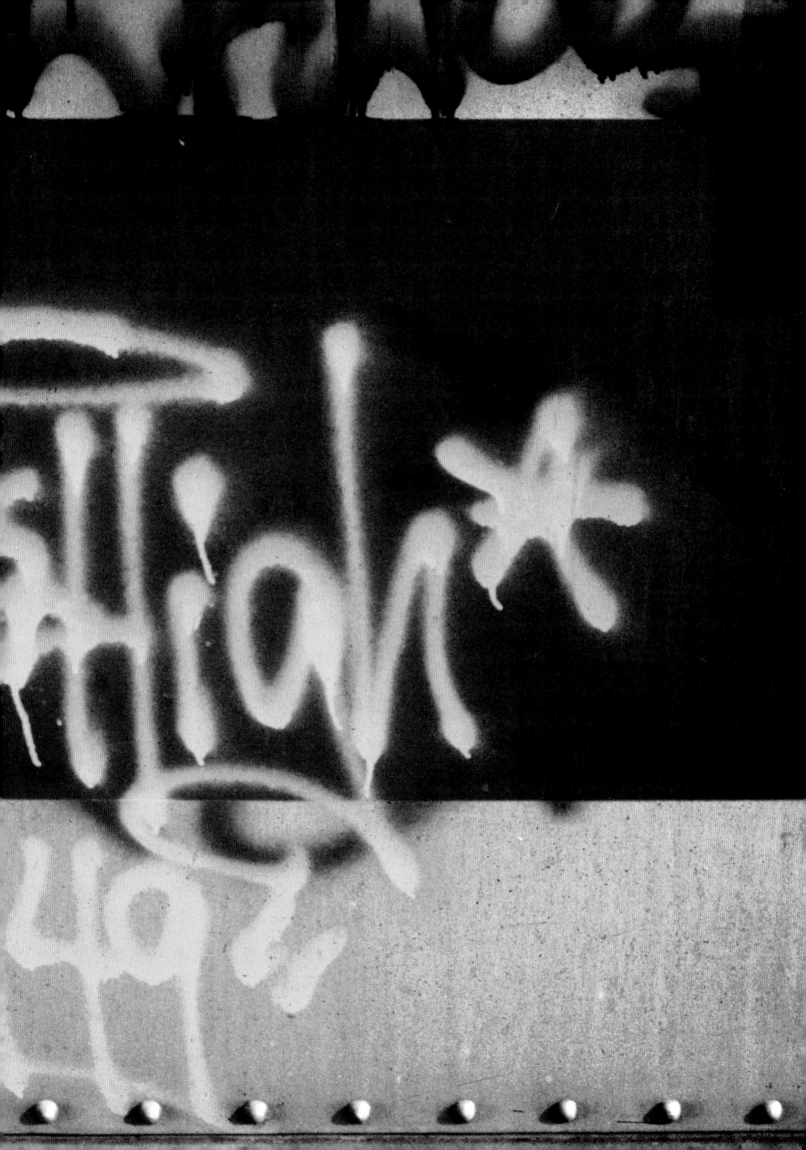

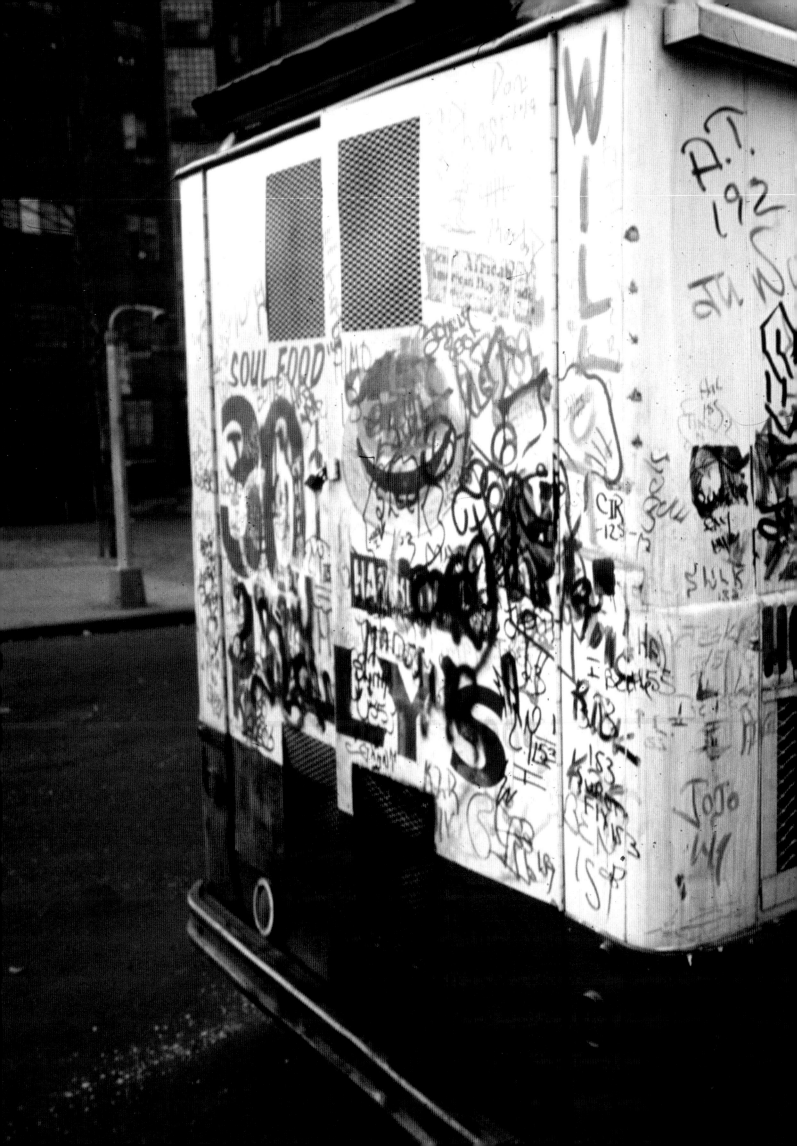

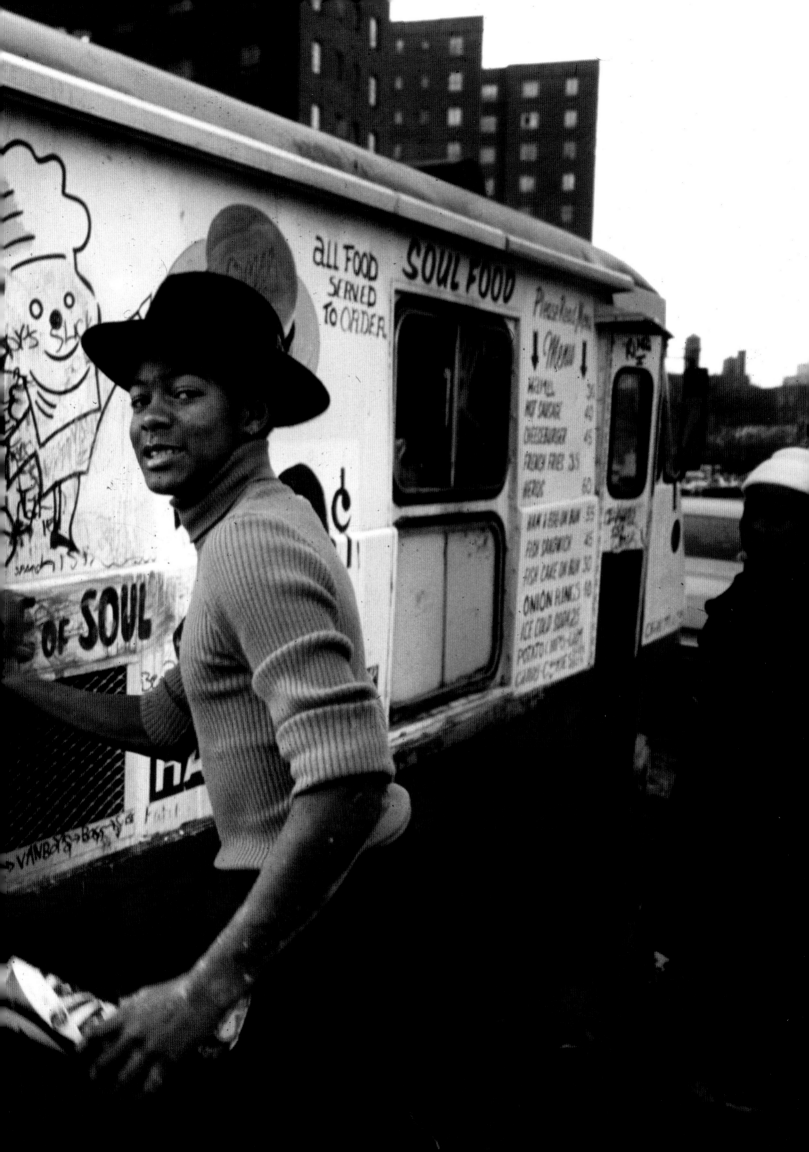

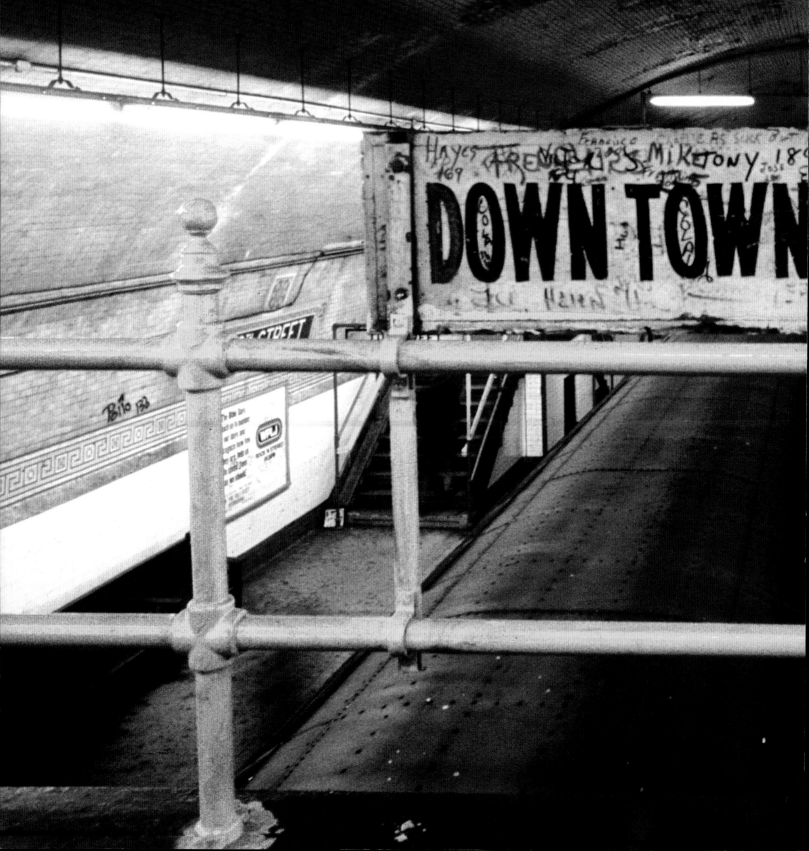

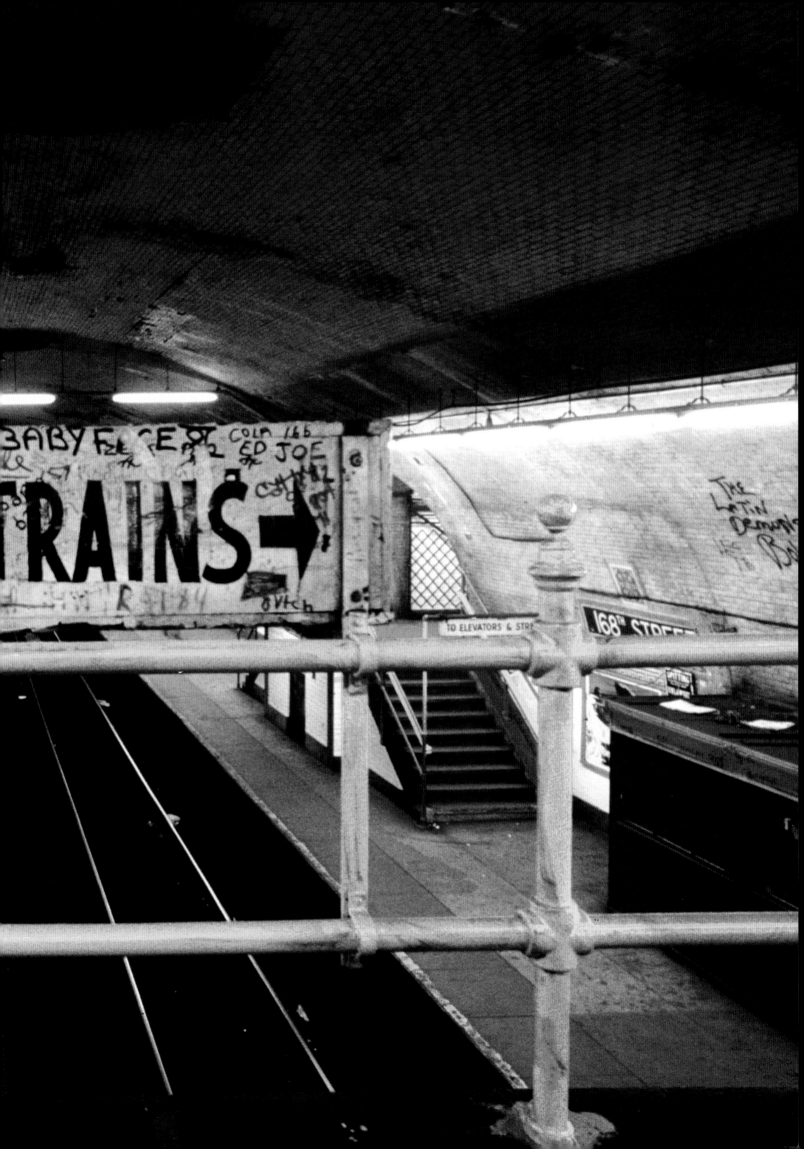

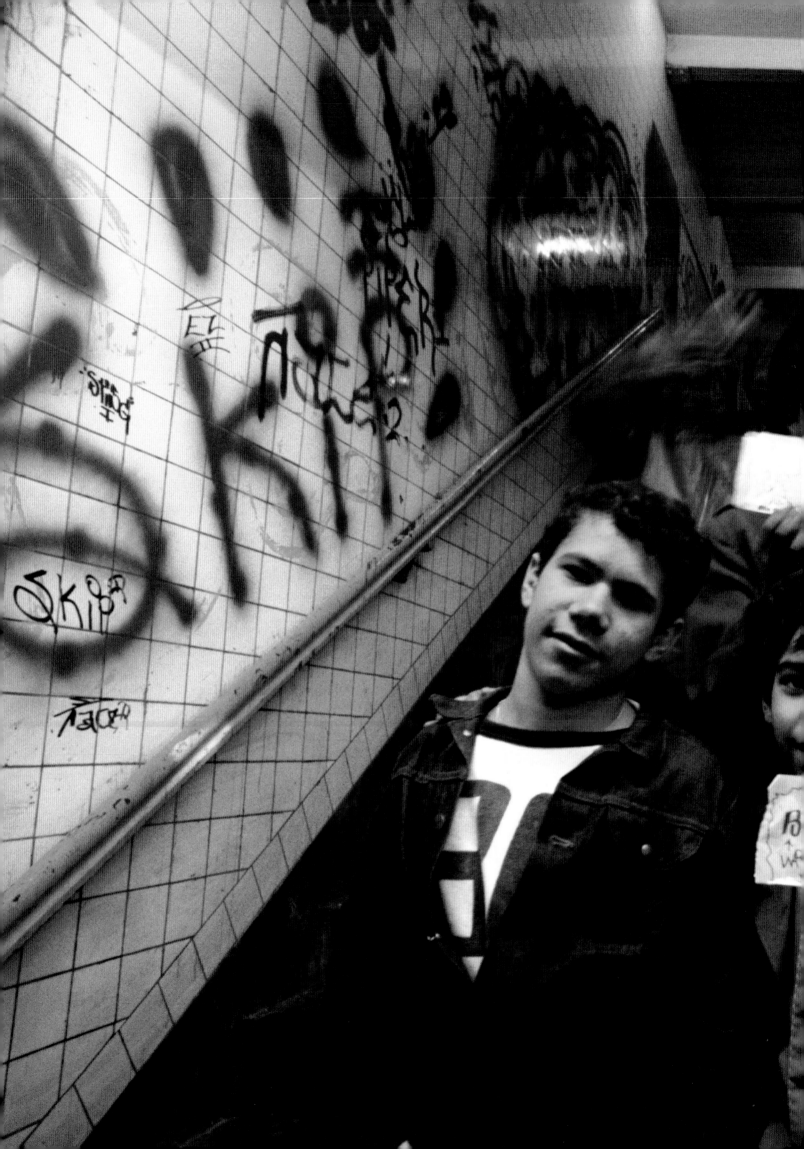

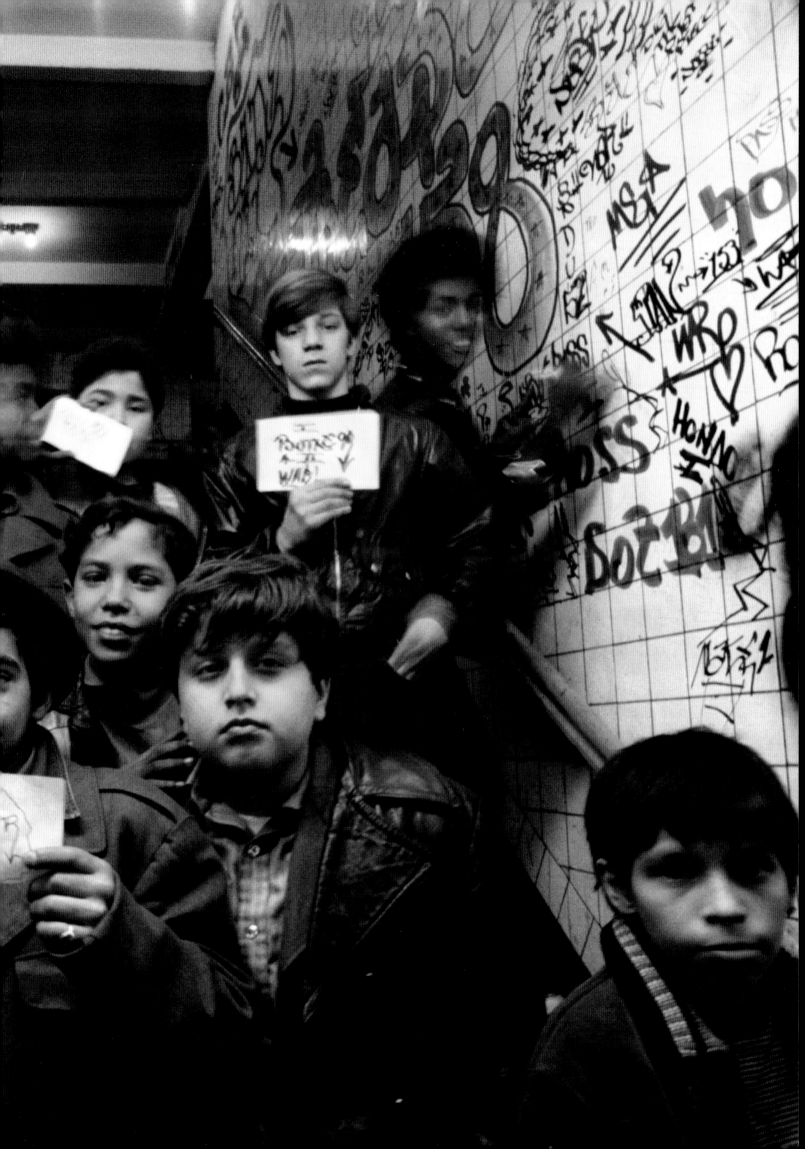

dedication

To Ruth Kurle, Alex J. Naar, Norman Mailer, and the graffiti writers listed here,
and others we may have inadvertently not acknowledged.

afterword

Over two months in December 1972–January 1973, I shot over 3,600 Kodachrome photographs of graffiti in New York for a book that became known as *The Faith of Graffiti*. Photographing the early days of the graffiti phenomenon, I was attracted to the exuberance of these writings – on trains, subway stations, buses, school playgrounds, and just about every other public surface you could find. The in-your-face impact of the "tags" – writers' first names (or nicknames) usually followed by the number of the street they came from, such as *Cay 161* – was overpowering, and as a photojournalist, I wanted to record this graffiti in the broader context of the city. I saw these taggers as young urban guerrillas putting up their names in defiance of the conditions of their existence; in defiance of a ubiquitous enemy they called "The Man." I was impressed with how they used their graffiti as a private code to communicate with each other via the public transit system and other means throughout Manhattan, the Bronx, Brooklyn, and Queens.

Looking at my photographs in this expanded version of *The Faith*, I believe they offer a kind of Proustian remembrance of lost time and things past. While I did this photographically, it was primarily Norman Mailer's words that gave them, and indeed the entire graffiti movement, legitimacy beyond their wildest imagination. He was, if not the first, certainly the most important social critic to call this form of writing art. Interestingly, the graffiti writers did not, nor do they today, use that term to describe themselves, preferring "writers," "taggers," or "bombers."

What impressed me as a self-taught photographer, as it did Mailer, was that these early graffiti writers were able to produce an existentially new form of graphic expression without having had (or perhaps *because* they never had) any formal visual arts training. In the photo *Hex Nixon*, you can see how the graffiti colors, red and black on a white background, pick up the same colors as the Nixon for President poster they embellish. The vibrant red signatures *Toots, Sissy, Maria, Fanny* on a painted green wood background have been described by several art critics as "Miro-like." Evil Eddy's use of outlining cleverly gives a trompe l'oeil effect of chiseling into the stone slab of the balustrade overlooking Riverside Park on Manhattan's West Side.

It is a source of great satisfaction to me that my (now mostly uncropped) photographs in this new version of *The Faith* have been restored to my original intent to show the spirit of a time and place gone by in celebrating those adventuresome young taggers who made the graffiti possible.

— Jon Naar, 2009

THE FAITH OF GRAFFITI.
Photographs copyright © 1974, 2009 by Jon Naar. Text copyright © 1974, 2009 by the Estate of Norman Mailer.
Afterword copyright © 2009 by Jon Naar. All rights reserved. A Polaris Communications, Inc. book.
This new edition of *The Faith of Graffiti* prepared by Lawrence Schiller, copyright © 2009 by Polaris Communications, Inc.
It should be recognized that the 1974 edition of The Faith of Graffiti was proposed, artdirected, and designed by Mervyn Kurlansky,
then a partner in the British design firm Penatgram. No part of this book may be used or reproduced
in any manner whatsoever without written permission except in the case of brief quotations embodied in critical articles
and reviews. For information address HarperCollins Publishers, 195 Broadway, New York, NY 10007.

HarperCollins books may be purchased for educational, business, or sales promotional use.
For information please write: Special Markets Department, HarperCollins Publishers, 195 Broadway, New York, NY 10007.

Works of art accompanying Mr. Mailer's text reproduced with permission of the Museum of Modern Art, New York;
the Vatican Museums, Rome, and the Australian National Gallery, Canberra, Australia.

Manufactured in China

This edition designed by Howard Ian Schiller.

Library of Congress Cataloging-in-Publication Data is available upon request.

ISBN 978-0-06-196540-1 (hc.)
ISBN 978-0-06-196170-0 (pbk.)

19 20 SCP 10 9 8 7 6 5 4 3 2